Women, Work, and Family

Understanding Families

Series Editors: *Bert N. Adams, University of Wisconsin*
David M. Klein, University of Notre Dame

This book series examines a wide range of subjects relevant to studying families. Topics include, but are not limited to, theory and conceptual design, research methods on the family, racial/ethnic families, mate selection, marriage, family power dynamics, parenthood, divorce and remarriage, custody issues, and aging families.

The series is aimed primarily at scholars working in family studies, sociology, psychology, social work, ethnic studies, gender studies, cultural studies, and related fields as they focus on the family. Volumes will also be useful for graduate and undergraduate courses in sociology of the family, family relations, family and consumer sciences, social work and the family, family psychology, family history, cultural perspectives on the family, and others.

Books appearing in **Understanding Families** are either single- or multiple-authored volumes or concisely edited books of original chapters on focused topics within the broad interdisciplinary field of marriage and family.

The books are reports of significant research, innovations in methodology, treatises on family theory, syntheses of current knowledge in a family subfield, or advanced textbooks. Each volume meets the highest academic standards and makes a substantial contribution to our understanding of marriages and families.

Multiracial Couples:
Black and White Voices
Paul C. Rosenblatt, Terri A. Karis, and Richard D. Powell

Understanding Latino Families:
Scholarship, Policy, and Practice
Edited by Ruth E. Zambrana

Current Widowhood: Myths & Realities
Helena Znaniecka Lopata

Family Theories: An Introduction
David M. Klein and James M. White

Understanding Differences Between
Divorced and Intact Families
Ronald L. Simons and Associates

Adolescents, Work, and Family:
An Intergenerational Developmental
Analysis
Jeylan T. Mortimer and
Michael D. Finch

Families and Time:
Keeping Pace in a Hurried Culture
Kerry J. Daly

No More Kin: Exploring Race, Class,
and Gender in Family Networks
Anne R. Roschelle

Contemporary Parenting:
Challenges and Issues
Edited by Terry Arendell

Families Making Sense of Death
Janice Winchester Nadeau

Black Families in Corporate America
Susan D. Toliver

Reshaping Fatherhood: The Social
Construction of Shared Parenting
Anna Dienhart

Problem Solving in Families:
Research and Practice
Samuel Vuchinich

African American Children:
Socialization and Development
in Families
Shirley A. Hill

Black Men and Divorce
Erma Jean Lawson and Aaron Thompson

Romancing the Honeymoon:
Consummating Marriage in
Modern Society
Kris Bulcroft, Linda Smeins,
and Richard Bulcroft

The Changing Transition to Adulthood:
Leaving and Returning Home
Frances Goldscheider and
Calvin Goldscheider

Families and Communes:
An Examination of Nontraditional
Lifestyles
William L. Smith

Women, Work, and Family:
Balancing and Weaving
Angela Hattery

Angela Hattery

Women, Work, and Family

Balancing and Weaving

UNDERSTANDING FAMILIES

Sage Publications
International Educational and Professional Publisher
Thousand Oaks ■ London ■ New Delhi

For information:

Sage Publications, Inc.
2455 Teller Road
Thousand Oaks, California 91320
E-mail: order@sagepub.com

Sage Publications Ltd.
6 Bonhill Street
London EC2A 4PU
United Kingdom

Sage Publications India Pvt. Ltd.
M-32 Market
Greater Kailash I
New Delhi 110 048 India

Printed in the United States of America

Library of Congress Cataloging-in-Publication Data

Hattery, Angela.
 Women, work, and family: Balancing and weaving / by Angela Hattery.
 p. cm. — (Understanding families; v. 19)
 Includes bibliographical references and index.
 ISBN 0-7619-1936-8 (cloth: acid-free paper) — ISBN 0-7619-1937-6
(pbk.: acid-free paper)
 1. Working mothers. I. Title. II. Series.
 HQ759.48.H384 2000
 306.874′3—dc21 00-010060

01 02 03 10 9 8 7 6 5 4 3 2 1

Acquiring Editor: Jim Brace-Thompson
Editorial Assistant: Anna Howland
Production Editor: Diana E. Axelsen
Editorial Assistant: Victoria Cheng
Typesetter/Designer: Doreen Barnes
Indexer: Mary Mortensen

Contents

To Travis and Emma

Acknowledgments

A s authors always note, the writing of a book, though an extremely solitary endeavor, could not be done without the help and advice of many people. I would like to acknowledge publicly those who have helped me with this book.

I would first like to thank Bert Adams and David Klein, the editors. They encouraged me to consider submitting my dissertation manuscript to the NCFR Student/New Professional Book Contest. Also, they have lived up to their word in being "hands-on" editors. They have read multiple drafts of the manuscript and have given tremendous advice regarding both the manuscript itself and the process of turning a dissertation into a book. I am grateful to them. I thank the anonymous reviewers for the NCFR Student/New Professional Book Contest for their constructive criticism. I also thank the anonymous reviewers who provided comment after the manuscript had been drafted. Their feedback pushed me to be more critical and precise. Though difficult at times, incorporating their suggestions has made the final product substantially more readable and accurate.

I would like to thank the members of my dissertation committee. Though the book has been rewritten so extensively that it bears little resemblance

to the original manuscript, the advice they offered contributed to the project on which this book is based. Thank you to Jim Sweet and Jane Piliavin, who provided mentorship throughout the project, and to Nadine Marx and Gary Sandefur, who served as nonreaders but whose advice was helpful nonetheless. At the dissertation stage, this project received financial support from the E. A. Ross Memorial Fund and the Janet Hyde Dissertation Award, both at the University of Wisconsin—Madison.

I would also like to thank others who offered advice or assistance on the project. Thank you to Pam Rathbun for her help in developing the measures, and to Margy Syse and Lisa Drummond, who performed transcription, thus allowing me to focus on the analysis. Additional transcription was performed by Melissa Otto, who later became Melissa Freetly when she married my brother-in-law. She has just become a mother, and I hope this book will ease her process in balancing and weaving work and family. Thank you to Shawn Ahern-Djamali; Neil Freetly, my brother-in-law and Melissa's husband; Michele Laux; and Steve Schollmeyer, all of whom helped with mailing the original survey. Thank you to Michelle Panos and Jeff Schulz for help with data entry, and to Nancy Annis, who took the lead in formatting the second survey for production.

During the summer and autumn of 1999, I worked arduously to turn the dissertation into a book. Several Wake Forest undergraduates read various drafts of manuscript chapters and offered their advice. I am grateful to Julie Cowley, Brenda Mock Kirkpatrick, Robert O'Kelly, and Rebecca Strimer. Craig Zakrzewski and Ben Stafford did wonderful work on formatting, compiling, and checking the bibliography. And Jim Fitzpatrick worked as my research assistant over the summer of 1999. He is an excellent writer, and his comments on the drafts have contributed substantially to the readability of the manuscript. Perhaps more important, the brainstorming sessions he shared with me clearly advanced my own thinking.

Emily Kane has been both my graduate school advisor/mentor and my close friend since 1989, the year I entered graduate school and she became an assistant professor. Emily's mentoring allowed me to grow as a scholar and as a feminist. I thank her for allowing me the freedom to develop in ways that best suited me. Her influences are apparent throughout the manuscript. She has tirelessly read every draft of this book and offered constructive criticism that has advanced my own thinking about the power of ideology in the social world.

Finally, there are the personal thank yous. Thank you to my parents, Bob and Diane Hattery. You told me I could do anything I set my mind to. You served as exemplary role models both professionally and as parents. Your encouragement has been vital to my success. Finally, thank you for reading every chapter of this manuscript. I think your red pens

must have run out by the end! Thank you to my spouse, Jim. You pushed me hard at many stages during this project, especially near the end, and you shared the work of home and family so that I could realize this project from start to finish. Thank you to my children, Travis and Emma. Your presence, which forced me to figure out effective ways to weave work and family, has provided the critical standpoint from which I investigate the world and write about it. Thank you for understanding when I needed to write. Finally, to the women who so graciously opened up their lives and homes to me. Without you, there would be no book.

1

Introduction and History of Women's Labor Force Participation

M any challenges face U.S. families in the beginning of the 21st century. Among these challenges is the care of family members at both ends of the generational spectrum. Families raising children face the challenge of providing care and supervision for them in an age when fewer families have a parent at home full-time, yet the school day remains 6 to 7 hours long and summer vacation is still an institution. Many families are also coping with the care of their eldest members. With life expectancy on the rise, many of us can expect to have parents who require care and supervision into their 90s. As a result of delayed childbearing, some U.S. families find themselves caring for young children and aging parents simultaneously, thus the coining of the term "sandwich generation." These challenges have been recognized by scholars, who suggest that resolving the conflict between work and family is of tantamount importance to present-day U.S. families. Families with children simply recognize that they are struggling to find a way to balance work and family. This study focuses on one piece of the issue by examining the ways in which 30 mothers with young children resolve the job-family conflict. These are their stories.

Despite declining fertility rates in the United States, 85.7% or so of women and only slightly fewer men will find themselves balancing and weaving work and child rearing (Bachu, 1993). Of the 15% of individuals who do not have children, estimates are that 7% of married couples are choosing to be child-free (Bachu, 1993). Yet many of these individuals are still not free from having to struggle with work-family conflict. For some, the decision to remain child-free is a response to anticipated work-family conflict (Gerson, 1985). Some child-free employees must deal with the fallout of work their colleagues leave undone when work-family conflict spills into the workplace. The relationship between work and family is complex and dynamic. At the beginning of the 21st century, the conflict between work and family is one of the most pressing issues facing families.

The conflict between work and family is played out in public discourse as well. For example, the 1997 trial of Louise Woodward, the British au pair who was convicted of manslaughter in the death of Matthew Eappen, the 8-month-old boy in her care, brought the issue to the forefront of the American debate regarding appropriate strategies for balancing and weaving work and family. As a researcher and a mother, I found it interesting that the tragedy of Matthew Eappen's death was soon overtaken in the realm of public discourse by discussions of child care. Many Americans voiced blame toward Louise Woodward, who was convicted but released shortly after her conviction by the judge, who credited her for time already served. But brewing beneath the surface and erupting in a variety of realms was a discussion of the role that Matthew Eappen's mother may have played in his death.

Eighteen months after the trial, in March 1999, CNN and other news programs reported the release of new medical evidence suggesting that Matthew Eappen died as a result of abuse he had experienced over a period of weeks or months. Thus, some have suggested that his parents, not Louise Woodward, may have been responsible for his death. Though new evidence may continue to arise, I would like to consider the public reaction in the period immediately following the conviction of Louise Woodward. In the absence of the new evidence that now appears to implicate the mother, many in the United States questioned Dr. Deborah Eappen's role in her son's death because it was she who hired Louise Woodward. Many suggested that his mother should have been more careful about providing appropriate care for her child while she was at work.

But the debate did not end here. Others blamed Matthew Eappen's mother for his death precisely because she was employed outside the home. Had she chosen to stay at home, forgoing her medical career, then she would not have been in the position of having to hire a child care provider—one who, it appeared, would eventually kill her young son.

On top of all this, some pointed out that Matthew Eappen's mother had not fulfilled her duties as a mother, not only because she chose to work, but also because she worked even though she was not a single mom on welfare, one of the many women who "have to work." Her husband, the child's father, was a highly successful, extremely well-paid anesthesiologist. Matthew Eappen's mother had not only acted poorly in her decision to hire Louise Woodward, some argued, but had also chosen to pursue her career and work outside the home even when she didn't "have to."

The Purpose of the Book

The purpose of this book is to examine this relationship between work and family and the process by which women with young children negotiate an arrangement that is satisfying to them. It is not the purpose of this book to endorse or attack any strategy for balancing and weaving work and family. In addition, I have attempted to do more than just describe the ways in which women and their families resolve this conflict. I have sought to understand the process by which the balancing and weaving are accomplished.

BALANCING AND WEAVING

This study and this book are about combining work and family and the various strategies that mothers employ for doing so. It is important to address issues of labeling and language as they relate to combining work and family. This juggling is typically referred to as "balancing work and family." Hochschild (1989) uses the image of an employed mother, briefcase in one hand and baby perched on the other arm, to symbolize the process of balancing that many employed mothers experience. Garey (1999) critiques this image of balancing and proposes the language of weaving instead. Garey argues that balancing implies a zero-sum game or a false dichotomy, that energy invested in one side of the scales requires taking energy away from the other side. For example, when I am at work, I am automatically deducting time from my family and vice versa. Garey proposes instead a model in which work and family are integrated. Her model suggests that energy can be invested in both work and family simultaneously. Moreover, she suggests that the dichotomy of work and family is false.

Given the lack of language for adequately describing the process of combining work and family, I will use both terms, *balancing* and *weaving*. Consistent with Garey's (1999) analysis, I believe that the terms are

not interchangeable. Further, I accept Garey's argument that balancing implies a zero-sum game whereas weaving does not. However, I will use both terms because I believe that some strategies for combining work and family can more accurately be described as balancing, whereas others can best be described as weaving. For example, the strategy of a mother who chooses to forgo her career to exclusively pursue life as a stay-at-home mother may best be described as balancing. In this case, the stay-at-home mother is focusing her energy toward mothering. In contrast, the strategy of a mother who provides child care for other children in her home can best be described as weaving—the lines between work and family are blurred. Therefore, I will use both terms in general discussions, and I will use specific terms when they best characterize specific strategies and examples.

In addition, I do not assume that balancing and weaving are for employed mothers alone. I believe that mothers who choose to stay at home are choosing a specific combination of work and family; they are choosing to put all of their energies into caring for their families and none of their energies into employment. However, I would argue that this is still a choice about how to combine work and family. It is not as if mothers who are staying at home are not aware that they could be employed. Rather, they are actively choosing to forgo employment for child rearing.

This book contributes to and advances our understanding of the process by which mothers determine their level of labor force participation in several ways. First, this book investigates the factors that are important in the labor force considerations of mothers with young children. Although previous literature has identified a series of factors, the importance of motherhood ideology has been vastly underrepresented in empirical studies. Thus, it deserves attention. For the majority of mothers, motherhood ideology is one of several factors they consider when they develop strategies for balancing and weaving work and family. However, for some women, it is the only relevant factor in their labor force deliberations. Second, mothers who stay at home full-time have been virtually ignored in the literature. Though often included in sex-role attitude research in which the attitudes of stay-at-home mothers are compared with those of women who are employed, very little work has been done to understand the choice to stay at home. For many mothers in this study, the decision to stay at home arose out of a careful cost-benefit analysis. It was, in fact, as "rational" a choice as for many mothers who chose some level of employment. Third, in addition to investigating the outcome of labor force considerations, this study focuses on the process by which mothers with young children conduct these considerations.

This study suggests that the process of determining whether to be employed full-time, part-time, or not at all is relatively straightforward

for some mothers, whereas for others, it is quite complex. Mothers for whom the process is complex often experience instability in employment and child care usage as they attempt to balance work and family while considering a variety of factors that are constantly in a state of flux. The data presented here are not longitudinal, and therefore, I am not able to address changes in labor force participation over the life course. However, because the interviews included the mothers' employment patterns and history up until the time of the interview, I am able to speak about change within the individual experiences of these mothers.

Though previous literature has identified many factors that promote or inhibit maternal employment, very little work has focused on the often complex process of finding strategies for effectively balancing and weaving these competing spheres of social life. By examining the process and not simply the outcome of mothers' attempts to balance work and family, I conclude that the dichotomy between employed mothers and those who stay at home is artificial. Instead, I identify four distinct groups of mothers. This typology distinguishes among mothers based on data regarding their employment status, beliefs about appropriate roles for mothers, and a myriad of other structural and human capital factors. This typology advances the literature by allowing us to obtain a clearer picture of maternal employment.

Theoretical Perspectives

A careful review of the literature on maternal labor force participation reveals that a variety of factors clustered in several theoretical paradigms have received empirical support for their predictive power. However, in this study, I am particularly interested in the role that beliefs about motherhood, or motherhood ideology, play in the process of balancing and weaving work and family. I will argue that motherhood ideology affects both the range of possible solutions women perceive for balancing and weaving work and family as well as the actual mechanisms that women choose in order to resolve the job-family conflict.

The discussion in Chapter 4 will be devoted entirely to the theoretical paradigms that are invoked to understand maternal labor force participation. It will be useful at this point, however, to briefly mention each of the theoretical perspectives and important variables that will be discussed later. Theories that will be reviewed are structural-functionalism; rational choice models (including new home economics theory); conflict theory; feminist theories; and race, class, and gender models.

Structural-functionalism is based on the assumption that social arrangements are configured to maximize function for society's members.

Therefore, gender differences in employment and child care must have developed because arrangements configured in this way were functional. Based in Western thought, structural-functionalism focuses on the notion that, throughout history, societies have evolved to include at least two different spheres—the sphere of work and the sphere of the home. Men have specialized in the sphere of work and thus have developed skills that allow them to succeed at work, whereas women have specialized in the work of the home and have developed skills that allow them to succeed there.

Rational choice models assume that individuals engage in a cost-benefit analysis in the process of decision making. In considerations of maternal employment patterns, several different strains of this basic model exist. Across the variety of rational choice models, the following variables have received the most support in explaining maternal labor force participation: mother's human capital (her educational attainment and occupational experience), economic need, occupational opportunity, child care cost and availability, and size and composition of the household.

Based in the Marxian tradition, the conflict perspective assumes that social arrangements arise out of various material conditions of different groups within a society. Specifically, Marx considered the relationship between the individual and the means of production to be of primary importance in determining all one's social relations. With regard to the strategies that families develop to ease the job-family conflict, the conflict perspective focuses on the ways in which social inequalities are both created and reflected within family life. Conflict theorists argue that as a result of men's greater participation in the labor force, they have greater access to rewards, resources, and power within the culture. This access translates into greater power within the family. As a result, conflict theorists analyze decisions about maternal labor force participation within the context of capitalism and patriarchy as they exist within the United States.

Feminist theorists also examine maternal labor force participation as a site of contention. Like many other paradigms, there are really many feminisms. However, at the central core of feminist theory is the belief that opportunity and reward structures are gendered. As a result of patriarchy, women have had less occupational opportunity, and they suffer from the wage gap. Inhibited by these structural factors, many women choose to remain out of the labor force even though this is disadvantageous to them because it leaves them economically dependent on men.

Race, class, and gender models seek to expand on the feminist and conflict perspectives by understanding women's experiences as a result of a matrix of domination that includes racism, classism, and sexism. This perspective examines differences in women's labor force participation with

attention to the social location of each individual woman. Race, class, and gender models assume that individual mothers chose their level of labor force participation in response to other systems of domination. For example, African American women are likely to have different patterns of labor force participation than white women as a result of racial discrimination they and their male partners experience.

Motherhood ideology is a factor that has received more attention recently in discussions of maternal labor force participation. However, motherhood ideology has been written about more at the theoretical level than at the empirical level. Discussions in the theoretical literature focus on the content and origins of motherhood ideology and its variance across demographic groups in the United States. Very few scholars have employed motherhood ideology in their empirical analyses of maternal labor force participation. This study will examine maternal labor force participation using motherhood ideology as a primary analytical category. The predictive power of motherhood ideology varies. In some cases, it is the most important factor in a mother's decisions about balancing and weaving work and family. In other cases, it is one of several factors that predict maternal employment. Nevertheless, this study suggests that including motherhood ideology in our models improves our ability to understand the labor force participation choices of mothers with young children.

The Power of Ideology

In order to understand the process by which motherhood ideology influences maternal employment, it is useful to understand more generally the ways in which ideology affects behavior. To do so, I will rely on Goran Therborn's conceptualization of ideology and discourse. Therborn is a prominent European theorist of ideology. His 1980 book *The Ideology of Power and the Power of Ideology* has been influential in examinations of both the content and the power of ideologies within different sociopolitical structures. Therborn writes about the process by which an ideology may gain dominance in a society and then exert power over individual-level behavior. Therborn's conceptualization of ideology will be the framework of my theoretical model for understanding maternal labor force participation.

A LOOK AHEAD

Chapter 2 will include a specific discussion of Therborn's conceptualization of ideology. Of primary importance is Therborn's assertion that ideology

defines what exists, what is good, and what is possible. In later chapters, I will apply this concept of ideology to the case of motherhood ideology and labor force participation choices. Chapter 2 will also include a discussion of contemporary perspectives on the content of motherhood ideology as well as a discussion of systems of discourse by which the dominant motherhood ideology, that of the stay-at-home mother, is disseminated.

In Chapter 3, I will introduce the mothers who form the basis of this study. Developing an understanding of the process by which mothers attempt to balance work and family requires an examination of the material conditions in which these women live. Chapter 3 includes the story of a woman who raises her family of three children on her husband's $20,000 annual salary. In contrast is a woman who, at 41, is the mother of one child, holds an MBA, and is a senior-level administrator in a university hospital. Chapter 3 will include an examination of the lives of mothers who stay at home, mothers who are employed, and mothers who, along with their spouses, supply all of the child care for their children. This chapter will be primarily descriptive.

Before analyzing the process by which these various mothers decided on their level of labor force participation, it is necessary to examine the work of other scholars in the area. Chapter 4 will examine the theoretical and empirical literature that has focused on women's labor force participation. Scholars in a variety of disciplines, from economics to women's studies, have examined the changing role of women in this culture and, in particular, their changing role in the labor force. In this chapter, I will summarize the existing literature on maternal labor force participation and outline my model, which includes the factors that I have found to be the most useful in understanding the labor force participation choices of mothers with young children.

Having reviewed the existing literature, I will focus in Chapter 5 on the qualitative analyses of the process by which the mothers introduced earlier determine whether to remain employed or remain at home following the birth of their first children. Using Merton's (1975) conceptualization of delinquency, I will argue that these data illustrate that mothers use one of four possible strategies for resolving the job-family conflict in the context of the dominant motherhood ideology in the United States at the end of the 20th century. Mothers can be identified as conformists, nonconformists, pragmatists, and innovators.

Mothers may conform to the dominant motherhood ideology and arrange their lives so that they may stay at home with their children. Conversely, mothers may reject the notion of the stay-at-home mother and continue to pursue their own interests despite a marked lack of economic need. For both of these groups of mothers, their beliefs about motherhood are critical to their decisions about balancing and weaving

work and family. Mothers may also act as pragmatists. Pragmatists engage in rational choice decision making. Though these mothers, for the most part, accept the dominant form of motherhood ideology, they constantly reassess their options and make decisions that result in outcomes that arise out of their ongoing cost-benefit analyses. Motherhood ideology is one of several factors they consider. Finally, mothers may act as innovators. Innovators accept the dominant motherhood ideology but reject the standard methods of achieving a balance between work and family. Innovators create new ways of meeting the demands of both their roles as caretakers and economic providers for their families.

I will use both qualitative and quantitative data in order to show that motherhood ideology is, in fact, important in the labor force participation decisions of mothers with young children. Furthermore, I will demonstrate that the four-category system I propose allows us to see the differences among mothers with more precision than the conventional system of dichotomizing mothers by employment status.

Economic need has long been considered the only, or the most acceptable, justification for the employment of mothers with young children. In Chapter 6, we will look closely at the subjective construction of economic need. I will show not only that economic need is subjectively constructed but also that one's motherhood ideology is central to the process by which economic need is constructed. Mothers who adhere strongly to intensive motherhood ideology (conformists) construct economic need around the income generated by their spouses. Mothers who either reject (nonconformists) or adhere less strongly (pragmatists and innovators) to intensive motherhood ideology construct economic need around their desired standard of living. The family's ability or inability to meet this standard of living on a single income strongly influences the labor force participation of these three groups of mothers.

Perhaps the most perplexing issue related to maternal labor force participation is solving the child care dilemma. In Chapter 7, I will examine the ways in which these 30 mothers solved the child care dilemma. Among employed mothers, child care solutions range from employing nannies to utilizing child care centers to providing all of the child care within the nuclear family. I will argue that beliefs about motherhood affect one's beliefs about the range of appropriate care providers. Additionally, motherhood ideology also determines one's beliefs about the role that mothers and fathers as well as alternative care providers play in child development. Nonconformists, for example, indicate that their use of child care not only solves the child care dilemma but also serves an important socialization function for their children. Finally, I will consider various proposals to ease the difficulties so often associated with dealing with child care.

In Chapter 8, I will summarize each chapter and its importance in understanding maternal labor force participation. Furthermore, I will tie theory, data, and analyses together while pointing out the limitations of the study. Though the impact of ideology on maternal employment varies, ideology is a powerful force in individual-level decision making. In the final chapter, I will consider the proposition that ideology can change over time. Using Therborn's framework, I will speculate about the forces that will drive changes in ideology at both the structural and individual levels. I will also consider the changes in demographics, most important, the continued rise in maternal employment and the changing economic system in which we live, and the impact of these changes on both motherhood ideology and the processes by which mothers and fathers balance work and family.

History of Women's Labor Force Participation

Much attention has been paid to changes in maternal employment over the past 30 years. As with so many social phenomena, change can really be understood only by examining the phenomena within a historical perspective. Because there is no better place to begin an examination of maternal employment than the beginning, the remainder of this opening chapter will be devoted to a brief review of maternal employment in U.S. history. A review of the history of maternal labor force participation is essential for four reasons:

- The emergence of the dominant motherhood ideology, the ideology of intensive mothering, and the alternative motherhood ideology can be understood only within the context of the history of actual maternal labor force participation.
- Knowledge of trends in maternal labor force participation is essential in understanding the power of ideology in contemporary maternal employment decisions.
- The intense conflict between work and family that is part of our landscape is more meaningful when we consider the absence of this conflict in our past.
- The strategies for balancing and weaving work and family of one group of mothers, the innovators, are best compared to the strategies men and women have used throughout history.

Many in our culture yearn for the "way things always were," the days when gender roles were clear: Mothers stayed at home raising their children while men did the economic work (Coontz, 1992). Yet if we look into our past, what emerges is a very different picture, one that suggests,

as Coontz says, perhaps things have not always been quite this way. How do we know what things were like in our past? Archaeologists and anthropologists have used studies of modern-day hunting and gathering cultures to paint a picture of our human past.

SUBSISTENCE CULTURES

It is difficult to use archaeological data to describe the division of labor among our ancient ancestors (Tanner & Zihlman, 1976). Often, the archaeological record is interpreted in contradictory ways. However, anthropological studies of modern-day hunters and gatherers, such as Shostak's (1981) study of the !Kung, give us clues about the social behavior of our ancestors. Shostak paints a picture of egalitarian sex roles. The !Kung, according to Shostak, are an egalitarian culture in which men and women share roles. Even though men do the majority of the hunting, women hunt small-game animals and birds. Though women do the majority of the gathering, men gather on occasion, especially when they are on hunts. Both men and women in !Kung culture engage in child care. And, both men and women in !Kung culture participate in decision making for the group.

What is economic production? In modern-day industrial capitalism, economic production is working for wages. But in the lives of subsistence people, economic production is the gathering of food, water, and other materials that are utilized for producing clothing and shelter. By this definition, then, both !Kung men and women engaged in economic production.

How are work and family balanced? In !Kung culture, as Shostak (1981) suggests was the case throughout most of human history, economic production and family work are interwoven. !Kung boys are often taken along by their fathers and male relatives on overnight hunts. In this way, these young boys are socialized to the roles they will play as adults. In addition, practices such as these serve a child care function. Women often take children with them while they gather. Toddlers walk alongside their mothers, and infants are carried in slings. Work and family are balanced.

AGRICULTURAL ERA

With the advent of agriculture, societies experienced many changes. As scholars have noted, perhaps the most profound change ushered in by agriculture was the division of labor (O'Kelly & Carney, 1986). Along with agriculture came the opportunity for some to accumulate wealth, for food to be grown in surplus, and thus for some members of the culture to

be freed up to engage in other types of economic production (Lenski, Nolan, & Lenski, 1995). A look at contemporary agricultural societies as well as a look at our own recent past suggests that sex roles became differentiated with the onset of agriculture. In contrast with !Kung culture, men and women engage in different tasks in an agriculturally based society (O'Kelly & Carney, 1986).

Agriculture dominated the U.S. economy from our beginnings until the turn of the 20th century. It is important, then, to examine family life and the division of labor during the first century and a half of U.S. history. The work of the family farm tended to be sex segregated (O'Kelly & Carney, 1986; Reskin & Padavic, 1994; Shorter, 1975). Men and boys were frequently responsible for the heavy work on the farm, including the care of large animals; the heavy work of plowing and harvesting; and the maintenance of machinery. Women's work typically included that associated with lighter agriculture, such as growing vegetables and caring for smaller animals, perhaps chickens and goats. Women were also typically responsible for the "indoor" work—cooking, cleaning, and taking care of the children. Until relatively recently, this included the production of household goods such as clothes, soap, and candles (O'Kelly & Carney, 1986; Reskin & Padavic, 1994). Though we often do not define these kinds of work as economic production, this production of goods for consumption by the family constitutes economic production based on Engels' (1884) definition. Thus, it is clear that even within the confines of sex-segregated labor typical in an agriculturally based economy such as our own, women engaged in economic production for their families.

How were economic production and child care balanced? As with families in a subsistence culture, work and family were interwoven. Children were assigned tasks as soon as they were able to participate in economic work. Children carried water, beat clothes, and assisted in candle making. Boys worked alongside their fathers in the fields. Girls worked alongside their mothers in gardens and kitchens. Work and family were balanced.

THE INDUSTRIAL ERA

The industrial revolution heralded a different sort of relationship between work and family and a different sort of division of household labor. The economy of an industrial culture defines economic production as work that produces goods or services that are then sold in the marketplace. The worker sells his or her economic labor for a wage. By this definition, unpaid work is not economic production (Reskin & Padavic, 1994). The culture does not measure this kind of work as part of the gross national product. Thus, the distinction between paid and unpaid

labor is critical in defining work and the ways in which it is understood (Reskin & Padavic, 1994).

This distinction between paid and unpaid work has created a critical distinction between men's and women's work as well. As noted by others (see Reskin & Padavic, 1994), men gained control of the public sphere while women's roles were relegated to the home, or private sphere. This relegation of men to the sphere of paid work and women to the realm of unpaid work had profound effects on the organization of gender, work, and family.

As the economy continued to evolve toward a pure market economy, money became the primary currency. Whereas food, goods, crafts, and other materials were currency in the barter systems associated with both subsistence and agriculturally based economies, men's paid work began to be viewed as more valuable than women's unpaid work (Reskin & Padavic, 1994). Though both men and women continued to provide economic goods for their families, women's work ceased to be defined as economic. Therefore, a seemingly natural outgrowth of industrialization is the sex-specific roles of instrumental leader, which has been assigned to men, and expressive leader, which has been assigned to women (Parsons & Bales, 1955). Thus was born the division of labor we currently see in U.S. culture, a division of labor that has been defined by some as natural, by others as functional (Parsons & Bales, 1955), by some as inevitable, and by others as oppressive to women (O'Kelly & Carney, 1986). The traditional U.S. family was born. As we continue to emerge as a culture characterized by information and technology, dominant family forms are likely to continue to change.

This traditional family form is defined as one in which the man is responsible for providing for the economic needs of the family members, whereas the woman is responsible for the care of the children and family (Parsons & Bales, 1955). Yet as noted by Coontz (1992), the "traditional" family was not the dominant family form throughout all of human or even U.S. history. Our brief tour through human history suggests that women have always provided and continue to provide for the economic needs of their families. Their production is not labeled as economic because it does not always produce goods for sale in the marketplace and because women do not always earn wages for their work. Furthermore, as scholars have documented, the division of labor we associate with the typical U.S. family is really the division of labor that is associated with white, middle-class culture (Amott & Matthaei, 1996; Coontz 1992; Hill-Collins, 1994; Reskin & Padavic, 1994). As many historians and sociologists have shown, lower-class women and racial and ethnic minority women have almost always worked (Amott & Matthaei, 1996; Hill-Collins, 1994; Romero, 1992; Segura, 1994).

RACIAL AND ETHNIC DIVERSITY

> Domestic servants descended from African slaves, Chinese women sold
> into the U.S. prostitution market, middle-class European American home-
> makers, and Puerto Rican feminist union organizers in the early-1900s. It
> seems the work experiences of women in the United States are so varied
> and multidimensional that a common history is beyond our grasp. (Amott
> & Matthaei, 1996, p. 3)

For a variety of reasons, women's labor force participation rates have
been much higher within many racial and ethnic minority communities.
Segura (1994) notes, for example, that although labor force participation
rates are lower among Mexican American mothers while their children
are very young, many mothers of Mexican descent become involved in
the paid labor force before their children reach school age. Because their
male partners often have minimal human capital, or few marketable skills,
and are restricted to agricultural and service-based work, their families
depend on the wages that these mothers are able to provide.

Mexican American women have worked alongside their male part-
ners in the fields. In addition, as noted by both Segura (1994) and Romero
(1992), despite experiencing discrimination in other economic sectors,
many Hispanic women have found employment in the very low paying
domestic sphere. As daily or live-in domestics, in spite of significant prob-
lems of wage discrimination and sexual harassment, many women of
Mexican descent have earned wages that have helped to secure their fami-
lies' financial situations.

African American women have a much longer tradition of working,
even while their children are young. The tradition of labor force partici-
pation among African American families has its roots in slavery (Amott
& Matthaei, 1996; Hill-Collins, 1994). When white women were ex-
empt from laboring, African American women were not. Race, not gender
or parental status, was the defining factor. African American women slaves
worked regardless of their pregnancy or motherhood status, and often
their children worked alongside them (Amott & Matthaei, 1996). Fol-
lowing the Civil War, both African American men and women faced
employment discrimination. However, like the Mexican American women
Segura (1994) and Romero (1992) describe, African American women
also found that they could secure work as domestics (Amott & Matthaei,
1996; Rollins, 1985). Faced with racism and often lacking marketable
skills, African American men frequently found themselves unemployed
and underemployed. One man interviewed by Rollins (1985) states,

> We only got seven dollars a week. We worked from eight A.M. to five P.M.
> Monday through Saturdays. Of course, the cost of living [in the 1930s]

wasn't what it is today. You could kind of survive. We thought, "Well, that's what the pay is, so . . ." And, there wasn't any other kind of work. (pp. 109-110)

As a result of their male partners' unemployment and underemployment, African American women sought work as domestics and in other industries in order to provide for the economic needs of their families.

PATTERNS IN THE 20TH CENTURY

Clearly, maternal labor force participation in the United States varies tremendously with the race or ethnicity of the mother. As noted by Amott and Matthaei (1996), there is no common history we can tell. However, changes have occurred in women's labor force participation across the 20th century, and therefore, it is useful to review these labor force participation trends.

The United States has been an industrial economy during much of the 20th century. As a result of the public/private split associated with industrialization, women's labor force participation was extremely low, about 20%, at the turn of the 20th century. However, women's labor force participation increased during the Great Depression as well as during World War II. During the Great Depression, when vast numbers of men were unemployed or underemployed, many women acted as wage earners for their families. During World War II, while men were off at war and factories relied on women's labor, women's rate of employment reached its highest level during the first half of the 20th century. However, in the period immediately following World War II, when men returned from war to reclaim their manufacturing jobs, women's labor force participation reached its lowest level of the century.

Several structural and ideological forces were at work during the post-World War II period (Hays, 1996). First, because the public sphere had been designated as men's, many women were strongly encouraged to return home, thus relinquishing the jobs to men who had returned from the war. In addition, the passage of the Family Wage Act allowed employers to pay men at higher rates than they paid women (Kessler-Harris, 1990; Reskin & Padavic, 1994). This served to further increase men's earning potential while discouraging women's labor force participation.

This historical period was also marked by an economic boom. The manufacturing industry was in full swing. Many men found employment in factories. Factory work during the 1950s and 1960s paid wages that allowed men the luxury of supporting a family on one income. In addition, the government offered home mortgages with low interest rates and low down payments in order to encourage home ownership (Reskin &

Padavic, 1994). These economic forces all created an environment in which white women were encouraged to stay at home. Furthermore, the dominant motherhood ideology endorsed the traditional family model in which men acted as breadwinners and women stayed out of the labor market in order to care for the home and the children (Hays, 1996; Klein, 1984). Public policy, as well as public discourse, endorsed this arrangement. *Leave It to Beaver* and *Ozzie and Harriet* dominated the airwaves (Hays, 1996).

However, as was the case prior to World War II, single mothers and those whose husbands were unemployed or underemployed continued to be employed. Despite working for reduced wages because of the Family Wage Act, many mothers earned breadwinner incomes as well as supplementary incomes that kept their families out of poverty (Amott & Matthaei, 1996).

Finally, the early 1970s brought a dramatic rise in the labor force participation of women, especially those with young children. For a variety of reasons, as noted by Hays (1996), women's wage labor has increased over the past two decades. As economists and sociologists have noted, men's wages began to decline during the 1970s and 1980s (Eggebeen & Hawkins, 1990; Reskin & Padavic, 1994). A number of situational and structural factors have caused this decline in real wages, including inflation and the decline in the manufacturing sector coupled with the growth in the service sector (Reskin & Padavic, 1994). In addition, as noted by Eggebeen and Hawkins, material expectations of young U.S. individuals and families have risen. Whereas our parents were happy to raise their children in a house with three or four bedrooms, two bathrooms, and a single, detached garage, many young families of today expect to have a much larger home replete with a master bedroom/bathroom suite and a two- or three-car attached garage housing a sport utility vehicle (SUV). In response to wage pressures experienced by men and rising expectations for standard of living, more and more middle-class women have entered the labor force (Eggebeen & Hawkins, 1990).

In addition to market and economic forces at work, women's labor force participation has risen for at least three additional reasons. First, the child care landscape has changed dramatically in the past 20 years. Whereas very little paid child care was available during the 1950s and 1960s, mothers' reliance on paid, nonparental child care has risen dramatically. Folk and Yi (1994) note that in 1958, when 18% of mothers with children under age 6 worked full-time, more than 80% of those children were cared for in their homes or in another family's home, and fewer than 5% were in day care centers. By 1997, when two thirds of all mothers with children under the age of 6 were employed, 29.4% of mothers utilized child care centers or preschools, an additional 15.4% took

their children to another family's home for child care, and 5.1% of children were cared for by a nanny in the child's own home (U.S. Department of Labor, 1997). Therefore, roughly half of all mothers reported relying on nonparental, paid child care while they were employed.

Second, our behavioral expectations for mothers have also changed over the past 20 years (Hays, 1996; Klein, 1984). Although women still earn vastly fewer advanced degrees than their male counterparts, women have caught up or surpassed men in the earning of high school diplomas and bachelor's degrees (U.S. Department of Labor, 1997). As a result of these overall improvements in women's human capital, women are both more able and more interested in pursuing employment as a route to self-fulfillment. Women have increasingly begun to delay childbearing or forgo it entirely in order to pursue their careers (Gerson, 1985; McMahon, 1995). Those who have children often hope to continue pursuing their careers after their children are born. There is every reason to believe that as women obtain more and more human capital, or marketable skills, they are less likely to exit the labor market entirely when they have children. Although women are working, as are men, for economic reasons, they will also continue to find occupational and professional outlets that are fulfilling.

The major thesis of this book is that motherhood ideology matters. It affects the labor force participation choices that mothers with young children make. Along with changes in women's biological and social mothering (such as the advent of formula and mandatory schooling), ideology regarding appropriate roles for mothers has also changed over the past 20 years (Hays, 1996; Klein, 1984). These changes in ideology reflect the belief that employed mothers can be "good" mothers, even when they are employed for noneconomic reasons. However, Hays argues that attitudes toward maternal employment and the content of the dominant motherhood ideology continue to be contested terrain riddled by contradictions.

2

Ideologies of Motherhood:
Content and the Dominant Model

Ideology is a set of interrelated beliefs concerning an area of social life. One may hold a gender ideology, a religious ideology, or a political ideology, for example. Often, a set of behavioral expectations flows directly from an ideology. The degree to which an ideological position will affect the behavior of an individual is dependent upon the strength with which an individual person subscribes to a particular ideology. According to Therborn (1980), "The operation of ideology in human life basically involves the constitution and patterning of how human beings live their lives as conscious, reflecting initiators of acts in a structured, meaningful world" (p. 15). This chapter will examine the content of various ideologies of motherhood, the ways in which these ideologies are expressed in discourse, and finally, the degree to which one or more ideologies of motherhood holds a hegemonic position.

Therborn's Writings on Ideology

IDEOLOGY AS A CONCEPT

There are many different ways in which to conceptualize ideology. For the purposes of this discussion, I will draw heavily on the work of Therborn (1980) and his conceptualization. Therborn defines ideology as "that aspect of the human condition under which human beings live their lives as conscious actors in a world that makes sense to them to varying degrees. Ideology is the medium through which this consciousness and meaningfulness operate" (p. 2). Therborn argues that to examine ideology and its power means to examine not only its symbolic representations and its presence in discourse but, most important, its ability to "operate in the formation and transformation of human subjectivity" (p. 2).

According to Therborn (1980), ideology is not a personal- or individual-level concept, although ideologies can be held by individuals and influence individual-level behavior. Individuals do not create ideology. Rather, ideology is created and sustained by the social structure and those who hold prominent positions in it. Ideology, explains Therborn, is developed within a complex system of sociopolitical structures. Ideology is related to the political, economic, social, and historical structure of a culture. Ideology is not reducible to culture but rather is developed within a cultural context.

IDEOLOGY AND INDIVIDUAL AGENCY

At the individual level, ideology is a set of beliefs that flows into behavioral expectations. These beliefs and behavioral expectations create the human subjective experience and thus qualify individuals to play particular roles in the society. Therborn (1980) says,

> The formation of humans by every ideology, conservative or revolutionary, oppressive or emancipatory, according to whatever criteria, involves a process simultaneously of subjection and qualification. . . . New members become qualified to take up and perform (a particular part of) the repertoire of roles given in the society. (p. 17)

In other words, at the individual level, men and women are trained according to the precepts of the ideological landscape in which they are raised. This training results in behavior that is consistent with the prevailing ideology.

However, Therborn (1980) also argues that humans are able to qualify ideology. Thus, if their social position is such that their subjectivity is defined by contradictory ideologies, they may choose how to react to this contradiction. Men and women have agency. Furthermore, men and women may react in a variety of ways to ideology. For example, they may accept ideological constraints or reject them. In Chapter 3, I will outline Merton's (1975) framework for analyzing these various reactions to ideological constructions and apply this to motherhood. Despite Therborn's concession to individual agency, he notes that because of the pervasive power of ideology, the majority of men and women undergo the process of subjection and qualification by the dominant ideology.

IDEOLOGY AS A FRAMEWORK

Therborn (1980) proposed a framework for analyzing the process by which ideologies "subject and qualify" subjects. In this text, I will argue that the process by which motherhood ideology "subjects and qualifies" subjects can be viewed as a specific application of Therborn's framework. Because this framework forms the basis of the analyses presented in Chapters 3 and 5, I will present Therborn's framework verbatim.

> Ideologies subject and qualify subjects by telling them, relating them to, and making them recognize:
>
> 1. *What exists,* and its corollary, what does not exist: that is, who we are, what the world is, what nature, society, men and women are like. In this way we acquire a sense of identity, becoming conscious of what is real and true; the visibility of the world is thereby structured by the distribution of spotlights, shadows, and darkness.
> 2. *What is good,* right, just, beautiful, attractive, enjoyable, and its opposites. In this way our desires become structured and normalized.
> 3. *What is possible* and impossible; our sense of the mutability of our being-in-the-world and the consequences of change are hereby patterned, and our hopes, ambitions, and fears given shape. (p. 18)

Using this framework as a guide, I will examine the ways in which ideologies of motherhood subject and qualify individual mothers in the contemporary United States. I will demonstrate that motherhood ideology has a powerful impact on the labor force participation decisions of mothers with young children as well as on mothers' evaluations of their decisions to seek employment or stay at home.

IDEOLOGY AS A SOCIAL PROCESS

As was previously noted, Therborn (1980) argues that ideologies do not exist at the individual level, but rather they exist as part of the social structure. "Ideologies are not possessions. They do not constitute 'states of mind,' above all because the ideological interpellations unceasingly constitute and reconstitute who we are" (p. 78). According to Therborn, ideologies may differ and be in competition in telling us who we are. Thus, an individual man or woman may see several different interpellations of what is right and what is possible. The complex process by which a subject is subjected and qualified, at times by competing ideologies, is an illustration of ideology as a social process, a dynamic rather than a static process. Ideology is also a dynamic process because of agency at the individual level. Many mothers may view competing ideologies and their respective interpellations. When these interpellations are in conflict, cognitive dissonance may arise. In an effort to reduce cognitive dissonance, mothers will necessarily respond to the interpellations of these ideologies.

THE POWER OF IDEOLOGY

Why does ideology matter? Therborn (1980) asserts that ideology matters because of its power in affecting such personal, individual-level decisions as a mother's debating whether to return to work or stay at home while her children are young. From where does this power arise? Therborn argues that it is critical that we acknowledge the relationship between ideological apparatuses and the state.

> The ideological apparatuses are part of the organization of power in society, and the social relations of power are condensed and crystallized within the state. The family, for example, is regulated by state legislation and jurisdiction, and affected by the forms of maleness and femaleness, sexual union, parenthood and childhood that are prescribed, favoured, or permitted by the state. (Therborn, 1980, p. 85)

Therborn (1980) asserts that the relationship between ideology and the state determines, in several different ways, which particular strain of ideology will be dominant. First, the state has the power to influence individual beliefs, and thus, the particular form of ideology that is endorsed by the state will hold hegemonic position. Second, the state will endorse ideologies that maintain the status quo. Third, those in power, those who control the state, will favor ideologies that benefit them and preserve their control

of power. Thus, the particular form of motherhood ideology that dictates maintenance of the status quo and benefits those in power will gain hegemony among all competing ideologies of motherhood. And the power of this ideology, derived directly from the power of the state, will have more influence over individual-level behavior.

Content of Ideologies of Motherhood

As with many concepts, there are variations in motherhood ideology. In this chapter, I would like to explore the content of these variations as well as their strength, or the impact they have on mothers' identities, on their concepts of self, and ultimately on their labor force participation decisions. I will show that the ideology of intensive motherhood is the dominant form of motherhood ideology in the contemporary United States.

INTENSIVE MOTHERING

As noted in Chapter 1, women's labor force participation has varied throughout history. However, scholars tend to agree that for most of our human past, with the exception of the period following World War II (Coontz, 1992), women have been engaged in economic production, though only recently has this production been in the context of the labor market (Reskin & Padavic, 1994). Although the vast majority of stay-at-home mothers have been white and middle or upper middle class, and despite the relatively short historical period during which the majority of mothers with young children stayed at home full-time—the 1950s and 1960s—this model of intensive mothering has pervaded motherhood ideology in the United States (Hays, 1996). Because the dominant form of motherhood ideology does not reflect the experience of the majority of mothers, it is important to examine the rise to hegemony of this form of motherhood ideology.

Tracing the history of the development of contemporary motherhood ideology, Hays (1996) argues that the ideology of intensive mothering began to emerge in the 1930s. From the 1930s to the 1970s, several key factors were at work that enhanced the development of a strain of motherhood ideology she terms "intensive mothering."

- Beliefs about child rearing were changing.
- Psychological and cognitive models of child development were emerging.
- Experts were gaining more popularity among mothers.

Beliefs About Child Rearing

Hays (1996) argues that beginning with the 1930s, the primary objective of child rearing changed from a focus on rigid behavioral training to a focus on nurturing the wholesome, inherent goodness in children. As a result, families became child-centered. Mothers, Hays argues, began to adjust their behavior to the needs of the children. She quotes Mary Aldrich, who says,

> To give the baby all the warmth, comfort, and cuddling that he seems to need; to meet his wishes in the matter of satisfying and appropriate food; to adjust our habit-training to his individual rhythm; and to see that he has an opportunity to exercise each new accomplishment as it emerges; these are the beginnings of a forward-looking programme in mental hygiene. (Aldrich & Aldrich, 1938, p. 215)

Motherly love and devotion were considered essential elements of child rearing. And mothers who did not devote themselves entirely to the nurturing of their children were accused of practicing maternal deprivation (Gordon, 1988; Hays, 1996).

Psychological and Cognitive Models of Child Development

It was also during this period that the works of several prominent psychologists became popularized. Freud and Erikson developed the psychosexual model of child development. According to Freud and Erikson, parents needed to help guide their children through a series of conflicts that must be resolved. The child who was able to successfully navigate these psychosexual conflicts would develop into a happy, well-adjusted adult. The child who was unable to progress through Freud's five stages and successfully resolve each conflict would develop into a maladjusted adult. Parental involvement, based on this model, was critical in child development.

Contemporaneously, Piaget, a Swiss cognitive psychologist, was developing his model of cognitive development. According to Piaget's model, children's cognitive abilities developed in a series of predetermined stages. Piaget argued that children, or "little scientists," as he referred to them, progressed in cognitive development by engaging in experiments on the world that allowed them to master certain cognitive skills such as object permanence and abstract reasoning. Although the child acted on his or her own, Piaget believed that adult interaction had a significant impact on the rate at which children developed their cognitive skills. In some cases, parents worked to engage the child in experiments. In other cases,

parents merely supplied the laboratory. At any rate, a child who lived in a deprived environment devoid of stimulation would not achieve to his or her cognitive capacity. Thus, parental influence was critical for the cognitive development of children.

Experts Gained an Audience With Mothers

In addition to the increased popularity of theorists such as Freud and Piaget, the 1946 publication of Spock's *Baby and Child Care* "dominated the literature as no child-rearing manual ever had" (Hays, 1996). Mothers turned in droves to Spock's advice on child rearing. Not only was his book extremely popular, but also its approach reinforced the need of mothers to rely on experts for advice on raising their children. Spock's step-by-step manual reinforced the belief that mothering was not instinctual. Mothers needed advice if they were to help their children to develop properly (Hays, 1996).

Not only did Spock's book provide "troubleshooting" guidelines for mothers, but also his "recommendations centered on the crucial importance of child rearing that was grounded in maternal affection" (Hays, 1996, p. 49). Spock argued that mothering was inherently pleasurable because children were naturally good and friendly and because mothers were naturally loving and empathetic. Based on these assumptions, Spock promoted the ideal of the stay-at-home mother for families who took child rearing seriously. "Thus, American history's most intensive model of mothering emerged shortly before World War II, and if Spock's continuing popularity is any indication, has maintained its dominance ever since" (Hays, 1996, p. 49).

Other Factors

As noted by Coontz (1992), Hays (1996), and Reskin and Padavic (1994), the period immediately following World War II was also conducive to stay-at-home mothering for a variety of economic reasons. Chapter 1 points out that the 1950s and 1960s can be characterized as a period that was dominated by manufacturing, which led to high wages for men. It was also an era replete with incentives for homeownership, such as low-interest government loans and the availability of mortgages with no down payments. Thus, the rise of intensive motherhood ideology to the position of dominance it occupies must be understood in the context of both the ideological as well as the economic landscape of the period around World War II. I will argue throughout this chapter as well as throughout this book that intensive motherhood ideology remains the dominant

motherhood ideology. Despite the clear pockets of resistance to and individual experiences in contrast with the ideology of intensive mothering, it holds hegemonic power. Intensive mothering dominates maternal labor force participation decisions as well as mothers' evaluations of their own employment and child care situations.

COMPETING IDEOLOGIES OF MOTHERHOOD

All women living in the United States are exposed to the ideology of intensive mothering because of its disproportionate representation in the media, which is typical of dominant ideologies. This is not to say, however, that all women adhere to this form of motherhood ideology. Mothers in certain race, ethnicity, and class groups are less likely to adhere to this ideology of motherhood. Just as the ideology of intensive mothering grew out of particular social and political arrangements, different life and labor force participation experiences of racial and ethnic minority women and lower-class women of all races and ethnic groups led to the development of competing ideologies of motherhood.

In writing about the situation among people of Mexican descent, Segura (1994) notes that many of the mothers she interviewed felt that being employed was part of their role as mothers. Because their economic support was construed as necessary, many of the mothers she interviewed did not report feeling guilty when they were working, though they did report resenting the limited time they had with their children. These mothers embraced an ideology of motherhood that valued both the domestic and economic aspects of women's roles. "The Mexicanas do not view these activities [market activities] as 'separate' or less important than the emotional nurturing of children and family. Rather they appreciate both the economic and the expressive as important facets of motherhood" (Segura, 1994, p. 224).

African American women, as noted in Chapter 1, have had very high rates of labor force participation since they arrived here during the period of slavery. As a result, there has been a clear relationship between labor force participation and the construction of motherhood ideology among African American mothers. Hill-Collins (1994) notes,

> Mothering occurs within specific social contexts that vary in terms of material and cultural resources and constraints. How mothering is conceived, organized, and carried out is not simply determined by these conditions, however. Mothering is constructed through men's and women's actions within specific historical circumstances. Thus agency is central to understanding of mothering as a social, rather than biological, construct. (p. 45)

Ideology both determines and reflects the material conditions of a population. Given the high rates of maternal labor force participation among African American mothers, it is reasonable to assume that they would hold a motherhood ideology that reflects and promotes the importance of economic contributions by mothers to their children's well-being. Hill-Collins (1994) suggests that this is the case, not just for African American mothers but also for other mothers of color. She notes that across historical periods, children have depended on their mothers for economic support; thus, mothers conceptualized their roles broadly, including both nurturing and economic roles. "Women of color have performed motherwork that challenges social constructions of work and family as separate spheres, of male and female gender roles as similarly dichotomized" (Hill-Collins, 1994, p. 47).

As this discussion demonstrates, there is no common set of beliefs about mothering that has been developed or embraced by all groups of mothers in the United States. Yet, as noted by Therborn (1980), groups in power are able to get more "play time" for their beliefs. As a result, certain strains of motherhood ideology are more likely to be adopted by mothers. Furthermore, as a result of its endorsement by the state, ideology with hegemony may still influence the behavior and/or the evaluations of the behavior of those in a group that does not adopt the dominant ideology. The content of motherhood ideology continues to be contested terrain. As Therborn points out, the power of ideology is not merely its ability to gain hegemonic position, but also its ability to affect individual behavior by defining what exists, what is good, and what is possible. How do ideas such as these get disseminated in the culture?

Systems of Discourse

If ideological positions merely existed, then they would have much less influence on individual behavior. Furthermore, when ideology is limited in scope or in audience, it has much less power in affecting individual-level behavior. If beliefs about motherhood ideology were laid out only within religious doctrine, for example, then our exposure to it would be limited to the degree to which each of us participates in religion or reads religious documents. Because ideological positions are represented and developed within systems of discourse, however, they become available for debate within a culture. To the degree that an ideological position assumes a hegemonic position, it will be represented in a variety of different discourses and hence be accessible to most members within a culture or subcultural group. Thus, the majority within a culture often adopts

dominant ideologies. Finally, when an ideological position holds a hege-
monic position, it becomes increasingly likely that this ideology will
influence the behavior of the majority of people within a culture, result-
ing in either conforming or resistance behavior. "Ideology operates as
discourse, addressing or . . . interpellating human beings as subjects"
(Therborn, 1980, p. 77).

In the United States, there are several different media for disseminat-
ing motherhood ideologies: family interactions, expert testimony, and
nonexpert high-profile testimony. It is important to examine each of these
sites of discourse in order to understand the ways in which each contrib-
utes to beliefs about appropriate roles among individual mothers.

FAMILY INTERACTIONS

All of us spend time in families, be these families of orientation, procre-
ation, or choice. Within these settings, we receive messages about all
sorts of appropriate behavior. Messages regarding motherhood, and fa-
therhood, are disseminated within the family both in verbal "lectures"
and in practice, or example. All the women I interviewed talked about
both what their mothers and fathers communicated to them verbally and
the ways in which their parents parented. Both of these types of messages
had an impact on the content of the motherhood ideology that each of
these women held.

Explicit messages about appropriate roles for mothers come in two
different forms. First, some girls grow up in homes where they are taught
that appropriate roles for women are limited to the domestic sphere. For
example, girls may be told that they can and should seek higher educa-
tion, but that any boy they marry will expect them to stay at home once
the children are born. In contrast, many young women, including most
of those in my university classes, report that their parents' messages en-
couraged them to pursue an education and an occupation that would
allow them to support themselves, "just in case." This type of messaging
may arise out of concern about the possibility of divorce among parents
of Generation Xers, a reasonable concern given the current state of mar-
riage in the United States.

Girls also grow up with implicit messages about appropriate roles for
mothers. For example, mothers and fathers may openly criticize other
mothers either for working outside the home or for staying at home and
relying on their husbands for their financial well-being. Parents may also
comment on how their own and other people's children have "turned
out." Often, comments about "turning out" are directly related to the
mother's employment status.

However, girls in the United States are not receiving just one message about appropriate roles for mothers. Rather, messages that girls receive may vary across race, ethnicity, and class groups (Amott & Matthaei, 1996; Garey, 1999). For example, I recently participated in a panel discussion about families. One of the panelists, an African American college professor in her 30s, recounted that the messages she heard as a child concerned her professional development rather than her future as a wife. Her parents told her that she should go to college and pursue a career that would allow her to support herself. If she found a person along the way with whom to share her life, that would be great. But the focus of the messages was on her professional development. The content of this message reflects the lower rate of marriage among African Americans, particularly women, who face a declining pool of marriageable African American men.

Boys, too, are influenced in their families. They, too, see how their parents divide household chores and balance work and family. Among boys growing up in two-parent households, those raised in egalitarian homes, where parents share household labor and child care and where the careers or jobs of both parents are important, will be more likely to be "involved" fathers themselves. However, boys who are raised in traditional families are more likely to seek to establish traditional families when they grow up. Thus, the types of families in which we raise our children are the sites of the most salient models that will influence the types of families they create for themselves.

EXPERT TESTIMONY

Parenting Books

A walk through the parenting aisle of any major bookstore, such as Barnes and Noble, will reveal the wide range of books available on parenting issues. The content of these books varies from ones that give advice on combining motherhood and employment to those related to stay-at-home mothering. For example, Hayes, Palmer, and Zaslow (1990) focus on how to find good child care. Their book provides mothers and mothers-to-be with advice on how to choose a child care provider, warning signs of dangerous child care situations, and typical issues related to the adjustment that mother and child will make to child care. In contrast, *The Womanly Art of Breastfeeding*, published by La Leche League International (1991), not only gives advice on successful breastfeeding but also endorses the role of the stay-at-home mother. This text suggests that mothers and their children are happier and healthier when

mothers breastfeed and when their lives are structured around the rhythms of the newborn.

Walzer (1998) examines parenting books as sites of ideological discourse. She notes that the book most frequently read by the mothers in her study endorsed the ideology of intensive mothering. *What to Expect the First Year,* preferred by 75% of the mothers in her sample, played a role in perpetuating gender differentiation in parenting responsibility.

> Mothers I met who already felt that they had the primary responsibility for their babies did not get any disagreement from the advice book they consulted most frequently: "If your husband, for whatever reason, fails to share the load with you, try to understand why this is so and communicate clearly where you stand. Don't expect him to change overnight, and don't let your resentment when he doesn't trigger arguments and stress. Instead, explain, educate, entice; in time, he'll meet you partway, if not all the way." (Walzer, 1998, pp. 40-41)

Books on Balancing and Weaving Work and Family

In another aisle at Barnes and Noble, or while browsing Amazon.com, one finds a series of books devoted to supplying expert testimony on balancing and weaving work and family roles. As one might expect, one shelf, real or virtual, is devoted to books that espouse the role of the traditional stay-at-home mother. Browsing Barnes and Noble's parenting section one afternoon in the summer of 1999, I found a series of books, including those of Brazelton (1992), Leach (1994), Spock and Parker (1998), and Dreikurs (1958), each of which noted the negative consequences of maternal employment on mothers and children alike. For example, Brazelton and Leach suggest that maternal employment impedes the bonding of mother and child. Dreikurs suggests that mothers who work outside the home are more likely to have children who engage in juvenile delinquency when they reach adolescence. Finally, Dreikurs, Leach, and Spock and Parker argue for parent roles based on biology. Because mothers incubate, bear, and suckle children, they are therefore better suited to rearing children, and the very best way in which a mother can rear children is to stay at home full-time.

In contrast, of course, is a set of texts that forces a debate over whether maternal employment is good for mothers and children alike. For example, Barnett and Rivers (1996) suggest, and Strober and Chan (1999) document, that the economic security that women forsake by extended absences from the labor force leaves them and their children distinctly disadvantaged in the possible event of widowhood or divorce. Not only do women often face economic hardship associated with lost wages, but they also lose human capital in terms of seniority and experience, which

will be disadvantageous in reentering the labor market. Furthermore, these absences from the paid labor market may be disadvantages at retirement time, as mothers often have accumulated less in their retirement funds as well as in the social security system.

In addition to economic issues, many others suggest that employment has other advantages over staying at home. Employed mothers are healthier, suffer less emotional and mental illness, and experience more self-fulfillment (Barnett & Rivers, 1996). Also, many texts of this persuasion suggest that not only do the mothers fare better, but the children of employed mothers do as well (Rubenstein, 1998). Though some have shown a disadvantage for adolescent boys of employed mothers, many authors and scholars point to several advantages experienced by both boys and girls of employed mothers. For example, there is evidence that girls benefit when their mothers are employed because their mothers provide a professional role model. Furthermore, both boys and girls raised in homes with employed mothers hold more egalitarian views of men and women and a more egalitarian gender role ideology (Barnett & Rivers, 1996). Thus, mothers are encouraged by these experts to remain in the labor force.

An additional set of books deals with issues of child care. As with the types of books discussed above, these also fall into two distinct categories: those that demonstrate the negative impact of child care on children and those that provide information on securing safe, reliable, and affordable child care. Again, the first set of books suggests that children in child care are harmed by it, that they have trouble developing trust of adults, and that they show poorer academic performance (Leach, 1994). In contrast, others show that the negative effects of child care are attributable to the low quality of many child care providers (Galinsky, 1999). They cite evidence that shows that children in high-quality child care fare as well as, if not better than, children of stay-at-home mothers when it comes to academic and social skills. These children are, these studies show, better prepared for kindergarten than children who have not been in a group setting such as a day care facility or preschool (Galinsky, 1999). Finally, several works expound on the ways to evaluate the quality of child care providers so that the employed parent may take advantage of the benefits of child care without assuming many of the risks. Hayes et al. (1990) and Zigler and Lang (1991), for example, offer guides to selecting appropriate child care providers for children of all different ages.

Parenting Magazines

Books are not the only source of information on mothering. Several magazines are devoted entirely to issues related to parenting. The two parenting

magazines with the widest circulation are *Parents* and *Working Mother*. A quick perusal of the pages of either magazine will convince the reader that each targets a specific population of mothers, with the former targeting mothers who stay at home and the latter written with mothers who are employed in mind.

Both publications devote a fair amount of space to the typical worries of the parent: how children grow, child development, health-related issues, and behavior and discipline issues. However, *Parents*, which has the widest circulation among the parenting magazines, tends to devote more pages and more articles to the issues facing mothers who stay at home than to the issues facing mothers who are employed. Often, the letters and opinions sections include essays from women who discuss the reasons they have left a career and the financial independence it offers in order to stay at home raising their children. Mothers find tips on how to get their husbands to help out at home and how to find time for themselves, often in the face of a resentful partner who underestimates the stress involved in staying at home full-time.

A recent issue of *Parents* included a letter from a stay-at-home mother who pampers herself by treating herself to a massage or a manicure every week. She wanted advice on how to convince her husband that staying at home all day long requires a break. He apparently felt that her massages and manicures were frivolous despite the fact that they could afford them ("The need to treat yourself," 1999). The space that is devoted to employed mothers often focuses on women who work from home, usually featuring a mother who freelances or telecommutes. Occasionally, *Parents* features an article on how to reorganize your life so you can "afford" to stay home on your partner's salary.

Working Mother magazine includes the same set of articles that is devoted to the health, well-being, and development of children. In contrast, however, *Working Mother* regularly features articles on issues such as how to juggle work and family, how to work more efficiently, and how to cook healthfully in 10 minutes per day. Each year, *Working Mother* devotes an entire issue to the job-family conflict. This issue features the top 100 employers in the United States as rated by *Working Mother*. To be placed on the list, an employer must be characterized as family friendly. Many of the top 100 companies offer flex-time and on-site child care centers. Clearly, the tone is that any "working mother" can and should demand these kinds of concessions from her employer.

Perhaps the most interesting ideological distinction between these two magazines is their focus on appropriate gender roles. Whereas *Parents* takes a more traditional approach as it relates to maternal employment, it is often full of tips for getting men to help out more around the house and for securing alone time for mothers (note the previous example). In

contrast, *Working Mother* seems to assume that men will not be around to help in either single- or dual-parent households. Catering to married as well as single mothers, *Working Mother* often includes articles devoted to the solutions that married, professional mothers use to network and share the load with other working mothers. These features focus on mothers who manage to climb the corporate and professional ranks while relying on each other rather than on their spouses for support. For example, a lengthy article entitled "Count on Me: How to Create and Nurture a Supportive Network of Friends, Neighbors and Other Moms" (Weissman, 1998) described the ways in which professional, married mothers set up extensive child care safety nets in order to deal with demanding careers. Not one mentioned that she relied on her husband, though all were married. The message to mothers seems to be, Don't feel guilty about working, but don't expect egalitarian relations at home!

In summary, it is apparent that both parenting books and magazines are sites for the dissemination of a variety of beliefs about motherhood. By reflecting existing ideologies of motherhood, the power of these beliefs is reinforced. However, these sources do more than simply reinforce ideology that is already there; they create ideology. These sources of discourse meet Therborn's (1980) requirements for ideology: They tell women (a) what exists, (b) what is good, and (c) what is possible. Therefore, as noted by Hays (1996), these sources of motherhood ideology are powerful in defining appropriate strategies for women in their individual attempts at balancing and weaving work and family. There are, however, other sources of discourse by which motherhood ideology is disseminated.

NONEXPERT HIGH-PROFILE TESTIMONY

Americans are well-known for voicing their opinions on various topics, and this extends to the case of appropriate roles for mothers. Over the past decade, many high-profile Americans who have no expertise in issues related to parenting, or mothering in particular, have made public, widely disseminated statements about motherhood in general or about the behavior of specific, often high-profile mothers. These nonexperts are not pediatricians or scholars of the family. Rather, they are well-known public figures who are trusted for their familiarity, not for their expertise.

Social psychological research on attitude change and persuasion has identified several variables that affect the degree to which attitude change is likely to occur. Though mothers may not be moved to change their ideology in the same way that we can be persuaded to buy certain products, we can apply the principles of attitude change as established by social psychological research when examining the mechanisms or discourses by which the content of motherhood ideology is transmitted.

Social psychological research that has examined the effect of the messenger on the acceptance of the message confirms that the status of the messenger is important in the process of attitude change. Expert testimony is valued more than "man on the street" testimony (Chebat, Filiatrault, & Perrien, 1990; Haas, 1981; Maddux & Rogers, 1980), as is noted by Hays (1996) in her discussion of the power of expert testimony on child-rearing practices. Nonexpert testimony can also be persuasive or influential if the messenger is viewed as trustworthy, attractive, or familiar (Chaiken, 1986; Eagly & Chaiken, 1975; Eagly, Wood, & Chaiken, 1978; Horai, Naccari, & Fatoullah, 1974; Walster, Aronson, & Abrahams, 1966).

Presidential Candidates

During the 1996 Democratic and Republican conventions, I was eagerly watching to see how gender and family issues would be discussed by various political figures. I was struck by the attention that motherhood and the family received during the speeches of extremely high-profile speakers. Bob Dole, the 1996 Republican candidate for the presidency, spoke about the decline in the American family. He argued that the changing American family has contributed to a wide range of social problems (*Newsweek*, 1996).

Dole's message was consistent with the Family Values rhetoric advanced by groups such as The Promise Keepers. This message is appealing because it is focused on social problems, such as teen pregnancy, drug abuse, and school violence, which many would like to see addressed. Who among us is not troubled and moved by recent episodes of child violence such as Columbine and Mount Morris Township? Furthermore, many Americans do blame families for the problems U.S. children experience.

There are at least two distinct ways in which to evaluate the role that families play in social problems experienced by children. Family Values proponents blame these social problems on the decline of the American family, or more precisely, the traditional American family. They argue that social problems have increased over the past few decades as a direct result of increases in women's labor force participation, divorce, and nonmarital childbearing. These problems can be alleviated, argue Family Values proponents, by returning to the model of the traditional family as it existed in the 1950s and 1960s. In this type of family, in which men take responsibility for breadwinning and women for nurturing and raising the children, children receive the care and supervision they need and they get into less trouble.

On the other side of the debate are those who believe that healthy children can be raised in a variety of family types. Though scholars and

advocates agree that children are disadvantaged when they are unsupervised, they do not blame changes in the American family for these outcomes. Clearly, there are negative outcomes of women's employment, divorce, and nonmarital childbearing. Scholars have noted, for example, that children are disadvantaged when they live in single-parent households (Edin & Lein, 1997; McLanahan & Sandefur, 1994). However, the primary disadvantages faced by children in single-parent homes are poverty and less adult supervision.

In contrast to Family Values proponents, scholars such as Coontz (1992) and McLanahan and Sandefur (1994) suggest a different array of solutions for creating healthy environments in which to raise children. Many single mothers, both those who are divorced and those who experienced a nonmarital birth, work in low-wage jobs that do not supply them an income adequate to raise a child. Therefore, problems associated with poverty can be partially alleviated by changing the wage structure and enforcing child-support orders (McLanahan & Sandefur, 1994). Second, supervision need not be provided directly by a parent. Many employed mothers, those in both single- and dual-earner families, cannot supervise their children all day long. They must rely on other people and programs to provide supervision for their children. However, because the majority of women work for low wages, they are unable to afford after-school or summer care for their children, who then remain inadequately supervised. Thus, changes in the wage structure as well as subsidized, high-quality after-school and summer programs would reduce the impact of poverty and minimal supervision experienced by children with employed mothers. From this perspective, returning to the model of the traditional family is not necessarily the best solution to the problems faced by children in the United States. In fact, these scholars and advocates suggest that there are many negative outcomes of the traditional family model, such as women's economic dependence on men and modeling of narrow gender roles. As noted previously, women's economic dependence on men leaves them and their children vulnerable in the event of divorce, widowhood, or layoffs. Thus, changes in the social structure rather than in the family are suggested to address the social problems that are experienced by U.S. children.

To summarize, many experts and nonexperts recognize that American children are in trouble. Child poverty rates have not changed much in several decades. Millions of American children continue to go to bed hungry each night. Millions of American children experience homelessness. Schoolyard violence, though perhaps no more prevalent in recent years, has become increasingly more lethal. Bob Dole's assessment of the problems experienced by youth rests on the underlying assumption that women belong at home raising their children and that fathers belong at work

providing for their families' economic needs. This rhetoric is attractive because of the simplicity of the solution. Women simply need to stay at home raising their children, and these problems will vanish. Opponents of the Family Values position suggest, however, that changes in family form, and in women's labor force participation in particular, are not the causes of children's problems. Rather, these problems are a result of wage discrimination and the lack of affordable child care in our postindustrial economy (Coontz, 1997).

Court Cases

I opened this book with a discussion of the case of Louise Woodward, the British au pair who was convicted of the death of the infant entrusted to her care, Matthew Eappen. As mentioned previously, perhaps the most interesting thing about this case was not whether justice was served but rather the degree to which people felt it appropriate to comment, in public forums, on the behavior of Matthew Eappen's mother. Discussions of the role Matthew Eappen's mother played in this tragic event erupted in such varied sites of discourse as talk shows and parenting magazines. The overall discussion centered on whether or not Matthew Eappen's mother—and by extension, all mothers—are entitled to seek employment for noneconomic reasons.

However, as tragic as the case of Matthew Eappen is, his is not the only child and family case that has been played out at the national level. Several custody cases in the past several years have rested on this debate of mothers' employment as well. A recent case from the world of sports demonstrates the power of the dominant motherhood ideology. Pam McGee plays professional basketball for the Los Angeles Sparks. As reported in the October 19, 1998, issue of *Sports Illustrated* (Howard, 1998), McGee is fighting her ex-husband for custody of their 4-year-old daughter. McGee's ex-husband, a minister, is suing her for custody of their daughter because he claims, "The level of [basketball] achievement accomplished by [McGee] . . . impairs her ability to parent her daughter." Her ex-husband argues that awarding custody to him serves the best interests of their daughter because "of [McGee's] rigorous travel schedule, unstable living environment, and lack of permanent job stability" (p. 23).

On September 14, 1998, Macomb County (Michigan) circuit court judge Peter Maceroni granted McGee's ex-husband temporary sole custody of the daughter. McGee, outraged, is quoted as responding, "If I have to provide for my children, as a mother and as a woman, I should have that option [to play pro basketball] and not be penalized" (Howard, 1998, p. 23). The irony is that though McGee's career requires her to travel 4 weeks every summer as part of the Women's National Basketball

Association (WNBA) season, her ex-husband reportedly travels 7 to 8 weeks per year as part of his ministry. Furthermore, he relies on day care and baby-sitters to care for their daughter while he works, and he charges that McGee's use of child care makes her unfit to have custody of her daughter.

Several key issues emerge from this case. First, the question is raised of how job requirements and family requirements are interpreted. McGee argues that her job, though it requires some travel, is necessary in order for her to provide economically for her child. Clearly, she could seek other employment, but short of going on welfare, any job that she takes will require her to be away from her child a minimum of 40 hours per week. Any of us should be concerned that this legal decision lays the groundwork for single mothers to risk losing custody of their children if they take jobs in order to support the children in their care. Potentially, women who are single parents could be forced to remain on welfare or risk losing custody of their children.

Second, this case demonstrates gender bias in the way that men and women are evaluated as parents. McGee's travel and use of child care while she is working are precisely the grounds on which her ex-husband contends she should be denied custody of her daughter. However, the judge in this case seems to have no trouble with the father's use of child care and his travel requirements, which are double hers. How can we interpret these facts here? I would argue that this judge holds a traditional ideology regarding parenting, one in which appropriate roles for mother and father are different. Using Parsons and Bales's (1955) framework, the appropriate role for the father is the instrumental role, whereas the appropriate role for the mother is the expressive role. By this standard, McGee is not able to adequately fulfill her motherly duties, the expressive role, because of requirements placed on her by her career, and her ex-husband, whose career requirements are equally if not more stringent, is fully able to fulfill his role as the instrumental provider for their daughter. By this double standard, McGee is defined as a "bad" mother while her ex-husband is defined as a "good" father; he meets the behavioral expectations for his role, and she does not. This court decision sends reverberating messages regarding appropriate roles for mothers and fathers. *Sports Illustrated* frames the question this case raises for all single mothers: "Could a judge take away your child because your job requires you to travel sometimes" (Howard, 1998, p. 23)?

Media Commentators

Another case of high-profile, nonexpert testimony on motherhood also comes from the WNBA. In this case, however, the testimony comes not from the courthouse but from the media. During the inaugural season of

the WNBA, in July 1997, Sheryl Swoopes, one of the most well-known women basketball players, took the court for the Houston Comets. What should be newsworthy about this is that it was the first time in U.S. history that women were being paid to play basketball. It was the first time that a woman could support herself and her family by playing a sport that men have been paid to play for years. What made the news, however, in the summer of 1997, was that Sheryl Swoopes began playing for the Houston Comets 6 weeks after she gave birth to a child. I will admit that as a mother of two children, I find it remarkable that any woman could be in the shape necessary to play basketball at the professional level only 6 weeks after she gave birth to a child. However, others saw it a different way.

Gwen Knapp (1997), a reporter for the *San Francisco Examiner*, wrote that many sports reporters and commentators felt compelled to speak out on Sheryl Swoopes's presence in the WNBA when she should have been home mothering. The most vocal, though not only, commentator on the issue was Indiana Pacer guard Reggie Miller, whose sister, ironically, is a prominent WNBA coach. At least twice in the summer of 1997, Miller made comments while broadcasting Houston Comets games on the Lifetime Television Network, which carried a number of WNBA games. He is reported as saying, "Sheryl should do what's right and stay home with her baby." Though Knapp reports that letters and phone calls came in disagreeing with Miller's position, she also notes that a fair number came in praising him for speaking out. A male columnist in Kansas City reportedly seconded Reggie Miller's comments by saying that "the ability to breastfeed should separate Swoopes from all of the male athletes who find fatherhood and athletic fame perfectly compatible."

Several important issues are raised by this story. First and foremost, it is important to recognize the significance in the mere fact that Reggie Miller, or anyone for that matter, felt comfortable making these sorts of comments. This in itself strongly suggests that women are still vulnerable to having the mechanisms they employ for balancing and weaving work and family judged by others, sometimes in public forums. Second, Knapp (1997) gives several examples of the double standard applied to men who were treated differently from Sheryl when they experienced job-family conflict. She cites the case of David Williams, the Houston Oiler lineman who lost a paycheck in 1993 for missing a game to remain by his wife's side the day after she gave birth. And Elvis Grbac, who plays for the San Francisco 49ers, got little sympathy when he performed badly in a 1996 game against Dallas despite the fact that he explained he was not adequately prepared because he had been concerned about his 9-month-old son's recovery from surgery. Men are chastised for putting family ahead of work, whereas women are criticized for working at all. Finally,

this case illuminates the ideological landscape in which mothers and fathers are trying to balance work and family. Men's lives reflect "compatibility" of fatherhood and employment. U.S. women, on the other hand, experience a culture in which motherhood and employment are defined as disjunctured. Though many women struggle to weave work and family together, as noted by Garey (1999), even when they are successful by their definitions in doing so, the culture continues to view their arrangements negatively. By defining work and family as inherently incompatible for women, there is no way in which to successfully weave together these aspects of women's lived experiences.

As in the Pam McGee case, it seems that the public views men's and women's parenting roles very differently. Not only are men not rewarded for expressive parenting that interferes with the duties of instrumental parenting, but in addition they are punished. And, as the case of Sheryl Swoopes demonstrates, women continue to be punished for engaging in instrumental parenting that interferes with the primary duties of intensive mothering. LaRossa and LaRossa (1989) explain,

> Because the meanings of roles are gendered, the impact of the competing demands of these roles is not uniform for women and men. For example, gendered expectations and the structure of every-day relations make being a "good" mother and wife different from the masculine roles of "good" father and husband. (p. 146)

Ironically, as Knapp (1997) points out, Swoopes's male partner, Eric Jackson, a college student and aspiring football player, takes on the expressive role of parenting, not only caring for the child but even sitting courtside with him while Sheryl plays. And Sheryl, for her part, earned a million dollars in 1997 in salary and endorsements. It is hard to argue that her family would be better off with her on the sidelines, living on the income of a college student athlete. In the estimation of Gwen Knapp and others, Sheryl Swoopes is not only providing for her child, but she is also setting an excellent example for her son.

Finally, the court settlements, such as in the case of Pam McGee, which discriminate against single mothers who are employed, are more dangerous than the public comments. The impact of these sorts of decisions, coupled with the public discourse that criticizes mothers who are employed, may do far more than contribute to their feelings of guilt. As mentioned earlier, judgments of these sorts may, in fact, discourage mothers, single and married, from seeking employment as they may fear losing their children altogether. In the face of record high divorce rates and nonmarital birthrates, as well as attempts to push women and children off welfare, these messages are troubling indeed (Edin & Lein, 1997).

In the next chapter, I will examine ideologies of motherhood in prac-
tice. The attention will turn to an examination of the specific relationship
between motherhood ideology and maternal employment patterns by
analyzing the data generated from interviews with 30 mothers with young
children.

Summary of Major Points

Ideologies of motherhood and the consequent beliefs about appropriate
roles for mothers are indeed contested terrain. Perhaps more important,
this terrain is being contested in the privacy of our own homes, between
partners, and in the public sphere of courtrooms, presidential addresses,
and magazines. Though the data tell us that perhaps 14% of all U.S.
families live as "traditional" families, in which the father is the sole bread-
winner and the mother stays at home raising the children, intensive
motherhood ideology seems to dominate our cultural landscape. This
ideology is disseminated in a wide variety of systems of discourse, in-
cluding popular parenting magazines and books, the speeches of
candidates for public office, the opinions of judges in court cases involv-
ing custody and child death, and the comments of sports reporters. The
simple fact that this ideology is being disseminated in such a broad range
of sites of discourse suggests its hegemonic position. Though many U.S.
families have relied on and continue to rely on the wages of women, the
dominant motherhood ideology remains that of the stay-at-home mother,
a family form that reached its peak in the 1950s and 1960s (Coontz,
1992; Hays, 1996).

It can be argued, in fact, that in the face of more and more mothers in
the labor force, these public proclamations have become more common
and more widespread. Given that the dominant ideology no longer re-
flects the dominant practice, one is left wondering if ideology changes so
slowly or if this represents an attempt on the part of some to encourage
mothers to return home by making them feel guilty and unfit for employ-
ment while their children are young. Though some of these examples,
such as the discussion of the Family Values perspective by Bob Dole and
Reggie Miller, seem innocuous, their accumulation reinforces the notion
that mothers belong at home and that mothers who choose to work out-
side the home while their children are young may face public scrutiny.
Therborn's (1980) framework is useful in understanding the pervasive-
ness and dominance of this iteration of motherhood ideology. Intensive
motherhood ideology is endorsed by the state because it maintains the
status quo and because it benefits those in power. It encourages women

to stay out of the labor market, thus reducing competition for jobs held by men. In addition, many men benefit from the services of a stay-at-home wife/mother who takes care of all the home and family responsibilities, thus freeing men to pursue their careers. This endorsement of intensive motherhood ideology by the state results in the wide dissemination of these beliefs through various sites of discourse. Thus, intensive motherhood ideology has the power to shape human behavior even when it does not reflect the lived experiences of most U.S. families or benefit all members of these families.

Applying Therborn's (1980) theory of ideology, the power of ideology is the power to direct human behavior and to reinforce the status quo, the power to legislate and adjudicate family forms. Though ideologies of motherhood remain contested, the ideology of intensive motherhood continues hegemonic rule, thus influencing the ways in which women balance work and family and the ways in which they evaluate their own mothering practices. Applying Therborn's framework to various forms of motherhood ideology results in the following assumptions:

Intensive Motherhood Ideology

- Differences exist in men's and women's child care abilities.
- Differences exist between mothers and any other care providers in their abilities to provide care.
- When women stay at home with their children, they are fulfilling the behavioral expectations of their role.
- This arrangement is good for and benefits everyone.
- Because of the gender differences that exist, there is no other possible way in which to arrange male and female roles.

Other/Alternative Forms of Motherhood Ideology

- Mothers are entitled, just as fathers are, to pursue employment for all its benefits, including economic gain and self-fulfillment.
- Mothers and paid child care providers can constitute a child care team.
- Mothers can and should contribute to both the instrumental and expressive needs of their children.

3

Balancing and Weaving
to Be a "Good" Mother

My History of This Project

In April 1993, I gave birth to our second child, a daughter, Emma. My plan for balancing and weaving my own work and family obligations was to take the summer off after Emma's birth and stay at home with her and her older brother, Travis, who was rapidly approaching his 3rd birthday. I spent the summer (a) reading literature in the sociology of gender as I attempted to pull together my dissertation proposal and (b) spending time with my children doing those things that mothers with young children do, such as playing at the park, creating sidewalk chalk art, and taking walks.

During that summer of 1993, I had two watershed moments. The first one involved my own disengagement from the original project I had planned to undertake for my dissertation. I was more interested in pieces such as *The Second Shift* (Hochschild, 1989) and less interested in the prospect of doing the project I originally envisioned, which would have focused on domestic violence. Second, the more carefully I read the literature on gender, work, and family, the more I realized that the empirical

literature I was reading did not necessarily reflect the world in which I lived. I was experiencing serious cognitive dissonance. I spent the summer with mothers who stayed at home and talked at length about how difficult it was for their families to make ends meet. Yet they did not want to go back to work because they believed that staying home was the right way to raise their children. Other moms I knew were employed, some of them full-time, even though they told me that the money was not their primary reason for working; their families did not need it. They were working because they wanted to. Our son attended a half-day preschool program in which I was one of only a small number of mothers who were employed or in school. Clearly, these mothers did not need "day care." They were utilizing preschool for its enrichment purposes.

Mothers in these distinct circles not only had little in common, or so it seemed at first glance, but also spent a great deal of time and energy criticizing the choices of mothers in the other groups. Being sort of a hybrid or crossover, I was able to move in both groups. It was my first vision of the divisiveness that exists between employed mothers and mothers who stay at home. This divisiveness was not motivated out of jealousy regarding material goods or the amount of time spent with one's child as much as out of fundamentally different beliefs about appropriate roles for mothers. In reflecting on these opposing views, as well as on my own choices, I began to believe that there was more at work than the economic model that was put forth by both scholars and popular writers alike. As I continued chatting with mothers, I began to realize that what was missing in attempts to understand women's labor force participation choices was ideology, a sense of what it meant to be a "good" mother and how this related to women's choices about work, family, balancing, and weaving. Therefore, I set out to better describe and understand the power of ideology in the labor force participation considerations of mothers with young children.

Searching the literature on balancing and weaving work and family, the division of household labor, and maternal employment, two important concepts emerged. First, most empirical models for predicting maternal employment patterns were rooted in economics. These models assumed that maternal employment decisions were based on the outcomes of analyses of the opportunity costs and benefits to employment, such as child care costs and wages. Second, ideologies of motherhood and their origins were being explored in the theoretical literature, especially in writings by women of color, such as Patricia Hill-Collins (1994) and Evelyn Nakano Glenn (1994). However, a gap existed between the theoretical and empirical literatures. Though Hill-Collins and, more recently, Hays (1996) and Walzer (1998) have identified the link between one's motherhood ideology and employment patterns, motherhood ide-

ology has only recently been examined in empirical studies of maternal employment (see Garey, 1999, as an example). Furthermore, though Hays explores the content of the dominant ideology of intensive mothering, she does not examine its power over the process of individual maternal employment deliberations.

AN EPISTEMOLOGICAL POINT

I felt that I had discovered the project I wanted to undertake, but I was forced to examine the implications of studying a phenomenon that I was currently experiencing. I turned to *epistemology*, which refers to a system of knowing. Epistemology is not a method for testing theory, but a system of acquiring knowledge. Epistemologies rest on sets of assumptions. Among the fundamental assumptions of the "scientific" epistemology, which arises out of positivism, is objectivity. Objectivity is believed to produce bias-free science. Central to the concept of objectivity and positivism is a separation of the researcher from his or her topic of research. Margaret Mead lived with the people of Samoa, but her valuable insights and analyses of gender relations among the Samoans were possible because, fundamentally, she remained an outsider. She was able to see the Samoan people and culture in ways that they were not able to see themselves. As a result of this concern for maintaining value-free science, most sociologists are trained in the scientific, positivist methods.

In the mid-1980s, however, feminist theorists with training in a variety of fields began to evaluate the scientific method as it had been practiced for centuries. Harding (1986) outlines the critiques made by many other feminist writers on the question of ways of knowing. She argues, as have Nancy Harstock, Jane Flax, and Dorothy Smith, that there are two major critiques of the standard scientific method.

1. *Feminist science,* which focuses on the experiences of women, has been criticized by the scientific community for being inherently biased. The scientific community charges that any investigation focusing exclusively on the experience of one half of the human population and purposively excluding the experience of other members of the population is inherently biased and unreliable. Harding (1986) contends, however, that *feminist standpoint epistemology* actually improves the scientific endeavor. She argues that feminism, by definition, strives to be inclusive, not simply to counterbalance, the traditional scientific standpoint.

2. Harding (1986) charges that practitioners of the scientific method have ignored the biases inherent in their own standpoint. For example, because science has been dominated by white, heterosexual, Western men, it has

been conducted primarily from this standpoint. One result of this bias is the problem of using male subjects in research to the virtual exclusion of the female subject.

Whereas feminist researchers are critiqued for at times focusing exclusively on the experiences of women, traditional science does not criticize itself for conceptualizing men as universal, as standing for both men and women, a practice which is very common in biomedical research. This problem extends, according to Harding (1986), to issues of epistemology. The epistemology of the scientific method, which, according to Harding, is flawed by its own androcentric bias, is characterized by "the selection of problems for inquiry and in the definition of what is problematic about them" (p. 22).

Several researchers, including Barnett and Rivers (1996), have commented on the result of this androcentric bias in social science research that focuses on the conflict between work and family. They charge, for example, that both scholars and the media have failed to note positive outcomes, such as health benefits, associated with women's work.

> The media and scholars have spent so much time looking for terrible problems they expected to emerge from women going to work that they paid too little attention to the quality of a woman's job and its impact on her health. Most of the concern seemed to be on steering women away from fast-track jobs. (p. 33)

In other words, the issue in this case is not the lack of attention paid to the employment of women, but rather the ways in which the issues are problematized. Barnett and Rivers (1996) charge that scholars and the media have investigated this phenomenon expecting to find a particular set of problems rather than examining this phenomenon in an unbiased fashion. Researchers, they charge, have problematized women's employment rather than problematizing the fact that any health risk associated with women's employment is due to "no control at work, low pay, and little support at home" (Barnett & Rivers, 1996, p. 33).

Finally, Harding (1986) argues that it is critically important for researchers to examine their own standpoint and their relationship to the topic under investigation as well as their relationship to the subjects who will provide the data. In many cases, common ground between the researcher and the subjects is advantageous to the research rather than a source of bias. For example, when a researcher has personal experience with particular phenomena, this often enables the researcher to establish rapport more quickly with the subjects. This personal experience may also provide the researcher with particular insights into the phenomena that will lead to a greater understanding. For example, Romero, in her

study of Hispanic domestics, utilized her experience as a domestic to develop rapport with her informants and to provide preliminary, anecdotal data that informed her long-range research (Romero, 1992). Thus, argues Harding (1986), feminist standpoint epistemology is critical to the scientific investigation of work-family conflict issues.

MY OWN STANDPOINT

Throughout this project, I have struggled with the question of my closeness to the research question. I am a mother with young children studying mothers with young children. I am a mother struggling with my own strategies for weaving work and family, investigating these same strategies as various types of families utilize them. I have constantly examined the ways in which my own personal experience is related to my intellectual curiosity and how, as a researcher, I must balance these perspectives. In fact, what I have done in this project is to use my standpoint as a way to develop rapport with my subjects and as a source of anecdotal data that has provided particular insights into the balancing or weaving faced by most mothers and their families.

That summer of 1993, when my daughter had just been born, I was able to interpret the scholarly literature on women's labor force participation through my own lens, that of a stay-at-home mother who was also a graduate student in sociology. The synthesis of the literature with my own experience and the experiences of my friends whom I observed that summer led me to ask the research questions that launched this project: What is the process by which mothers determine whether they will stay at home or seek employment while their children are young? What are the roles of various factors such as economic need and motherhood ideology in this process? And in what ways does the dominant ideology of motherhood influence mothers' labor force participation decisions and evaluations of their satisfaction with their choices?

Profiles of the Mothers

Even in a lengthy discussion such as this, it is simply not feasible or efficient to discuss the lives of each individual woman. In an attempt to streamline the presentation of this rich, qualitative data, I quickly saw that a category system for grouping mothers would be useful. When the experiences of the women who are the focus of this book were viewed systematically based on their motherhood ideology, the importance of this variable emerged. Motherhood ideology was more useful than any

other single variable that is typically measured, including spouse's income and employment status of the mother, not only in predicting maternal employment but also in differentiating mothers with young children from one another. Therefore, I found it useful to group mothers by their motherhood ideology rather than their employment status. Variations in employment and child care are considered within each distinct group.

THE INTERVIEWS

The mothers whom I interviewed were all initially identified through birth certificate records. I simply requested from the county all birth certificate records between January and March 1994. The first quarter of 1994 yielded 1,000 birth certificate records, from which 600 were randomly selected. Because the births occurred a year before the sampling, the addresses on the birth certificates required verification. Of the sample of 600, correct addresses were obtained for 450 mothers. Of the 450 surveys mailed, 231 (51%) were returned. The survey asked mothers who were interested to volunteer for an interview, and 30% of the mothers did so. My intention, in attempting to understand the process by which mothers with young children determine whether to seek employment or stay at home, was, first and foremost, to interview women who were involved at various levels in the labor force. Therefore, because I had three times as many women as I could interview, I utilized a purposive sampling technique. I began by sorting the mothers into three separate categories: those who were employed full-time, those who were employed part-time, and those who stayed at home full-time. I selected for interview equal numbers of mothers from each of these three groups, resulting in an interview sample of 30 mothers, 10 from each employment category.

The labor force participation rate for women with children under the age of 6 in the upper Midwestern county in which the data were collected is 75%, whereas the national rate is only 67%. As a result, the sample of mothers surveyed included more employed mothers than the national average. However, among the mothers whom I interviewed, two thirds were employed, whereas one third stayed at home full-time. As a result, those interviewed were less likely to be employed than mothers in this county but as likely to be employed as mothers nationwide.

Once I had sorted the mothers by employment status, I selected mothers for interview who varied on many other important variables, such as educational attainment, number of children in the household, occupation, spouse's income, total household income, and child care arrangements. Mothers ranged in age from 26 to 47 with most, 84%, falling between 25 and 35. With the exception of Cheryl and Jean, all the

mothers had either one or two children. All the mothers were married at the time of the interview, though at the time of the follow-up survey 2 years later, several had divorced. The sample was relatively well-off financially; 17 out of 30 (56%) had an annual household income greater than $50,000. The remainder fell between $20,000 and $50,000 per year, with most falling between $30,000 and $50,000 per year. This is attributable in large part to the fact that two thirds of the interviewed mothers were in dual-earner households. Also, the mothers and fathers were relatively well educated. All the parents had graduated from high school, and the majority had either an associate's or a bachelor's degree. I ended up with a sample of 30 mothers who were diverse in every regard except for geographic region (they all live in the upper Midwest) and race. Descriptions of each mother are located in Appendix B.

Limitations of the Sample

Because of state laws regarding paternity establishment, researchers are limited to obtaining birth certificate information on births to mothers who were married and over age 18 at the time of the birth. Family demography research suggests that in 1990, 3 in 10 births were to unmarried mothers. Furthermore, 25% of all births to white mothers, 70% of all births to African American mothers, and 41% of all births to Hispanic mothers were nonmarital births. As a result of the sampling restrictions and these demographic trends, certain populations are underrepresented in this sample. The survey sample is 93% white, and the interview sample included only one nonwhite mother. In addition, mothers who divorced before the birth of the child and lesbian mothers were automatically excluded from the sample. Because ideology is deeply rooted in and connected to human experience, the limitations of the sample—particularly those involving race, marital status, and sexual orientation—will undoubtedly be linked to limitations in the ideologies of motherhood held by the respondents. For example, based on Amott and Matthaei's (1996) work, I would expect to find racial and ethnic minority mothers in my sample to hold ideologies of motherhood that endorse maternal employment. The lack of racial and ethnic diversity in this sample is likely to result in a lower prevalence of this type of ideology than a more diverse sample would produce. The same argument holds true for marital status and sexual orientation. Married and heterosexual women are less likely to hold nontraditional views than are single women or lesbians.

However, though the prevalence of various ideologies of motherhood is limited by the restrictions on this sample, the relationship between motherhood ideology and consequent labor force participation should not be

affected by the limitations. Clearly, studies of balancing and weaving work and family should not focus exclusively on white, heterosexual, married mothers. With all the shortcomings of this sample, however, it does allow me to consider women's labor force participation choices within the context of a partnership. As noted by Garey (1999), stable partnerships provide mothers with much more flexibility in their employment decisions. Thus, this study serves as a test of the limiting case; I am able to examine labor force participation among women who do not "have" to work.

The Interview Process

Because of my own experience as a mother, I strongly suspected that it would be very easy to get women to agree to an interview, and I believed that I would be easily able to establish rapport. I was right on both accounts. Since the time that I had first become a mother, I had spent hour upon hour engaged in conversations with other mothers about balancing and weaving work and family. We shared our hopes, our dreams, and our frustrations over Cokes at the McDonald's Play Land, in the park, or in the playroom at one another's homes on cold, dark January afternoons.

Despite being women who were busy with young children and the work of the home and sometimes the office, those whom I contacted were eager to participate in interviews. Given that I was already asking much from them in using up their valuable time, we met in places and at times that were convenient for them. I interviewed all of the stay-at-home mothers and many of the employed mothers in their homes. Often, they shared coffee and cookies with me. At times, we sat on the floor with their young children. I also interviewed mothers at their offices or places of employment. Some of the employed mothers met me over lunch, in a local restaurant or park.

Although it took just about an hour to complete the interview questions, many of the interviews stretched on for hours. Sometimes, the interviews were punctuated by children's needs, diaper changes, napping schedules, and the like. Most of the women shared their lives, their hopes and dreams, and their frustrations with me, in the same way that I experienced informal sharing with other mothers at the park or the McDonald's Play Land.

ANALYTICAL TECHNIQUES

Qualitative data raise their own distinct analytical challenges. The tendency in most scientific endeavors is to distill one's findings into a few key numbers or trends. Distilling the stories of these 30 mothers and

their struggles with balancing and weaving work and family into just a few numbers or trends was an impossible task. I employed two basic analytical techniques. The first was a descriptive technique. Individual cases were reviewed systematically and grouped. As noted previously, the most interesting and significant grouping was by ideologies of motherhood. Each group can be described in terms of the individuals' beliefs about motherhood, employment status, household income, and so forth, which forms the basis of the ideal types outlined below. These systematic descriptions serve much as means and percentages do in quantitative analyses. Second, thematic coding, as outlined by Strauss and Corbin (1990), was used both in the development of the ideal types and in the analysis that seeks to illuminate the relationships among factors in the data, much as bivariate and multivariate analysis would be used in quantitative analyses.

PERSONAL REFLECTIONS

The experience of interviewing these 30 mothers was certainly intellectually stimulating, but it was also personally challenging for me. I completed all the interviews in June and early July 1995. During that time, I was asked to challenge my own motherhood ideology and confront my own feelings about myself as a mother and a scholar. Despite being excited about participating in the interview and believing that the study was addressing critical questions, one mother, Cheryl, asked me how I could possibly leave my children in someone else's care in order to do this research project. She challenged me to think about the choices that I had made to balance and weave work and family. Not even a week later, I interviewed Emily, a career mother, who challenged me to consider that any time I spent away from my children made me a better mother because I was advancing my ability, by earning my PhD, to enrich their lives. I spent half that summer feeling that I was unfair to my children by working at all and the other half of the summer feeling that I was being unfair to my career by not working enough.

This is precisely the issue that Harding's discussion of feminist standpoint epistemology addresses. My shared status with the mothers I interviewed made them more willing to share with me and, at times, confront me. Furthermore, the mothers I interviewed did not merely share information with me; they became partners in the research pursuit. Harding (1986) and other feminist methodologists suggest that scientific inquiry produces more accurate results when subjects and respondents are involved in the scientific process. These mothers helped to shape the process of inquiry, a desirable outcome of this methodology according to

scholars such as Harding. They contributed their own analyses and inter-
pretations. In one particular case, a mother asked me a question that I
incorporated into the subsequent interviews. This provided another "way
of knowing." And it produced data in which mothers' beliefs about moth-
erhood could truly find voice.

Even now, when I talk about the research I do, women and men will
share with me their thoughts, their own experiences, and their hopes
and dreams. Many times, they ask my advice. Why are mothers so in-
terested in sharing their experiences in balancing and weaving work
and family? This is an important question, and I think it stems from the
situation in which mothers with young children find themselves in the
dawn of the new millenium.

Though many mothers have always worked outside the home, never
in history, except in the 1950s and 1960s, have so many women grown
up in families with stay-at-home mothers. Coupled with this, many moth-
ers raising young children today were raised when there were virtually
no representations of employed mothers in the media. At the beginning
of the 21st century, the majority of mothers with young children, many
of whom were raised in families with stay-at-home mothers, are in the
labor force. As a result, many mothers raising young children in the
new millenium find themselves in a state of normlessness. They find
themselves creating their own norms. Therefore, many mothers sec-
ond-guess their own choices, are highly critical of the choices other
mothers make, and often feel less than adequate in the ways that they
are balancing and weaving work and family.

IDEAL TYPES

Weber originally developed the concept of ideal types, which serves as an
analytical tool. Ideal types are developed after careful observation of a
series of people, places, or events. Based on this set of observations, the
researcher or observer constructs an ideal type that exemplifies the es-
sential characteristics of the person or thing being described. Ideal types
are employed for two purposes: (a) to recognize people or phenomena
that fit into the same type and distinguish them from other types and
(b) to stand as an example or illustration of this type. An ideal type is not
an average, and neither is it typical or representative of all the observa-
tions. Rather, an ideal type serves to illustrate the distinctive characteristics
of the type. The analyses that follow in this and subsequent chapters rely
on the use of this analytical tool. The women who are profiled in this
chapter are ideal types whose individual stories illustrate most clearly the
concepts laid out in the analysis.

Naming of Ideal Types

Finding names for the ideal types was a challenging task. After examining a number of naming systems used by other scholars and finding these systems unsatisfying, I have developed a system based on the work of Robert Merton.

Adapting Merton's Framework

Robert Merton (1975), a structural-functionalist sociologist, developed a theory called strain theory, which he used to understand delinquent behavior. Merton argued that individuals in a given culture have access to the set of ideologies and norms for behavior that hold a hegemonic or mainstream position in that culture. Merton noted, however, that sometimes, cultural ideals—both the goals and the strategies for reaching the goals—and the social structure are incompatible. In other words, access to legitimate means of attaining cultural goals is not available to particular portions of the population. Thus, individuals may develop alternative strategies for attaining culturally defined goals. For example, earning good grades is a culturally defined goal for students. Students who lack the skills, motivation, desire, or commitment to earn good grades may become delinquent. They may reject the cultural goal and the strategies for attaining it (retreatists); they may reject the goal but nevertheless continue to work toward the goal (ritualists); or they may accept the goal but reject the strategies for attaining it (innovators). Retreatists are likely to drop out of school; ritualists are likely to remain in school but simply go through the motions; and innovators are likely to cheat or engage in other illegitimate strategies for attaining good grades.

Merton's category system can be modified to apply to the situation of mothers with young children. In this case, there are two critical cultural goals: caring for and nurturing one's children according to the norms of intensive mothering and providing a comfortable, middle-class standard of living for one's children. Applying this modified version of Merton's strain theory, I argue that mothers can be categorized into four distinct groups based on their acceptance or rejection of these cultural goals and the strategies they employ for achieving these goals.

The first group of mothers conforms to the dominant form of motherhood ideology, that of intensive mothering. They believe that mothers should not return to the labor force once they have had children. Furthermore, these mothers accept the male breadwinner, single-earner means to achieving economic stability. In addition, these mothers place the goal of intensive motherhood ahead of that of securing a comfortable standard of living. In

Merton's (1975) terms, these mothers conform to the dominant standard of motherhood and accept the terms for achieving this goal. Thus, borrowing from Merton, I will call these mothers *conformists*.

The second group of mothers rejects the dominant form of motherhood ideology. They define the role of mother in such a way that includes both the provider and the nurturer roles. Their definition is consistent with the types of alternative motherhood ideology described by Glenn (1994) and Hill-Collins (1994). Furthermore, they believe strongly in taking an active role in securing a middle-class standard of living for their children. For example, they believe firmly in saving for a college education and providing a wide range of enrichment experiences for their children. As a result, they make labor force participation decisions that do not conform to the dominant norm of the stay-at-home mother but are consistent with alternative constructions of motherhood. Borrowing again from Merton (1975), though choosing an alternative label, I will call these mothers *nonconformists*.

The third group of mothers accepts both the dominant motherhood ideology and the desire to achieve a culturally defined middle-class standard of living. In many cases, they choose an option that allows them to meet these goals simultaneously; they desire to stay at home while their children are young and depend on their husbands to provide for the economic needs of their families. However, for many families, as was noted in Chapter 1, both of these cultural goals cannot be achieved simultaneously. In the case of this group of mothers, neither goal outweighs the other. Instead, these mothers take a more pragmatic approach to balancing and weaving work and family. They undertake a cost-benefit analysis of their options and select that which best meets the needs of the family. This is not unlike the approach new home economics theorists have used in analyzing all maternal labor force participation decisions. Because the environment and their preferences are constantly shifting, this group of mothers experiences frequent changes in employment status, employers, and child care providers. Because this group makes labor force participation decisions by weighing a series of interrelated factors rather than adhering to one ideological position, I have termed them *pragmatists*.

The final group of mothers, using Merton's (1975) system of categorization, accepts both the dominant motherhood ideology (or a slightly modified version of it) and the economic goal of providing a middle-class standard of living. However, unlike the pragmatists, who base their labor force participation decisions on the options that are defined by the culturally specific social structure, these mothers seek alternative means to achieving the culturally defined goals. They, in fact, innovate new ways of balancing and weaving work and family. These mothers participate in the labor force without relying on any paid child care. Thus, borrowing directly from Merton, these mothers are termed *innovators*.

A Note on Categorizing Mothers

For reasons that will be explored in Chapter 8, the mothers were not equally divided among the four categories. The sample included 5 conformists, 3 nonconformists, 14 pragmatists, and 8 innovators. Furthermore, as suggested by the typology, the labor force participation decisions for certain types of mothers were very straightforward, whereas they were quite complex for other mothers. All the conformists stayed at home full-time, and all the nonconformists were employed. Thus, I have used just one ideal type for each of these two groups. However, though the process of determining labor force participation was consistent, there was so much variation in the actual behavior of the pragmatists and the innovators that I was compelled to use more than one ideal type to represent each group. As a result, I developed the number of ideal types that I felt adequately represented the degree of variation within each of these two groups. I chose to develop two ideal types for the pragmatists and three ideal types for the innovators. The demographic data pertaining to all 30 of the mothers are presented in Appendix B.

Pinching Pennies: The Story of Cheryl, a Conformist

When I arrived to interview Cheryl, she had two towheaded boys at her feet, ages 2 1/2 years and 15 months, and she was very visibly 7 months pregnant. She was 25 years old; she had completed "some college," and her total family income was between $10,000 and $20,000 per year.

I interviewed Cheryl in the living room of the family's two-bedroom rental home. In addition to the two bedrooms, one shared by the children and the other by Cheryl and Paul, the modest house had a small living room, a tiny kitchen, and one bathroom. It was probably 500 to 750 square feet. Cheryl and Paul owned one car, an older model. She informed me that all the family's furniture and clothes had been purchased secondhand at either yard sales or the local Goodwill. Cheryl's home was modest but clean and very well kept.

I began by asking Cheryl when she first started thinking about how to balance and weave work and family. She told me that she and her husband, Paul, had begun talking about it when they were engaged. She had always believed that her job or role was to be at home full-time with the children. Although active in her husband's ministry (he was the pastor of a small local church), she otherwise did not pursue any interests of her own outside of her family.

Cheryl believed that her desire to be the primary care provider for her children stemmed from two places: her own experience as a child and her beliefs about the moral development of children. She began by discussing

her experience as a child. She was raised in a traditional family, which she believed is the ideal family in which to raise children, and her mother stayed at home full-time. She said, however, that she would never raise her children the way her mother had; her mother was "not really home." Though physically in the home, she was engaged in work much of the day and spent very little time actually caring for or teaching her children. Cheryl and Paul felt that parents are the primary teachers of their children. At several points in the interview, Cheryl talked about instilling morals and values in her children, of wanting to raise them the "right way." She believed that having children cared for by those other than their parents would result in the children having to deal with different philosophies of discipline and morals. She said,

> I know their philosophy and their personality and everything is developed in their first three years, and I wanted to be the one that would infiltrate that. I didn't want somebody else to do that. That was too important for me. . . . You don't know what they're going to teach your children.

Much of Cheryl's moral conviction appeared to be derived from her conservative religious affiliation. However, all the other women who adhered to this intensive motherhood ideology expressed the same sentiments. Three of the conformists (including Cheryl) aligned themselves with fairly conservative traditions, one was Catholic and two indicated they were "Christian." However, the remaining two conformists noted that they had no religious affiliation, suggesting that this intensive motherhood ideology has roots both in and outside of conservative religious groups. According to Hays (1996), it is the dominant form of motherhood ideology in U.S. culture.

ENTITLED TO WORK: THE CASE OF EMILY, A NONCONFORMIST

Emily and I agreed to meet at her office for the interview. When I arrived for our interview, I was greeted by an older mother (Emily was in her mid-40s) wearing a red "power suit," hose, and heels. She was quite well groomed—her hair was styled and her nails manicured. She wore stylish pearls and diamonds. She was a picture of success. On her desk were reports and memos and pictures of her son. Emily was a highly successful health care administrator and the highest paid woman in my sample, earning between $50,000 and $75,000 per year. Although she earned a salary similar to that of some pragmatists who were the breadwinners in their families, Emily could hardly be considered a breadwinner because her husband made substantially more money per year than she. Emily reported on the survey that his income fell in the "greater than $75,000" category. During the interview, Emily suggested that her husband's earn-

ings were greater than \$150,000 per year. I chose to interview Emily primarily because her husband earned what can be described as a better-than-adequate wage. Women such as Emily, by most estimations, do not have to work.

Why had Emily come back to work? Originally Emily came back to work out of both perceived economic need and a desire to continue pursuing her career. Emily had since realized that she had little money left over after child care costs and work costs (such as clothes and manicures) were deducted. She came to believe that she worked primarily as a means of pursuing her own interests. There was never any debate for Emily about whether or not she would come back to work; she always knew that she would return. For her, the question was how to have her baby cared for while she was at work.

> Even though part, essentially not quite a third, of my income would be depleted by compensating her [the nanny], I still felt that I wanted to come back. I wanted to be independent. I've always worked. I wanted my own resources. My husband and I work out money actually quite well, but maybe it's part of my upbringing. I remember my parents arguing about money, so it was always important for me to have my own resources.

Emily suggested by this statement that in addition to her perceived need for a total family income that would guarantee her desired standard of living, it was also important for her to have her own personal resources, her own money. Emily, as previously mentioned, was an older parent. She had spent many years working and commanding her own salary. To give up this control of resources was not something with which she felt particularly comfortable.

Emily's situation, however, provided an interesting twist. She was relocating for her husband, who was taking another position. He had been highly recruited for this position and was going to be compensated at a much higher rate than his current salary. Given this opportunity to rethink her own career, Emily was contemplating part-time employment after the relocation. She indicated that she had previously considered part-time employment but found that part-time upper-level executive positions simply do not exist, a structural constraint faced by pragmatists as well. She felt that she might pursue this option after relocating. At the time of our interview, however, Emily had not yet begun to look for a job, and she faced the prospect of being home full-time immediately following their move 400 miles away. In discussing her thoughts about initially staying at home full-time, she said,

> There was something that made me really claustrophobic. . . . I've had real anxiety attacks about what it's going to be like for me to be home. And John has been very reassuring and very much, "I want you to have

. . . I want you to get baby-sitters. We're going to look for that so that you can have some time to yourself." I used to take a lot of ballet, and I've given that up the last 2 years. I'd like to do that again, and I think he'd like to have me do that. He'd like to have me explore some of my own interests. So he doesn't want to see me a stay-at-home mother all the time.

In sharp contrast to Cheryl, Emily's beliefs can be categorized as nontraditional. She believed she was entitled to seek employment. If employment was not available, Emily felt that she was not obligated to stay at home full-time. Rather, she was entitled to pursue her own interests even if they did not produce an economic benefit for her family. In fact, Emily believed she was a better mother precisely because she continued to pursue her own interests. Despite the fact that this belief runs counter to the dominant motherhood ideology, Barnett and Rivers (1996) also note this belief in their extensive study of dual- and single-earner households: "So looking after your own interests and intellectual pursuits isn't being 'selfish'—it may, in fact, make a woman a better mother" (p. 37). Emily noted that until she determined what she wanted to do in terms of pursuing her career after the relocation, she and her husband, given his additional income, had settled on a way to continue to provide Emily with her own income.

We have basically the same arrangement that we do now. I'd pay him part of my paycheck, and the rest is mine to pay off my credit cards and to do with as I please. He is going to give me that same amount every month. So I can buy clothes for Max [their son], or I can buy . . . you know . . . do whatever I want.

Emily's rejection of the norm of intensive motherhood ideology was a rejection of a cultural goal. Thus, Emily felt entitled to seek employment. She did not judge her behavior by the standard of this rejected cultural goal. Rather, she engaged in decision making to maximize both her own motherhood ideology as well as her desire to provide a comfortable lifestyle for her family.

TRYING TO BALANCE IT ALL: THE STORY OF TAMMY, A PRAGMATIST

Tammy was a stay-at-home mother of two young boys. She was in her mid-30s. She held a college degree and had worked for several years in an administrative position in a local insurance firm. Her husband held an associate's degree and had worked his way up through the management ranks of a local contracting firm. I arrived at Tammy's home to interview her one afternoon in early July 1995. Tammy and her husband resided in a small bedroom community in the county. They lived in a large, two-story, three-bedroom, two-bathroom contemporary home.

Their house was nicely, though not extravagantly, furnished. In the back-yard, they had a deck, under which was a play area and sandbox. I asked Tammy to recall for me what it had been like for her when her first child, Trey, had been born. I was unprepared for the saga that unfolded.

Tammy began by telling me about their life before parenthood. She and her husband had always worked hard and wanted to provide a nice home for their family. He was climbing the ladder as a contract adminis-trator, but she, with a bachelor's degree, had always had a better job and made more money than did her husband. She loved her career. Tammy had worked for the same company for 10 years and had progressed into a management position in a company that had seen tremendous growth during the decade in which she worked there. After struggling to become pregnant, Tammy and her husband began early in Tammy's pregnancy to discuss their options for juggling the new baby and their respective ca-reers. Tammy and her husband had just had a home built, and they felt overwhelmed by the prospect of making the house payment exclusively with his salary. They both agreed, therefore, that she would have to re-turn to work.

Both of the pragmatists profiled in this chapter and many other prag-matists I interviewed reported that they had extensive discussions with their spouses about whether to stay at home or return to work. The con-clusion from the discussions in many, though not all, pragmatists' households was that the economic contributions of these women were necessary in order to maintain the family's current standard of living; therefore, it was necessary that they return to work. Economic need was an influential factor in the considerations of the pragmatists.

Tammy's return back to work was slow and gradual. She began by working over the phone, as her staff included her in important meetings via conference calls. During this stage, she was interested in work. And though she had promised herself a longer maternity leave, Tammy re-ported that she felt excited about the prospect of returning to the office.

What was supposed to be a stint of part-time employment quickly turned into full-time days in the office. Based on her desire to work part-time, Tammy had negotiated a deal that allowed her to work a reduced workweek in exchange for a prorated paycheck. However, as noted by many other professional mothers and fathers, professional part-time employment is very difficult to find. As a result, Tammy soon found that she was working full-time for part-time pay. Because of this dilemma as well as the self-gratification she felt as a result of being back in the work-place, Tammy sought appropriate full-time child care and returned to work full-time.

Despite feeling reluctant about leaving her infant, she settled on leav-ing Trey in a family day care situation. What had originally seemed like a high-quality family day care soon turned into a nightmare. Tammy said

she returned to pick up Trey one day to find 17 children in the care of one provider. She immediately terminated the arrangement and found herself saddled with needing to find another provider immediately. Luckily, she found another family day care provider, one with whom she felt considerably more confident. However, in the interim, she had needed to ask her employer for a significant amount of time off, as had her husband, so much so that he feared losing his job. For the most part, her employer had been understanding of her difficulties with being employed and searching for decent child care. However, she recalled that instead of trying to temporarily reduce her workload, his only attempt at helping her solve her time conflict was aiding her in finding appropriate child care. In retrospect, she felt that it was this insensitivity to the needs of working mothers—not only the need for good child care but also the need to juggle the commitment to work and family—that eventually drove her to quit her job.

The term *family friendly* is used these days in reference to the degree to which employers are willing and able to work with their employees, both male and female, to successfully balance work and family. Most of the women in the interview sample who were employed discussed strategies such as changing the number of hours and the schedule they worked, doing some work at home, and taking unpaid leaves in order to provide care for their children. In discussing the years she spent being employed, Tammy recalled how she juggled her working hours. She first returned to employment by working from home; then, she went into the office part-time; and finally, she returned to work full-time. While working full-time, she tried working early hours, such as 6 A.M. to 2:30 P.M., but found herself exhausted (she left home at 5:15 A.M. and, at the time, had a baby who was still not sleeping through the night). She thought the stress would lighten at home if she changed her hours; therefore, she tried working from 8 A.M. to 4:30 P.M. Tammy remembered, however, that her life "was total chaos." Despite having a company that was outwardly "family friendly," Tammy remembered that she felt tugged.

> Everything was a compromise. When I went to work, I felt like I should be at home. And when I was at home, I thought I left in the middle—all of these management meetings would be going on, and I'm like up and out of there. And everybody's looking around like, "Where's she going?" . . . I was gone on Trey's 1-year-old birthday . . . or his . . . he must have been 2. I was up in Duluth, Minnesota. I was just a wreck, calling and crying, sobbing. . . . And he doesn't know what day it is. Still to this day he has no clue that I wasn't here on his birthday. But that just symbolically meant something to me. And that's when I was just like, this is not worth it. I don't care how much I'm making; it's not worth it. But at the time I was making . . . the whole time always more than Neil. So it was . . . you know,

it was a big sacrifice when I finally said no way. Because it cut our income to less than half. More than in half.

Tammy's attempts to weave work and family had resulted in her feeling stress both at home and at work. Though she was committed to both roles, Tammy's role as a mother came to be more important to her during this process than her professional role. Whereas Emily felt entitled to pursue her own interests and did not judge her own involvement with her child against the norm of intensive mothering, Tammy did not feel similarly entitled. Tammy desired to provide a comfortable lifestyle for her family, and she desired to engage in intensive mothering. When these goals came into conflict, Tammy reevaluated her situation. Just prior to the time of our interview, she and her husband had determined that their family could maintain the standard of living they desired on his salary alone. Tammy quit her job because at that time quitting was the best mechanism for achieving both cultural goals.

I'M THE BREADWINNER: THE CASE OF BOBBI, A PRAGMATIST

I selected Bobbi for an interview primarily because she was the breadwinner for her family. She not only earned a moderately high salary herself, she also earned substantially more than her husband. When I called Bobbi to arrange an interview, she suggested that we meet over lunch. Her days were filled with work, and her evenings and weekends were reserved for her family. We agreed to meet in a popular, sit-down, deli-style restaurant. I arrived to find Bobbi in a pair of jeans and a polo shirt—dressed casually despite being the breadwinner for her family and working in a professional job. As was typical, I began by asking Bobbi to tell me about her considerations when she first became a mother. Bobbi indicated that there was really no question that she would need to return to work after the birth of her child. Bobbi's husband made much less money than she did, and when they assessed their family income, it seemed apparent that Bobbie would need to work outside the home in order to maintain a comfortable standard of living. Bobbi indicated that she would have liked, initially, to stay at home with her child.

> Initially, I would have preferred . . . I mean a long time ago, I would have preferred to stay home with my kids. . . . It was not realistic that I was going to be able to stop working. . . . And so I just figured . . . I made a conscious decision to be a working mom—I guess when I decided to have children.

Even before she became a mother, Bobbi knew that she and her family would not be able to keep her at home full-time; therefore, she committed to being a working mother when she had children.

Bobbi went back to work as a market analyst when her son was 12 weeks old. She indicated that it was hard at first to go back to work because she missed her son and felt guilty about leaving him. However, she felt that there was really no other alternative.

Bobbie's spouse earned $10,000 to $20,000. Living on his income alone did not seem like a realistic possibility for Bobbi and her family. Bobbi and her family chose to exchange the traditional family arrangement for the pursuit of an upper-middle-class lifestyle. This choice is the opposite of that made by Cheryl and her family, who conformed to the traditional construction of the mother and father roles.

The pragmatists, as illustrated by the cases of both Tammy and Bobbi, engaged in a cost-benefit analysis in which they carefully considered cultural goals, intensive mothering, and standard of living. Though Bobbi chose to be a working mother and Tammy a stay-at-home mother, the process by which they weighed the relative importance of these cultural goals and arrived at a strategy for pursuing them is the same. The outcome does not define and distinguish the mothers from one another; the process does.

NONOVERLAPPING SHIFT WORK: THE CASE OF JEAN, AN INNOVATOR

Presser (1988, 1989, 1994) has demonstrated the importance of shift work among dual-earner families with small children. Her research has suggested that the primary reason families employ shift work is to reduce child care costs. Therefore, I specifically chose to interview some women, such as Jean, who indicated on their questionnaires that they engaged in this type of arrangement. Though nonoverlapping employment patterns were a mechanism that saved on child care expenses for Jean's family, Jean adopted this strategy primarily in order to provide continuous parental care for her children. Furthermore, in a survey of the entire sample of mothers engaged in nonoverlapping shift work, none of the respondents indicated that this arrangement was selected purely to save on child care expenses. Rather, most indicated that they selected nonoverlapping shift work in order to provide parental care for their children and that the child care savings associated with this option were simply an added bonus.

Jean worked full-time during the third shift in a local meat processing plant. When I arrived for our interview, Jean's home was rather chaotic. Jean's family was not typical of this sample in that she had six children: a teenager from a previous marriage and five children under age 8 from her current marriage. The chaos, however, was typical of all the families of innovators who utilized opposite shift employment. Jean worked the third shift (from 11 P.M. to 7:30 A.M.) in a blue-collar manufacturing job.

Her husband worked the second shift (2 P.M. to 10:30 P.M.) during the school year and the first shift (7 A.M. to 3:30 P.M.) during the summer as a custodian for the local school district. After working an 8 $^1/_2$-hour grave-yard shift, Jean returned home to take care of their children while her husband was at work. On a typical day, such as the day I arrived, Jean had just returned home from working all night and was not looking for-ward to a "good night's sleep" until 4 or so that afternoon.

It is interesting to examine the outcomes of these arrangements for the mothers and their families. The nature of the situation associated with nonoverlapping shift work resulted in significant stress in the lives of these women. For example, Jean suffered from exhaustion. In addition to working full-time, she provided a significant amount of solo child care. Other working mothers who were married utilized paid child care during the day and returned from work to share the care of the children with their spouses. In contrast, Jean was providing a substantial amount of child care by herself. Also, mothers such as Jean reported that they had very little family time. Most often, the children were cared for by either their mother or their father but very seldom by both parents simul-taneously. Because the parents were rarely home at the same time or, if they were, one of them was trying to sleep, they clearly sacrificed marital couple time. Finally, it was hard for these families to keep ahead of house-hold work. Jean noted,

> It's very stressful for both of us doing this swing shift. Because any kind of extra day care we get—like the neighbor kids or whatever—most of the time when we hire those kids, it's to get our hair cut. Two weeks ago I said, "We're paying extra money for day care; let's do something fun. Let's go out for dinner." Because otherwise, I hire a sitter to go grocery shopping or to get my hair cut. He does it to mow the lawn and that kind of stuff. It's kind of hard to get all of those things done.

As a result of these kinds of stresses, families who utilize nonoverlapping shift work experience slightly higher rates of divorce, as noted by White and Keith (1990).

A follow-up survey I conducted with mothers engaged in non-overlapping shift work revealed that the most significant problem they faced in weaving work and family was the extra stress associated with extended periods of solo child care that followed shifts at work. As sleep-deprived as Jean was, she reported two primary reasons for engaging in shift work: the money she saved on child care and her desire to provide parental child care for her children. I asked Jean specifically why she chose to work a nonoverlapping shift, and she responded, "I don't want a baby-sitter. I don't like baby-sitters." Mothers who were able to pro-vide parental care and remain employed full-time saw costs and benefits

to their situations. However, they all preferred costs such as sleep deprivation to utilizing paid child care. Again, on the follow-up survey, the vast majority of the mothers engaged in nonoverlapping shift work indicated that the benefits to this arrangement were worth the associated costs.

WORKING FROM HOME: THE CASE OF HALEY, AN INNOVATOR

Haley's story is a bit different from that of Jean. Haley had two children and lived on a reasonably high household income. Her spouse was an attorney who earned between $40,000 and $50,000 per year. Haley earned an additional $20,000 to $30,000 per year. Their total family income fell in the $50,000- to $75,000-per-year range. I interviewed Haley in her large four-bedroom home in a suburb. Although Haley indicated that it had only recently been furnished, her home was nicely appointed, and the backyard was well outfitted with children's play equipment. Though not as chaotic as Jean's home, Haley's illustrated her situation as a mother who worked from home. Her desk, fax machine, computer, and files were in a corner of the kitchen, the hub of the family home. She could work while still being involved in her family life. Her home was a symbolic representation of her strategy for balancing work and family, a true blending or weaving of her work and mother roles.

Jean had spoken primarily about her distrust of baby-sitters as a reason for avoiding paid child care. Haley, on the other hand, was highly committed to intensive motherhood. She noted that her ideology regarding the role of mother was based on her value system, as was Cheryl's. "Well, I guess it comes down to our value system and what I think is important. And I think the most important thing that I could possibly do is be their mom and be there for them."

Garey (1995, 1999) studied nurses engaged in night-shift employment. She noted that they chose the night shift because it allowed them to meet their expectations of a good mother by "being there" during the day when good mothers are supposed to be at home and available for their children. Haley and Jean echo this sentiment. Much like Cheryl, they believe that being there is a critical component of being a good mother. Even though Jean leaves home at night to work, and Haley works while her children nap or after they go to bed at night, both women, by virtue of being at home during the day, are "there" for their children and consequently meet their shared definition of a good mother as prescribed by the ideology of intensive motherhood.

Although it is hard to evaluate how widespread these kinds of home-based employment options are, another mother, who provided child care in her home, mentioned trying to pursue a career doing medical tran-

scription via telecommuting. Providing child care in one's home is most frequently cited as an example of women's home-based employment. However, the innovators clearly illustrate the much wider range of home-based employment options engaged in by mothers with young children. Furthermore, research on telecommuting indicates a rapid rise in the percentage of the U.S. population that engages in telecommuting. The interesting question is the degree to which telecommuting is seen as a strategy for balancing and weaving work and family, as it is for Haley, and the degree to which it reduces the job-family conflict experienced by working parents.

Like Jean, Haley and the other mothers involved in home-based employment noted that there were trade-offs to this type of arrangement. Because Haley worked while her children slept, during naps and at night, she has virtually no leisure time.

> The costs are that I have absolutely no free time. I don't do cross-stitch; I don't read. You know, as far as having a lot of free time to myself, I don't have it anymore. To me, that kind of goes along with it; I can deal with that. The house isn't super neat, you know.

In addition to sleep deprivation, other costs to employment with no paid child care are a lack of leisure time and the inability to keep up on household chores (as noted by both Haley and Jean).

TAKING THE CHILDREN TO WORK: THE CASE OF KATE, AN INNOVATOR

Originally, I contacted Kate for an interview based on her ownership of a small business. Her self-employment status was an interesting variation in maternal employment. What I found was that Kate had started a small business specifically in order to deal with the issue of employment and child care. When Kate was pregnant, she knew that she wanted to remain at home full-time with her child. However, she also feared that she would be bored by the life of a stay-at-home mother. She felt that she needed more intellectual stimulation. Therefore, while pregnant, she began exploring the option of owning her own business. Near the end of her pregnancy, Kate opened her own retail fitness-attire business.

Kate and I agreed to meet at her shop for our interview. I arrived to find her daughter entertaining herself in the store. A box of toys was conveniently located near the window. She had a crib in the office and a high chair near the cash register. Juice boxes dotted the shelves, and there was a microwave and a set of bottles near the dressing rooms. Kate and her daughter seemed perfectly comfortable at work. Kate worked approximately 35 hours a week and hired employees to work the additional

hours the store was open. When Kate worked evening shifts, typically 5
hours per week, her daughter stayed at their home with Kate's husband.
Like Haley, Kate's combination worked well, and she could not justify
losing either the income or the noneconomic benefits she reaped from
working.

When Kate and I discussed her decision to take this innovative ap-
proach to balancing or weaving work and family, she talked about her
desire to raise her daughter and her desire to pursue her own career and
continue to identify herself as a career woman. Like many of the pragma-
tists and other innovators, she truly valued both roles. However, Kate
differed from the pragmatists in that instead of being restricted by struc-
tural constraints in identifying strategies for balancing or weaving work
and family, Kate created her own means of combining these roles. Like
other innovators, she did not see these roles as inherently conflictual. She
believed she could weave these roles together seamlessly. Kate saw a much
broader range of "what is possible." She provided care for her daughter
full-time because "I think I want her to grow up with my influences. The
only way to do that is to spend time with her. You can't just 'preach.' She
actually has to see, I think. I feel that's important." Yet Kate also believed
she was not "cut out" to be a stay-at-home mother. "I always felt like I'd
have to have something to do, whether it would even be child care at
home. Something besides just sitting home all day." As with the other
innovators, being there was important to Kate's definition of a good
mother.

Kate's situation was unique, and I wondered how other businesspeople
responded to her. I asked both Kate and Haley how colleagues and cli-
ents treated them. Kate indicated that she never felt disrespected or
undervalued in her enterprise. Over time, all her clients and colleagues
had become accustomed to having her daughter around and actually
seemed to respect her for her ability and creativity in weaving work and
family. She described the response of both her customers and her vendors
toward the presence of her 18-month-old daughter in the store.

> She gets along with all the customers. They'll come in and she'll play with
> the little kids. . . . There are a few [vendors] that get a funny expression,
> but the rest are used to her. A couple of times, I've had to call in orders,
> and she was kind of crabby and screaming. They always laugh.

Haley had this to say about conducting business dealings from her home:

> I deal with a lot of women in their 60s and 70s whose husbands have died.
> [She probates estates and wills.] They all stayed home with their kids. So
> to know that you're able to stay home and work, they have absolutely no
> problem with it. So, it's neat.

All the women who worked with their children present, either from home or in their offices, perceived that the reactions from their clients and peers were always positive.

The cases of these three innovators demonstrate other strategies for balancing and weaving work and family. Rather than seeing the cultural goals of raising children and providing for their economic needs as in conflict or opposition, innovators envision ways in which to truly weave these goals together. Furthermore, rather than relying on the standard mechanisms for weaving work and family, innovators design and take advantage of innovative strategies.

In the next chapter, I will consider the theoretical underpinnings of women's labor force participation more generally, and in Chapter 5, I will return to a discussion of the impact of motherhood ideology on the labor force participation of the women in this study. I will take a closer look at the data and analyze the processes by which these mothers weave and balance work and family roles.

Summary of Main Findings

What exists, what is good, and what is possible are the interpellations of ideology according to Therborn (1980). The interviews conducted for this book and the analyses of these data suggest that the differences among mothers with young children and their strategies for balancing and weaving work and family are based in ideology. When reading descriptions of Cheryl, Emily, Tammy, Bobbi, Jean, Haley, and Kate, many differences are apparent. These mothers differed in all kinds of structural ways. Their level of educational attainment varied, from Jean, who had a high school diploma, to Emily, who held an MBA. Cheryl and her family hover just above the poverty line, with a family of nearly five living on $20,000 per year, whereas Emily and her family of three live an affluent, upper-middle-class lifestyle. Cheryl, Tammy, Jean, Haley, and Kate provided virtually constant parental care for their children, whereas Emily and Bobbi both employed a child care provider. All the mothers except for Cheryl and Tammy earn a wage. And the list goes on and on. What differentiates these mothers is not necessarily their employment status or their use of paid child care. What differentiates these mothers is their motherhood ideology and the outcomes defined by this ideology: What exists, what is good, and what is possible.

The labor force participation decisions of these mothers represent a complex interplay of factors ranging from beliefs about motherhood to human capital and structural factors. The relative power of each factor

in the considerations of individual women varied. However, the one factor that was consistently important in the decision process was motherhood ideology. For mothers such as Cheryl and Emily, motherhood ideology was the centerpiece around which all the other factors were considered. For mothers such as Tammy and Bobbi, beliefs about motherhood were weighed along with other factors. However, even when motherhood ideology was only one of many factors being considered, these mothers continued to judge the outcomes of their labor force participation decisions against the mandates of ideologies of motherhood, particularly the ideology of intensive motherhood.

The stories of these mothers illustrate the complex process by which labor force participation is negotiated. These 30 mothers employed a variety of strategies for balancing and weaving work and family that are not divisible by economic need or other human capital or structural factors alone. Just as Luker (1984) argued that attitudes about abortion were not about reproduction but rather about ideologies of motherhood and gender, I argue that labor force participation decisions are often rooted primarily in one's ideology of motherhood. Some mothers, particularly single mothers, work out of sheer economic need. But many mothers who are employed work because they believe they are entitled to do so. Many of those who stay at home full-time do so not so much because they can afford to but because they believe this is fundamental to being a good mother. Finally, these stories demonstrate the power of the dominant form of motherhood ideology, that of intensive mothering, in influencing both the labor force participation decisions of mothers as well as their self-evaluations of their employment choices.

For example, although Cheryl and Tammy both stayed at home full-time, their differing strategies for dealing with the dominant motherhood ideology defined very different worlds for them. Cheryl believed that the only appropriate role that exists for mothers is that of the stay-at-home mother; the only way in which Cheryl can be a good mother is to stay at home full-time. Cheryl stayed at home despite the fact that her family was eking out a very meager existence. As a pragmatist, Tammy engaged in a cost-benefit analysis of choices she perceived for balancing and weaving work and family roles. Motherhood ideology was only one of the many factors she considered. After returning to work, Tammy was overwhelmed trying to manage her work and her home life. After a series of discussions, she and her husband determined that they could afford for her to stay at home. So, she did. Tammy came to enjoy being at home with her two young sons. However, she and her husband would not have been happy had their standard of living fallen substantially, and Tammy would have returned to her career in order to prevent the downward slide. Thus, what distinguishes these mothers from each other is not the

outcomes of their labor force participation decisions but their beliefs about appropriate roles for mothers. In order to best understand their employment outcomes, it is necessary to examine the content of their ideologies of motherhood.

Strategy	Relevant Factors	Outcomes
Conformist Cheryl—stays at home	Motherhood ideology	Stays at home **Balance**
Nonconformist Emily—is employed full-time	Motherhood ideology	Employment **Weave**
Pragmatist Tammy—stays at home Bobbi—is the breadwinner	Structural factors Human capital factors Economic need Motherhood ideology	Stays at home or employment part- or full-time **Balance** **Weave**
Innovator Jean—engages in nonoverlapping shift work Haley—works from home Kate—takes her child to work with her	Motherhood ideology Beliefs about child care	Employment No paid child care: nonoverlapping shift work, taking children to work, or working from home **Weave** **Weave** **Weave**

4

Theoretical Paradigms for Understanding Maternal Labor Force Participation

Whether by gathering fruits and nuts or making lye into soap and candles, women have produced economic goods for their families throughout human history. Women's economic production has not been limited, however, to nonwage work. Women's nonwage work, particularly in preindustrial societies, has often been ignored, but even U.S. women's wage work has failed to be recognized. Coontz (1992) argues that because the conception of the U.S. family has been so centered on the white, middle-class family, the economic contributions of racial and ethnic minority women and lower-class women have often been ignored. Thus, until the recent resurgence of women, particularly white, married mothers, into the labor force, women's employment was not cause for debate. However, for the past 20 years or so, women's employment has become contested terrain as well as an important site for scholarly inquiry. There are several important paradigms, both theoretical and empirical, for understanding maternal labor force participation. In this chapter, I will review each as well as propose my own theoretical model for understanding maternal labor force participation.

Structural-Functionalist Paradigm

Structural-functionalists, such as Parsons and Bales (1955), argue that men and women have evolved both biologically and socially toward distinct spheres of specialization. Based on this perspective, men and women are believed to be biologically suited for different tasks. As a result, men have come to dominate the *instrumental* sphere, whereas women have taken over the *expressive* sphere. The instrumental role, according to Parsons and Bales, refers to the activities associated with providing for the basic needs of the family. In contrast, the expressive role refers to meeting the emotional needs of family members.

Parsons and Bales (1955) and others construct a logical argument that traces our current division of labor back to our earliest roots as humans. According to the structural-functionalist perspective, women's lives have been dominated throughout human history by pregnancy, childbearing, and lactation. However, several relatively recent developments have changed the biological components of motherhood (Klein, 1984). The advent of highly effective birth control mechanisms, such as oral contraceptives, which became available in the early 1960s, have radically altered women's control over their own fertility. The development of commercial formula in the 1950s made it possible for a mother to choose not to breastfeed (Klein, 1984). In addition, because preparing table food for babies was a highly labor-intensive job or because appropriate food was not available, as in the case of subsistence cultures like that of the !Kung, breastfeeding often extended well into the child's 3rd year.

Structural-functionalists argue that these maternal requirements left women with little opportunity to engage in activities that took them away from their children. The results of this, over time, were twofold: Women did not develop the drive to become the instrumental leaders for their families, and these centuries of exclusive child care resulted in women becoming more skilled at child care and nurturing than men were. As Parsons and Bales (1955) noted:

> In our opinion the fundamental explanation for the allocation of the roles between the biological sexes lies in the fact that the bearing and early nursing of children establishes a strong and presumptive primacy of the relation of mother to the small child and this in turn establishes a presumption that the man who is exempted from these biological functions should specialize in the alternative [occupational] direction. (p. 23)

As important as it is to consider the issues that allowed women to develop as child care specialists, it is also important to consider how these forces affected the development of men's instrumental skills. Structural-

functionalists argue that as with women, the early division of labor that existed among our human ancestors resulted in men's being more equipped to leave home and provide for their families. For example, a man's greater ease at being away from his children for 40-plus hours per week, and even traveling away from home as part of his job, has evolved out of the time in human history when men went on long, extended hunting trips in search of meat. These hunting excursions encouraged a more detached masculine character. Furthermore, men's lack of involvement with their children throughout much of human history has impeded men's ability to develop nurturing skills. As a result, note structural-functionalists, women are "naturally" more suited to staying at home and taking care of children, whereas men are naturally more suited to involvement in the labor force (Parsons & Bales, 1955).

Rational Choice Paradigms

There are several distinct perspectives on maternal labor force participation that fall under the general rubric of the rational choice paradigm. These include new home economics theory and the sociostructural perspective. Furthermore, several different empirical models that vary in content fall under the umbrella of the sociostructural perspective.

NEW HOME ECONOMICS AND HUMAN CAPITAL THEORY

New home economics theory proposes that families make decisions regarding the division of roles and the labor associated with these roles by engaging in a cost-benefit analysis of the different possible matrices (Becker, 1981; Berk, 1979). This perspective emphasizes the economic utility of role differentiation. In regard to maternal labor force participation, men's and women's human capital in the marketplace must be assessed as well as the costs and benefits of providing parental child care. Within this paradigm, human capital refers to the set of individual characteristics people have to sell in the labor market. Typically, human capital is defined to include educational attainment, work experience, occupational training, number of years in the workforce, and so on. After weighing the complex array of options, the most efficient one for meeting the needs of the family will be selected. Thus, factors such as men's and women's human capital, job availability, wage opportunity, child care costs, and the relative benefit of having a stay-at-home mother will be assessed. Among a variety of labor force participation options, solutions will be selected based on their ability to maximize the goals of the

family: economic production, or earning a wage, and social production, or rearing children (Polachek, 1981; Strober, 1990; Strober & Chan, 1999).

As noted by many scholars, men have a clear advantage in the workplace. Men hold the vast majority of positions of power and prestige, those with decision-making potential, and those paying substantially higher wages for their labor inputs. Because of gender discrimination in the workplace, women are less likely to receive promotions or be paid equitably (Reskin & Padavic, 1994; Strober & Chan, 1999). Thus, new home economics theorists note that men's clear advantage in the workplace will seldom result in a family's choosing the mother's employment over the father's (Barnett & Rivers, 1996; Becker, 1981; Berk, 1979; Strober & Chan, 1999).

Men's and women's child care abilities are also evaluated. In the same way that structural-functionalists, such as Parson and Bales (1955), have noted women's suitability for taking care of children, new home economics theorists view women's abilities to rear children as an asset that is difficult and costly to replace. Therefore, it is often to the advantage of the family to keep a mother at home rather than trying to replace her child care inputs with those of a paid employee (Becker, 1981; Berk, 1979). Ultimately, note new home economics theorists, the family engages in a complex set of rational choice comparisons that will determine the most efficient manner in which to provide economic and nurturing support for the family members (Becker, 1981; Berk, 1979; Strober & Chan, 1999).

SOCIOSTRUCTURAL PERSPECTIVES

Several empirical investigations have focused on the role that sociostructural variables play in mothers' labor force participation decisions. Empirical models that focus on sociostructural variables conceptualize maternal labor force participation decisions as yet another example of a rational choice decision. Investigations of this sort have identified a series of structural variables that are related to maternal employment (Brayfield, 1995; Cattan, 1991; Gerson, 1985; Hochschild, 1989, 1997; Leibowitz & Klerman, 1995; McHale & Crouter, 1992; O'Connell & Rogers, 1983; Perry-Jenkins & Crouter, 1990; Stafford, Beckman, & Dibona, 1977). These include the following:

- Marital status
- Economic need
- Occupational opportunity
- Child care cost
- Child care availability
- Number of children in the home
- Father's employment schedule

Paternal employment is predicted by a much narrower set of variables. Among men aged 18 to 65, only human capital factors and occupational opportunity affect the variance in employment (Strober & Chan, 1999). In contrast, maternal labor force participation is affected by a wider set of variables, as noted above. Let us take a closer look at each factor. Clearly, marital status is one of the best predictors of maternal labor force participation. However, because this study is based on interviews with married mothers, marital status is a constant and will not be discussed here.

ECONOMIC NEED

Most sociostructural models of maternal labor force participation include measures of economic need. Economic need is purported to have a strong impact on maternal employment. Just as men's primary reward for employment is the income they earn, the same is believed to be true for women. All factors being equal, it is presumed that women remain in the labor force when their families rely on their income. Women whose spouses or partners earn an adequate salary will have the luxury of remaining at home to care for the children. However, as noted by new home economics theorists, a mother's income cannot be evaluated independently as there are substantial opportunity costs—primarily, replacing the mother's child care functions—to her employment.

OCCUPATIONAL OPPORTUNITY

Occupational opportunity represents the degree to which employment in the worker's field is available within the community or nearby. Different from human capital, occupational opportunity means actual jobs that are available to the worker. For example, an agricultural specialist may have very limited opportunities in an urban setting, whereas a specialist in Russian literature may have few opportunities in Rochester, Minnesota. Thus, maternal employment is predicated on the availability of meaningful employment for which the woman is suitably trained within her community. For many women, occupational opportunity is critically important.

CHILD CARE COSTS

Child care costs have previously been identified as an inhibitor of maternal employment (Brayfield, 1995). The average American woman earns a mere $456 per week (U.S. Department of Labor, 1997). After taxes, she may bring home approximately $365 per week. Child care for young

children may average $80 to $100 per week per child. Thus, a typical mother with two children is likely to pay $160 to $200 per week in child care. After child care costs are deducted, the average U.S. woman takes home a mere $150 to $200 per week, or $600 to $800 per month. Once other work-related expenses are deducted, her take-home pay is even lower. As a result, many women, especially those with lower earning potential, argue that it simply does not pay to work outside the home. They are, in effect, working full-time for little take-home pay, and they feel that their time is better spent by staying at home full-time. Unfortunately, the cost of child care is even more prohibitive for women working minimum-wage jobs. A woman earning $5.25 an hour earns approximately $210 per week. After taxes and child care costs are deducted, she may have little to no take-home pay. Thus, as many scholars have noted, child care costs play an important role in women's labor force participation considerations (Brayfield, 1995).

In addition to the economic costs of child care, many scholars and parents point to the effect of child care on children. Although there have been definitive studies that suggest that child care has an overall negative effect on child development, some studies have shown that it is the quality of child care that is related to child outcomes. Hayes et al. (1990) and Zigler and Lang (1991) discuss the effects of child care on child development. They note that poor child care, defined as child care that is characterized by high staff turnover, high child-teacher ratios, poor facilities, crowded conditions, and untrained staff, is associated with negative outcomes for children, whereas high-quality child care is associated with positive outcomes for children. They conclude that it is not child care in and of itself that is related to child outcomes, but rather it is the quality of child care that is associated with child development. As with occupational availability, child care availability (or, more precisely, the availability of high-quality child care) varies tremendously from community to community. The availability of high-quality child care in a community will significantly affect the rate of employment among mothers with young children (Brayfield, 1995).

Not only have scholars highlighted the impact of high-quality, affordable child care on mothers' employment patterns, but so have business leaders. As previously noted, *Working Mother* magazine selects each year the 100 U.S. companies that are the most "family friendly." Companies that have on-site child care available to employees always top this list. Companies clearly recognize that they will be more competitive in recruiting and retaining top employees if they reduce the barriers to female employment, especially the difficulty of finding quality child care (Hochschild, 1997). Several specific examples should serve to illustrate this point. Many companies, particularly those who compete for the top

employees in their selected fields, either already have or are discussing
the addition of on-site child care centers. Another research project in
which I am currently engaged involves determining the child care needs
and proposing appropriate solutions for one of the leading medical cen-
ters in the United States. Furthermore, my own university is currently
engaged in a campuswide debate regarding the need for an on-site child
care facility.

However, the development of on-site child care facilities and other
solutions are not limited to institutions that primarily employ profes-
sionals. Companies that require their employees to work a swing or
rotating shift must also deal with child care concerns. As the United States
becomes dominated by service sector employment, and as women in-
creasingly fill the ranks in these lower-level jobs, service-oriented
companies are more and more facing a workforce that demands acces-
sible, affordable child care. Let's examine the case of one of the nation's
largest airlines, Northwest Airlines.

Northwest Airlines is based in Minneapolis, a city that has a healthy
child care market. However, Northwest Airlines houses its major tele-
phone reservation center in Chisholm, a town with fewer than 10,000
citizens in northern Minnesota. In anticipation of the 1996 opening of
the reservation center, which employs telephone personnel 24 hours a
day, 7 days a week, Northwest Airlines recognized the child care void in
Chisholm. Not only did Chisholm lack enough high-quality, affordable
child care, but it lacked enough child care spaces of any kind for the
families that were recruited primarily from the Minneapolis area to work
these swing shifts. As a result, prior to the opening of the new reservation
center, a new child care center was built in Chisholm. Chickasagga Child
Care Center provides quality, affordable child care from 5 A.M. to mid-
night, Monday through Friday. This allows employees of Northwest
Airlines to work both the first and second shifts and still provide care for
their children.

FAMILY SIZE

The number of children in families has also been noted as a correlate of
maternal employment, and even more important is the number who are
younger than school age. There are really two important issues at work
here. The first, which was addressed earlier, is the cost of child care.
Obviously, the more children for whom child care must be purchased,
the higher the total child care cost per month and the lower the impact of
the mother's wages on the total household income. It is interesting to
note that both researchers and women whom I interviewed frequently
referred to child care expenses as the mother's responsibility (Peterson &

Gerson, 1992). Some of the mothers I interviewed reported, for example, that their spouses' main concern with their employment was the wives' ability to obtain and pay for adequate child care. I believe that this assumption—the belief that arranging and paying for child care is the responsibility of the mother—rests on the belief that, fundamentally, child care is women's work. The implications of this assumption will be discussed at length in Chapter 7.

Second, in addition to the costs of child care, the new home economics perspective notes that the more children under school age there are in the household, the more valuable the mother's time is at home. In other words, when a woman is caring for and socializing multiple children, the family is gaining even more from her talents than when she is home caring for just one child (Becker, 1981; Berk, 1979). Typically, then, maternal employment is associated with smaller families and with families in which all the children are school age or older, whereas the presence of multiple children who have not yet reached school age is prohibitive to maternal employment.

In contrast, however, Estes and Glass (1996) and Rosenfeld and Spenner (1992) argue that family size is proportional to maternal employment. These researchers argue that as family size increases, the family becomes more and more dependent on the mother's wage. Estes and Glass, using longitudinal data, show that, in fact, the more children a mother has, the more likely she is to remain employed. Additionally, the more children a mother has, the more likely she is to change employers, thus increasing her salary. These various findings suggest that the relationship between number of children in the home and maternal employment is complex.

FATHER'S EMPLOYMENT SCHEDULE

Finally, some scholars have noted a relationship between maternal employment and the father's employment schedule (Leslie, Anderson, & Branson, 1991). Based on the continued widespread belief that men's careers are more important to the family than are women's, women's employment is often arranged around that of their spouses (Strober & Chan, 1999). The importance of men's jobs relative to women's is more basic than the economic contribution men make to their families. Even more fundamental is the concept of entitlement. In U.S. culture, men's work is more highly valued than women's, and as a result, men feel a greater sense of entitlement to pursue their own careers than women do. For example, among families who move in order for one parent to take a new job or promotion, only 10% to 15% do so because of the woman's career (Saltzman, 1997). Therefore, a married woman's labor force participation is often designed with her husband's schedule in mind. Men

who travel a great deal or work extended hours, rotating shifts, or un-
predictable schedules are less likely to have working wives than are those
whose schedules are more predictable (Strober & Chan, 1999). For ex-
ample, many mothers find it difficult to commit fully to a job if they are
always responsible for dropping off and picking up children or taking
days off in order to care for sick children, even if their spouses do not
have particularly demanding jobs (Barnett & Rivers, 1996). Maternal
employment is typically higher in families in which these sorts of respon-
sibilities are shared. In these latter situations, women are able to commit
more fully to work because they are not required to shoulder the entire
burden of changing their work schedules in order to deal with child care
crises (Barnett & Rivers, 1996; Hochschild, 1997).

Neoclassical Economic Theory

The most often cited, most heuristically pleasing explanation of mater-
nal labor force participation is economic need. The economic need
explanation of women's labor force participation presumes that married
mothers with children work for the same reason all other people work—
in order to earn a living! This neoclassical economic model assumes that
mothers will seek employment when it is necessary in order to provide
economically for their families, whereas they will choose to remain at
home when there is no pressing economic need for their wages. This seem-
ingly logical, streamlined approach to understanding maternal labor force
participation is frequently cited in scholarly circles (Gnezda, Hock, &
McBride, 1984; Hochschild, 1989; McLanahan & Glass, 1985; Moore
& Hofferth, 1979; Pleck, 1979; Ross, Mirowsky, & Huber, 1983; Scarr,
Phillips, & McCartney, 1989) as well as in dinner table conversation. In
fact, it is so commonly endorsed that references to it account for the vast
majority of conversations I have with men and childless women regard-
ing maternal labor force participation. Although it is widely believed to
be the major factor that determines women's labor force participation,
the interviews that will be discussed here, as well as several empirical
studies, suggest that economic need is only one of a host of factors that
determines the labor force participation of mothers with young children.
 At first glance, the economic need perspective may appear to be merely
a subplot of rational choice explanations such as the new home econom-
ics paradigm. However, the economic need explanation is clearly distinct
from both of these perspectives. Whereas the rational choice perspectives
include economic need among the array of variables that are used to
predict maternal labor force participation, economic need is only one of

many factors included in the cost-benefit analysis. For example, the new home economics perspective assumes that families will consider noneconomic outcomes of employment or staying at home. The potential wages of a mother are considered in the context of opportunity costs to her employment: economic costs, such as child care, and noneconomic costs, such as the potential negative outcomes of having children in child care for extended periods each day. In contrast, the neoclassical economic explanation is based on the assumption that economic need is the only consideration, that it overrides all other concerns.

The role of economic need in maternal labor force participation is complex. Although I will later argue that it is but one of many important predictors of maternal employment, it is critically important to consider the economic situation of the 1990s and how it has contributed to an overall increase in the labor force participation of mothers with young children. Many scholars, such as Barnett and Rivers (1996), Eggebeen and Hawkins (1990), and Reskin and Padavic (1994), have observed that the economic climate in the United States has changed strikingly during the 20th century. As noted in Chapter 1, for example, women's labor force participation increased dramatically during the Great Depression in response to the rate at which men's unemployment climbed. In addition, in response to the lower earning power of African American and Hispanic men, the employment rate among African American and Hispanic women has been higher than that of other U.S. women.

The economic situation of the 1950s and 1960s, as noted by Coontz (1992), was such that the majority of U.S. families could attain a middle- or upper-middle-class standard of living solely on the wages of the male breadwinner. Reskin and Padavic (1994) mention several factors that created this unique economic climate: high wages, an economy built primarily around manufacturing, and very low-interest mortgages that were offered to veterans and first-time homeowners. Therefore, many U.S. families could afford to own a home while living on one income (Coontz, 1992; Reskin & Padavic, 1994). Additionally, we must consider the issue of standard of living. In the 1950s and 1960s, a comfortable middle-class existence consisted of a 1,500-square-foot house, one car, and one television set and included little concern about saving for a college education for one's children.

The economic situation in which we currently find ourselves is vastly different. The decline in the manufacturing sector and the rise in the service sector of our economy has caused a decline in men's real wages, making it increasingly difficult for families to attain a middle-class standard of living on one income (Reskin & Padavic, 1994). Although women continue to earn a mere 71 cents to men's dollar, the decline in men's real earnings has made women's wages proportionately more valuable.

Whereas women's wages in the 1950s and 1960s were often considered supplemental, allowing a family to purchase additional luxuries, women's wages in the 1980s and 1990s figure prominently in the standard of living in the vast majority of U.S. households (Estes & Glass, 1996). In addition, the material expectations of the middle class have also changed. Many middle-class families expect or at least aspire to own a larger home, drive two vehicles, one of which should be a sports utility vehicle, and have cable TV in several rooms in the house. Women's wages are now "necessary" for many families who wish to live a middle-class lifestyle (Barnett & Rivers, 1996; Eggebeen & Hawkins, 1990; Estes & Glass, 1996; Reskin & Padavic, 1994). Perhaps, then, economic need explains the vast majority of maternal labor force participation decisions in the United States.

Scientific principles require that theoretical explanations of phenomena be reduced to those that are the simplest and most streamlined, the most heuristic. For this reason, adopting a purely economic model of maternal labor force participation is tempting (Becker, 1981; Berk, 1979; Parsons & Bales, 1955). And as noted above, much of the literature focuses on the role that economic need plays in maternal employment. The economic need explanation of maternal labor force participation is so pervasive that it has also been investigated in attitudinal research. For example, Etaugh and Study (1989) used scenarios to assess college students' judgments of various justifications for maternal employment. They observe that the most widely accepted justification for the employment of mothers with young children was economic need. Mothers who were depicted as working for personal reasons, which excluded economic need, were judged to be selfish. This finding confirms the notion that economic need is widely considered the most justifiable reason for maternal employment. Furthermore, this finding reinforces the claim that intensive motherhood ideology holds a hegemonic position among the array of beliefs about appropriate roles for mothers.

I will admit, however, that my own anecdotal experience as a mother watching other mothers negotiate the balance between work and family has led me to conclude that an economic model for predicting maternal labor force participation is too simplistic. I personally know women who have chosen to stay at home even though they indicated that their families would be more comfortable financially if they were to seek employment. And I know just as many mothers who were employed even when, by their own accounts, their families did not need the money they brought home.

Eggebeen and Hawkins (1990) studied the relationship between economic need and labor force participation. In their study, which focused on two-parent families, they divided families into two categories, those

in which the husband earned a salary deemed *adequate* (adequate salaries were defined as greater than 2½ times the poverty line) and those that were deemed *low*. They examined rates of maternal employment among these two groups and found that maternal employment was more likely in families in which the husband earned an adequate wage than in low-income families. They explain this counterintuitive finding:

> The need to provide basic necessities for the family has declined over time as a motive for White married mothers' labor force participation. Over the same time, desires to achieve and maintain a higher standard of living have increased. Couples' choices to enjoy the fruits of a prosperous economic system and the products of a technologically advanced society, and to enjoy them at a younger age, are responsible for this important trend. (p. 56)

Strober and Chan (1999) confirm this finding. In the U.S. families they studied, they note that the mean annual earnings difference between men whose wives were employed and those who stayed at home full-time was only $5,000. They quote one female Stanford graduate, "Living on one income in the Bay Area is difficult, but being an at-home mother is my career choice and top priority in our home" (p. 98).

Feminist Paradigms

Women's roles and women's involvement in the labor force have been of interest to many feminist scholars. As do many other theoretical paradigms, feminist theory attempts to understand the forces that predict women's labor force participation patterns. The term *feminist theory* refers to a broad-based, sweeping set of theories that arise out of a central core. The basic core around which most feminist perspectives are organized is the premise that the organization of gender relations within a culture will determine outcomes for real men and women in that culture. For example, when men and women exist in a hierarchical structure, such as patriarchy, and one gender is allocated more power and resources than the other (a situation of unequal gender relations), then the society is likely to experience outcomes such as high rates of sex segregation, high rates of violence against women, and a stronger preference for male children.

Feminist perspectives are also characterized by their critical approach. Though feminist perspectives range from liberal feminism to radical feminism, these perspectives share a critique of the gender relations that exist in most cultures. The solutions that are proposed to eradicate problems

such as sex segregation in the workplace vary. Liberal feminism argues
for greater opportunity for women in male-dominated industry and an
increased presence of men in female-dominated occupations. Radical femi-
nism, on the other hand, agitates for a dismantling of the sociopolitical
structures of capitalism and patriarchy (Jaggar, 1988).

Given this core principle that institutionalized gender relations pro-
vide the structural backdrop against which gender roles are both created
and reflected in the social world, feminist theory lends itself to examin-
ing the labor force participation of mothers with young children. It is
important to recognize that just as there are many different ways in which
feminist theory can be conceptualized, there are many different ways in
which it can be used to interpret patterns of behavior. However, the ma-
jor contributions that feminist theory makes in understanding women's
labor force participation falls into two main categories: inequality and
exploitation.

Many feminist writers suggest that gender relations in the home both
reflect and reinforce the structural inequality that is apparent in the larger
social context. Feminist theorists argue that gender roles that differenti-
ate men and women and allocate them different tasks and differential
access to rewards are inherently unequal and thus discriminate against
women (England & Farkas, 1986; Ferree, 1990; Thompson & Walker,
1989). When one considers the conflict inherent at the intersection of
work and family, feminist theorists raise several key points. First, femi-
nist theorists agree that women are assigned to the work of the home and
men are assigned to the work of the labor force based on the doctrine of
separate spheres. According to the feminist perspective, this division pro-
duces a situation in which women, regardless of their employment status,
are relegated the work of the family and of home life. Second, once tasks
have been assigned based on this gendered system of stratification, the
tasks themselves become gendered and come to represent "natural" dif-
ferences between men and women. Thus, women's essence is constructed
such that they are believed to be naturally suited to nurturing, whereas
men's is constructed such that they are believed to be naturally suited to
the competitive nature of the marketplace. Third, because women have
been assigned the tasks of managing home and hearth as well as the
children, they are often unable, when they do seek employment, to com-
pete with their male colleagues who have wives at home taking care of
the family and home work. Thus, the systems of patriarchy and capital-
ism create a system of gender oppression both at home and in the labor
force.

Although women have been entering the labor market in greater num-
bers in the past 20 years, so much so that women constitute virtually half
of the employed ranks, they are climbing the corporate ladder and

receiving promotions at much lower rates than their male counterparts. Several studies explore the reasons for this gender difference (Reskin & Padavic, 1994; Strober & Chan, 1999). Among them are the competing demands that women face in balancing work and family. Because family and home work continue to be defined as women's work, women's employment is often considered to be less important to them than their home life, and their level of commitment to the job is often judged by the standards developed for the man with a stay-at-home wife (for a lengthy discussion of this, see Hochschild, 1989).

The crux of Hochschild's (1989) argument is that the notion of the "ideal" or "normative" employee is constructed around the typical employee of the 1950s and 1960s, the married man with a stay-at-home wife. As a result, policies and standards reflect his reality rather than the array of realities that exists in any labor force. Additionally, when all employees are judged by this standard, those who deviate from the norm are likely to fail to meet this standard and will be judged negatively. This further disadvantages women and can be particularly dangerous for mothers in the labor force. Women, who may be at their jobs during the first shift and at home doing work during the second shift, are often unable to compete with their male peers and are less likely to attain the rewards that accompany employment.

As an aside, it is important to mention, as Reskin and Padavic (1994) do, that this system designed around male employees with stay-at-home wives penalizes men as well. Men who are single, widowed, or divorced, especially those who are single parents and who have to take care of their home lives on their own, often find themselves less able to compete with the standard. In addition, men in dual-career families and "involved" fathers in all types of families (Gerson, 1993) find that the behavioral expectations associated with their roles as employees, fathers, and husbands to their career-oriented wives leave them less than adequately positioned for success in the highly competitive labor market, an issue of which I am acutely aware.

Another strain of feminism is conflict feminism. Based in the Marxian tradition, conflict feminism examines the manner in which gender relations are affected by both patriarchy and capitalism. When patriarchy and capitalism are combined, as they are in U.S. culture, the outcome is doubly lethal for women. In addition to the effects of patriarchy, which were just discussed, women are far more likely to be workers than owners of the means of production. As a result, they are further exploited by the system of capitalism under which we live. Again, several theorists have examined this dynamic as it relates to the terrain marked by the intersection of work and family. The writings of Engels (1884) and Randall Collins (1992) are particularly illustrative of the

possible ways to evaluate women's roles within the family and their labor force participation.

Expanding on Marx's perspective, Engels (1884) applied it to the case of the family. He argued that the family is essentially a privatized, individual-level system of patriarchy in which the husband is dominant and the wife is subordinate. Of course, family-level patriarchy does not operate independently of societal-level patriarchy. In fact, family-level patriarchy relies on societal-level patriarchy as a source of power and legitimacy. Within the family, gender relations are defined within this system of patriarchy, and wives become engaged in "private service; the wife became the head servant" (Engels, 1884, p. 68). Women become the property of their husbands and are essentially indentured to them for the duration of the marriage. For their part, men function as the breadwinner. Similar to concepts in exchange theory, men provide some portion of their income as well as provide their protection in exchange for their wives' household labor. As Engels (1884) noted, this relationship models the relationship between the capitalist and the proletariat.

Randall Collins (1992) also interprets the gender relations at home as paralleling those of the capitalist and the proletariat. As social relationships change in the larger cultural context, gender relations at home will change in order to reinforce and reflect these changing social relationships. Based on the system of patriarchy and capitalism that continues to exist in the modern United States, Collins argues that women become the erotic, generational, and household property of their husbands.

Collins (1992) states that in the typical U.S. household, men contribute their labor outside of the household in exchange for the wages they receive. These wages, in turn, are reinvested in the household by purchasing goods and services that are necessary for the family. However, as Collins describes, these "raw goods" that are purchased with the husband's wages cannot be readily consumed by the family. Therefore, women's work is to take these raw goods and input their labor in turning them into consumables such as meals, clean clothes, and a clean house. As noted by Collins and supported by virtually every study on the division of household labor, even when women are employed outside the home, these gender relations, based on a property relationship, result in women doing the vast amount of household labor.

Although neither Engels nor Collins wrote about the outcomes of conceptualizing gender relations in this way, many feminists suggest that this private system of patriarchy and capitalism reinforces norms that dictate that women's roles should be limited to the household and care of the children, whereas men's roles should be focused toward participation in the economic and political spheres within the culture. Clearly, this way of conceptualizing the U.S. family is troubling to feminists, as it points

out the very ways in which men are able to dominate women within the family. Furthermore, by extension, when women find themselves or place themselves in positions that leave them dependent on men for economic support, they are vulnerable. Thus, the doctrine of separate spheres, which prescribes that women be relegated to household production, is not only oppressive to women but is in fact dangerous. One of the natural solutions to women's oppression that arises out of the conflict-feminist analysis is increasing women's labor force participation. This often leaves women vulnerable to the double duty of the second shift (as noted by Hochschild, 1989, and Collins, 1992), but from a conflict-feminist perspective, women will remain subject to oppression by their male partners as long as they remain economically dependent on them.

Finally, it is important to mention that conflict feminism can be used not only to describe gender relations but also to analyze the outcomes of gender relations. Keeping women at home makes them subject to oppression and also benefits men, who are then freed from having to participate in household and family work. Thus, as with all other conflict analyses, the traditional model of gender relations persists because those in power benefit from this arrangement. Furthermore, Collins (1992) argues that this sort of household division of labor exists because it benefits individual men but, even more so, because it benefits the system of patriarchal capitalism at the cultural level. Not only does the family, as described by Collins, mimic the system of patriarchal capitalism that dominates the culture, but it actually reproduces this system of domination. He notes,

> What women's work in the home does for the larger capitalist economy is to reproduce the labor force. All the cooking, cleaning, shopping, child care, and even the emotional affection given to the husbands serve to keep the extra-familial male labor force ready to go to work the next day. Labor is a crucial aspect of the capitalist economy, but the capitalists themselves do not see to its everyday maintenance. This is left to the hidden economy of the household, where women do this essential work of keeping the capitalist system going. (p. 138)

Race, Class, and Gender Model

Amott and Matthaei (1996) outline a model of women's labor force participation that focuses on the intersection of race and class on women's economic behavior. Amott and Matthaei's analysis of labor force participation considers the way in which race, class, and gender interact to result in particular labor force participation patterns. They note that there is no such thing as "women's economic experience." Rather, they suggest

that because of distinct forces associated with race, ethnicity, and social class, we must interpret women's labor force participation within the context of their race, ethnicity, and social class positions.

The race, class, and gender model assumes that most women have worked throughout U.S. history, but the conditions of their work have varied. Nevertheless, their contributions "have been essential to the development and reproduction of the U.S. economy" (Amott & Matthaei, 1996, p. 355). Throughout U.S. history, women have worked in agriculture, in small family businesses, as domestics, and as slaves on southern plantations. Some of this work has been paid and some unpaid, but all of it has contributed to the economic shifts across the centuries. Furthermore, as noted by conflict theorists, "women have given birth to and raised new workers, without financial compensation and with little social recognition" (Amott & Matthaei, 1996, p. 355).

In addition to noting women's contributions to the U.S. economy, Amott and Matthaei (1996) also note race and class differences in women's labor force participation. As labor market scholars observe, many industries and jobs within industries have been segregated by race, ethnicity, and gender. As a result, European immigrants during the colonial period worked mostly in family-owned businesses and farms, whereas later European immigrants, including women, were channeled into factory work. Africans were enslaved and worked primarily in agriculture and domestic work. This labor force pattern continued for African Americans following emancipation. Asians were employed primarily in the construction of the transcontinental railroad, whereas Mexicans were employed in the haciendas of the southwest (Amott & Matthaei, 1996). Therefore, to speak about "women's employment" is to oversimplify a complex phenomenon.

Amott and Matthaei (1996) employ a stratification model to explain women's economic and employment strategies. They argue that the most effective model for interpreting women's labor force behavior must be based on understanding the outcomes of race, ethnicity, gender, and social-class stratification. The picture of women's labor force participation that we see is a direct result of sex, race, and ethnicity segregation in the labor market. Thus, to examine the labor force participation of one subgroup of women requires that we look carefully at the racial and class forces that influence their lives. As noted previously, African American women's employment, for example, must be viewed as a reaction to the employment opportunities faced by African American men.

I would suggest that the structural location of an individual woman directly affects her labor force participation choices, as noted by Amott and Matthaei (1996). However, an indirect effect may be seen as well. I would argue that these indirect effects occur via the pathway of ideology. As noted previously, Hill-Collins's (1994) work suggests that differential

experiences lead to differences in motherhood ideology. Thus, higher rates of labor force participation by African American women are a reaction to their specific material conditions as well as an outcome of a motherhood ideology developed out of their specific collective experiences endorsing the economic role of mothers.

Motherhood Ideology

Economic variables, structural variables, and human capital variables have been investigated most often in understanding and predicting maternal employment, but several scholars have also investigated the role that motherhood ideology plays. Hays (1996) focuses on the "cultural contradictions of motherhood" and the ways in which constructions of motherhood influence the abilities of individual women to balance work and family. Walzer (1998) examines the transition to parenthood among men and women who have recently become parents together. She notes that beliefs about motherhood were frequently mentioned when new parents discussed their emerging roles as parents and employees. The parents she interviewed vary, as the mothers in this study do, in the power that ideology played in their decisions about balancing work and family as well as in their self-evaluations of the arrangements they made, but for many parents, beliefs about appropriate roles for mothers and fathers played a crucial role.

Hays (1996) and Walzer (1998) demonstrate the pervasiveness of the dominant motherhood ideology in men's and women's beliefs about appropriate parenting styles for men and women. Both studies illustrate the impact that motherhood ideology has on the actual process of balancing work and family and on the individual's evaluation of his or her performance in this complex task. In other words, motherhood ideology affects the choices people make about balancing work and family as well as how individuals feel about the outcomes of these choices. These studies document significant gender differences in both parenting styles for men and women and in an individual's beliefs about appropriate roles for mothers and fathers. (Please refer back to Chapter 2 for a lengthy discussion of the content of motherhood ideology.)

Anita Garey's 1995 study of nurses who work the night shift suggests that ideology, or beliefs about appropriate roles for mothers, was significantly related to labor force decisions. Garey (1995, 1999) studied mothers who were employed as nurses during the third shift in a hospital in California. Her interviews with these mothers suggested that, contrary to popular belief, they chose the night shift precisely because it allowed

them to meet the requirements of economic provider as well as the requirements of a "good" mother. In other words, because they were at work while their families slept, they were not missing out on family time. Furthermore, because they were home during the day, they were available to participate in family activities as well as keep up the image that they were stay-at-home mothers. The vast majority of mothers who chose the night shift indicated that their primary reason for satisfaction with this arrangement was the fact that it allowed them to reap the benefits of employment as well as the benefits of stay-at-home motherhood. Garey suggests that these mothers believed that they were, in fact, getting the best of both worlds.

Among the first studies of motherhood ideology and labor force issues was Gerson's (1985) early work that examined the ways in which women made choices about balancing work and family. Her study focused on women who chose to remain childless as well as those who became mothers. Gerson noted that women's decisions to become mothers or not and to stay home or enter the labor force were based primarily on structural factors, such as economic need, noneconomic benefits of employment, and occupational opportunity. Gerson acknowledged the importance of motherhood ideology in labor force participation decisions, but she did not view motherhood ideology as the primary influential factor. Rather, she argued that women "adjust" their ideology to be in alignment with their childbearing and labor force participation choices. For example, Gerson states,

> However powerful the forces that pushed domestically oriented women out of the home, a new emerging nondomestic orientation was sustained in the long run only when these pushes were supported by strong pulls into the workplace . . . a sense of accomplishment, upward movement toward a goal, and significant material and emotional rewards.

I argue that women's motherhood ideology affects their labor force participation decisions rather than arguing, as Gerson does, that motherhood ideology is primarily adjusted to match one's decisions.

Another examination of ideology and motherhood is McMahon's (1995) *Engendering Motherhood*. McMahon examined the ways in which beliefs about motherhood affected women's transition into motherhood. She identified two distinct groups of women. The first group she identified transitioned easily into motherhood. These mothers made a commitment to pursuing motherhood and devoted themselves to it. Many viewed motherhood as a much more fulfilling role than the occupational roles in which they found themselves or that they saw as existing for themselves. McMahon found that a second group of mothers had a more

difficult time transitioning into motherhood. These mothers either were initially less committed to motherhood or found their professional roles personally satisfying and were thus ambivalent about pursuing the role of mother. McMahon's work suggests that ideology affects the ways in which various women transition into the role of mother.

MOTHERHOOD IDEOLOGY AS A VARIABLE

Beliefs about "good" mothering are not limited, however, to the tenets of intensive motherhood ideology. As noted in Chapter 2, black feminist theorists, such as Patricia Hill-Collins, have observed that definitions of good mothering vary. She suggests that the most prevalent form of motherhood ideology among African American women focuses on two key issues: caring for one's children and providing for their economic needs.

Despite these theoretical examinations of the variation in motherhood ideology, it is rarely measured as a variable in empirical studies. When motherhood ideology is mentioned in empirical work, it is treated as a constant that either affects or does not affect labor force participation, child care decisions, or attitudes regarding social issues. Very few attempts have been made to quantify the variation in motherhood ideology. However, this study is based on the premise that motherhood ideology is a variable and that the employment decisions of mothers with young children are influenced not by the presence or absence of motherhood ideology but rather by the form of motherhood ideology with which one identifies. Moreover, this study does not focus on the process by which individual women develop or internalize various forms or contents of motherhood ideology. However, it is strongly recommended that further research focus on the role that social location, socialization, and the relative power of various forms of motherhood ideology play in this process.

GENDER ROLE STRATEGY

A concept related closely to motherhood ideology is gender role strategy. Coined by Hochschild (1989), gender role strategy refers to an individual's beliefs about appropriate roles for men and women in regard to employment, child care, and the division of household labor. Hochschild asserts that a woman's gender role strategy is important in her decisions about balancing work and family. Hochschild identifies three gender role strategies: traditional, transitional, and egalitarian. Traditional gender role strategy is the belief in the doctrine of separate spheres, the belief that men's work is the work of providing economically, whereas women's

work is to take care of the home and the children. Egalitarian gender role strategy is the belief that men and women should share equally in the role of economic provider and the work of the home and family. It is not simply that men should help out at home. Rather, according to Hochschild, it is the belief that the jobs of the husband and the wife are equally important.

Finally, transitional gender role strategy is the belief that women should pursue their professional and occupational goals alongside their husbands and that men should engage in family and home work alongside their wives. However, it is distinct from an egalitarian gender role strategy in that a transitional gender role strategy prescribes that although women can and should pursue employment, their husbands' jobs are more important. Furthermore, even though men can and should take on some responsibilities at home, ultimately, this responsibility belongs to their wives. Hochschild (1989) argues that a woman's gender role strategy figures prominently in her decisions regarding work and family and in her evaluation of and satisfaction with her current arrangements. Although she recognizes that other factors, such as economic need and occupational opportunity, will sometimes override gender role strategy, she argues that couples attempt to reach solutions that are consistent with their gender role strategies. The happiest couples are those who are successful in matching gender role strategies and work-family solutions.

GENDER ROLE STRATEGY VERSUS MOTHERHOOD IDEOLOGY

Several studies have noted a relationship between traditional gender role beliefs and employment status (Glass & Camarigg, 1992; Glass & Riley, 1998; Hochschild, 1989). However, it is important at this point to distinguish between gender role strategy and motherhood ideology, as they may appear to be the same thing. Perhaps the best way to distinguish these two concepts is to examine their degree of overlap. Theoretically and practically, we can see that gender role strategy and motherhood ideology may have overlapping outcomes. However, one may hold a gender role strategy that is inconsistent with the parallel motherhood ideology. To illustrate, a woman who holds a nontraditional motherhood ideology, who believes that she should be employed in order to provide economically for her children and because she finds the pursuit of her professional goals personally fulfilling, may hold an egalitarian gender role strategy. She may believe, for example, that her job is as important as her husband's; thus, they should be willing to relocate for her promotion opportunities as well as for his. She may also believe that they should share equally in the household and family work.

Conversely, a mother who holds a nonconformist motherhood ideology may hold a transitional gender role strategy. She may believe that she should work to meet the economic needs of her family, and she may feel entitled to pursue her occupational and professional goals. Despite this, she may feel that her husband's job is more important than hers. And she may feel that "in exchange for" pursuing her own professional and occupational goals, she should take on the bulk of the responsibility for the home and family work. Therefore, although Hochschild's (1989) work is very useful in thinking about the role that ideology plays in women's labor force decision making, it is important to consider motherhood ideology in addition to gender role strategy.

My Model

In this study, I adopted an inductive rather than a deductive approach to analyzing the data. Based on the literature and my own personal and anecdotal experience, I developed a tentative paradigm for understanding maternal labor force participation. My primary "hypothesis," if you will, was that motherhood ideology mattered in the labor force participation decisions of mothers with young children. And in some cases, I believed it would matter more than any other factor, including economic need.

However, the analytical technique that I employed in this study required that I go to the data first and generate the paradigm for understanding maternal labor force participation based on inductive reasoning. In other words, I examined these data with my primary hypothesis in mind but without many preconceived ideas about what would emerge. Rather, I allowed my theory for explaining maternal labor force participation to emerge from the data. The paradigm that I have found to be most useful for understanding maternal employment combines a number of concepts that are drawn from other theoretical and empirical models but are combined here in a unique manner.

STRUCTURAL-FUNCTIONALISM

Structural-functionalism suggests that as a result of history and social evolution, the natural division of labor within families is based on gender. Because gender roles have evolved in this way, they are believed to be functional—the most efficient manner in which to meet the needs of the family (Parsons & Bales, 1955). Therefore, an examination of maternal

employment through the lens of structural-functionalism will require us to consider the overall efficiency and benefit of various strategies for resolving the job-family conflict. Based on Merton's (1975) typology, we should expect that mothers and their partners will choose strategies for resolving the work-family conflict that result in maximizing the pursuit of desirable cultural goals, caring for one's children and providing for them economically, and minimizing the strain associated with achieving these goals.

RATIONAL CHOICE AND HUMAN CAPITAL

The data I gathered suggest that many, though certainly not all, mothers engage in a cost-benefit analysis of their options for balancing work and family. Half of the mothers I interviewed weighed structural factors such as occupational opportunity, noneconomic benefits associated with employment, and child care cost and availability, and weighed family factors such as spouse's work schedule and the number of children in the family. Additionally, these mothers noted the importance of human capital factors such as educational attainment and work experience in their labor force participation decisions. Therefore, the model I am proposing must include structural and human capital variables.

ECONOMIC NEED

Economic need was clearly an important factor in the labor force participation decisions of many mothers. For some mothers, economic need was simply one more factor considered as part of a cost-benefit analysis. In many cases, however, it was not important, and in others, it was the only important factor. Thus, a rational choice model that simply adds economic need is unsatisfactory in explaining maternal employment patterns. Therefore, I will propose that economic need be included in this model, but its effect can be understood only by interpreting it through the lens of motherhood ideology.

FEMINIST PARADIGMS

There are as many feminist perspectives[1] as there are feminists, but the basic core of these various perspectives is critically important to our understanding of maternal labor force participation. The gender paradigm illuminates two important concepts. First, the sociopolitical structures of any culture produce and reflect actual gender relations in that culture. And second, in most cases, this sociopolitical structure

results in outcomes that benefit men and harm women. Furthermore, the intersection of work and family represents the intersection of two of the most gendered, sex-segregated institutions in U.S. culture, as noted in the following quotes:

- "Differences between husbands and wives in child care responsibility represent a crucial aspect of gender inequality inside and outside the home" (Peterson & Gerson, 1992, p. 529).

- "The relationship between labor and gender is a substantial portion of what family organizes, both in and out of the household" (Ferree, 1990, p. 871).

Peterson and Gerson (1992) and Ferree (1990) observe that work and family are inextricably linked and gendered. Thus, the model that I propose for analyzing maternal employment patterns must include the basic assumption that individual beliefs and actions about weaving work and family must be considered within the larger framework of gender relations. Finally, as noted by Amott and Matthaei (1996), race, ethnicity, and social class stratification create different labor markets with different benefits and opportunity costs. Therefore, in order to predict maternal employment, we must consider the social location of individual mothers.

MOTHERHOOD IDEOLOGY

Many studies discussed in this chapter note the importance of motherhood ideology in maternal employment patterns. In particular, both Hays (1996) and Walzer (1998) report that mothers and fathers make decisions about balancing work and family based on their beliefs about appropriate roles for mothers and fathers. Also, both of these studies demonstrate that individuals evaluate their own performances in balancing work and family using culturally defined and constrained beliefs about motherhood and fatherhood. Coupling this empirical support for the importance of motherhood ideology with my own personal and anecdotal evidence, it is clear that my model for understanding maternal employment patterns must include motherhood ideology. As noted above, I conceptualize motherhood ideology as a variable. Its impact on maternal employment decisions assumes that mothers hold an ideology; the issue is determining whether different forms of motherhood ideology result in different levels of labor force participation.

In addition to utilizing the concept of motherhood ideology as developed by scholars such as Glenn (1994), Hays (1996), Hill-Collins (1994), and Walzer (1998), the motherhood ideology framework that I propose uses Therborn's (1980) work on ideology to understand the power of motherhood ideology in maternal labor force participation decisions.

Synthesis

As with many social phenomena that sociological theory attempts to explain, no single perspective is able to satisfactorily explain all the variations of the phenomena. Without much further testing, I will not claim that the model I am proposing for understanding maternal labor force participation will be applicable in all cases. However, based on the analysis of qualitative and quantitative data that follow, I will argue that this model substantially improves on previous models and increases the precision with which we are able to predict which mothers will seek employment while their children are young and which mothers will chose to stay at home.

I find the theoretical underpinnings and empirical support for many of the perspectives reviewed in this chapter to be compelling, though as noted above, I find that none of them includes all the concepts necessary to explain maternal labor force participation. Each model is left with unexplained cases—a black box, if you will, in the equation for explaining and predicting maternal labor force participation. Therefore, in building my own model, I will draw on all the models presented in this chapter. However, my model is not merely a combination of the concepts and perspectives outlined above; it is not an additive, catchall model. Rather, my model combines the concepts from other models that have received the most support and extends concepts that have remained relatively underdeveloped.

The model that I propose to understand and predict maternal labor force participation includes the following concepts:

- Economic need
- Structural factors: occupational opportunity, child care cost, child care availability, number of children in the family, spouse's schedule
- Human capital factors: educational attainment, work experience
- Motherhood ideology
- Race and ethnicity of mother
- Social class location of mother

As was discussed at length in Chapter 2, Therborn (1980) argues that ideology exists within all cultures. Multiple ideologies may exist and therefore compete for hegemonic position. Among its several purposes, ideology should provide a framework for behavior and uphold the status quo. Motherhood ideology can be examined using Therborn's framework, as was discussed in Chapter 2. This type of application of Therborn's work on ideology results in several important outcomes:

- Intensive motherhood ideology holds hegemonic position, and therefore, all the strategies mothers utilize for establishing standards for behavior are in response to the behavioral expectations of intensive motherhood ideology.

- Intensive motherhood ideology dominates the motherhood ideology landscape because it is beneficial to those in control of political and economic resources.
- Strategies that result in behavior that runs counter to that prescribed by the dominant motherhood ideology may be viewed as deviant by the actor as well as by others and may result in cognitive dissonance for the actor.
- Changes in the dominant motherhood ideology will occur slowly and only when a change benefits those in positions of power and prestige. (This will be examined further in Chapter 8.)

In addition, the model that I propose rests on the assumption that there is more than one process for weighing the relevant factors in maternal employment. Therefore, in order to understand and predict maternal labor force participation, we must consider the factors within the framework of available strategies for weighing these factors. As was noted in Chapter 3, the strategies for weighing the factors can best be understood using Merton's strain theory as a framework. The motherhood ideology framework I am proposing here as a model for understanding maternal employment can be expressed in the following chart.

Strategy	Relevant Factors	Outcomes
Conforming	Motherhood ideology	Stay at home
Nonconforming	Motherhood ideology	Employment/education
Pragmatic	Structural factors Human capital factors Economic need Motherhood ideology	Stay at home or employment part- or full-time
Innovative	Motherhood ideology Beliefs about child care	Employment with no paid child care

This model is built around the basic premise that mothers fall into four distinct groups in terms of the strategies they adopt for dealing with the dominant motherhood ideology. Once mothers have opted for a particular strategy, the importance of various factors emerges. Applying this model for understanding and predicting maternal employment requires that each mother's strategy be determined. Measures of motherhood ideology and other relevant factors may be taken and predictions can be made about labor force participation at the individual level.

In the next chapter, I will examine the actual mechanisms by which the four types of mothers determined their level of labor force participation. The role of motherhood ideology in the decision process in which these mothers engaged as well as the roles of other variables, such as

human capital, child care cost and availability, occupational availability, and economic need, will be examined. For some mothers, motherhood ideology is the single most important predictor of their level of labor force participation. For other mothers motherhood ideology is considered along with a whole host of other factors as these women determine whether they will remain at home or seek employment. I will consider data generated by qualitative interviews. In addition, Chapter 5 will include a brief review of the findings of a survey that tested quantitatively the effect of motherhood ideology and other factors influencing the labor force participation of these mothers with young children.

Summary of Main Points

Several theoretical paradigms have been developed to understand various aspects of maternal employment.

Structural-Functionalism

- Men are suited for instrumental roles.
- Women are suited for expressive roles.

Rational Choice Paradigms—New Home Economic Theory and Human Capital Theory

- Cost-benefit analysis to determine the configuration that maximizes utility for the family unit as a whole; wage potential of mothers is weighed against providing alternative care while she works.
- Cost-benefit analysis centers on mother's human capital.

Sociostructural Perspectives: Focus on several structural factors, including the following:

- Marital status
- Economic need
- Occupational opportunity
- Child care cost
- Child care availability
- Number of children in the home
- Father's employment schedule

Neoclassical Economic Theory

- Most workers work primarily for the economic benefit of doing so.
- Maternal employment is a response to the "economic squeeze."

- Economic need has been identified in the social psychological literature as the most acceptable rationalization for maternal employment.

Feminist Paradigms

- Examines critically the issue of gender inequality that characterizes home and work.
- Focuses on the economic dependency that women choose when they are not employed.
- Raises the issue of false consciousness among stay-at-home mothers.
- Examines the matrix of capitalism and patriarchy that leads to the oppression of women both at home and at work.

Race, Class, and Gender Model

- Examines the matrices of oppression that occur with various configurations of race, class, and gender.
- Makes central the case that beliefs about appropriate roles for mothers vary by one's social location.

Motherhood Ideology

- Identifies motherhood ideology as a central factor in predicting maternal labor force participation.
- Identifies the dominant motherhood ideology as that of intensive mothering.
- Treats motherhood ideology as a constant, a binary; either mothers adhere to motherhood ideology, or they do not.

My Model

- Includes factors from all the previous models, but synthesizes them rather than treating them as additive.
- Conceptualizes motherhood ideology as a variable; all women adhere to some form of motherhood ideology.
- Makes central the concept of motherhood ideology in the model that predicts maternal labor force participation.

Note

1. I acknowledge that there are a variety of feminist perspectives, but for ease of presentation, I will refer to the shared concepts among these various perspectives as *the gender perspective*.

5

To Work or Not to Work?
That Is the Question

One common thread that binds all women to one another and sepa-
rates all men from all women is the ability, theoretically at least, to
bear children. A small proportion of women are not able to carry a preg-
nancy to term, and a slightly higher proportion choose not to have
children. However, the vast majority of women bear children at some
time in their lives. Furthermore, the latest figures indicate that the labor
force is approximately 49% female. Therefore, the balancing and weav-
ing of work and family is an issue that the great majority of women will
confront at some time in their adult lives. As Barnett and Rivers (1996)
point out, balancing and weaving work and family is not exclusively a
"women's issue." Rather, work-family conflict affects virtually all adults.

The relatively recent implementation of the Family Medical Leave Act
extends the option of unpaid leave to new fathers as well as to new moth-
ers. Though very few men participate formally in family leave, many
take informal leaves created through accumulated vacation and sick leave
(Barnett & Rivers, 1996). But men are affected by work-family conflict
indirectly as well as directly. In fact, it is reasonable to assume that the

impact of work-family conflict that many men feel is primarily via the experiences of the mothers of their children. The choices women and their families make to balance work and family affect the lives of all the family members.

Despite the impact that work-family conflict has on men, an increasing number of whom take temporary or permanent leaves from the labor force, most families and employers continue to view solutions to the job-family conflict as actions that women take. Certainly, mothers are far more likely to take on the majority of the responsibility for performing child care or securing it than fathers are (Peterson & Gerson, 1992). However, men will still feel the indirect effects of the job-family conflict regardless of their relative isolation from or involvement in the process of balancing and weaving work and family. For example, when a mother chooses to stay at home raising her children, the father is affected by becoming solely responsible for providing for the economic needs of the family. This study focuses on the choices families make in order to balance work and family. There are many different strategies for balancing and weaving work and family. These include the following:

- Never entering the labor force and staying at home raising children
- Permanently exiting the labor force when the first child is born
- Temporarily exiting the labor force with each birth but reentering the labor force between births
- Taking a leave but never exiting the labor force
- Remaining childless

Many different studies have examined the variety of choices that women have made to balance work and family. What we know from census data is that 67% of mothers with children under the age of 6 are in the labor force at any given time. Approximately 14% of families fit the traditional family model with the father acting as the breadwinner and the mother staying at home full-time raising the children (U.S. Department of Labor, 1997). As noted in the previous chapter, many different theoretical paradigms and empirical studies have identified variables that are related to maternal labor force participation. The set of variables that has received consistent support in the literature includes the following:

- Economic need
- Educational attainment
- Occupational opportunity
- Child care availability
- Child care cost
- Number of children in the home, especially the number under age 6

- Marital status
- Male partner's work schedule

Each variable has been shown to either inhibit or promote maternal labor force participation. In this chapter, we will examine both qualitative interview as well as quantitative survey data in order to understand the importance of these variables on the process by which mothers determine whether to seek employment or remain at home while their children are young.

My reading of the literature on maternal labor force participation, which is outlined in Chapter 4, and my initial observations of mothers were inconsistent. As I noted earlier, the theoretical and empirical literature both rely heavily on economic need and variation in structural variables to explain maternal labor force participation rates. Yet, my casual observations led me to conclude that something else was at work. Therefore, when I first began analyzing the interview data using the constant comparative method (Glaser & Strauss, 1967) and thematic coding techniques (Strauss & Corbin, 1990), I looked first at economic and structural explanations for the variance in labor force participation I observed among the mothers I interviewed. I found that economic need explained part of the variance in maternal labor force participation. However, relying on it alone, I was left unable to distinguish which mothers would engage in part-time or full-time employment and which would choose to stay at home.

Certainly, economic need is important. It is so important that Chapter 6 will be devoted entirely to it. Yet, I will argue in this chapter that economic need and structural factors do not explain the entire picture. In fact, economic need and structural factors did not matter at all in the labor force participation decisions of a third of the mothers. Rather, these mothers relied on motherhood ideology to guide them in adopting strategies for balancing and weaving work and family. For many more mothers, a variety of factors, including motherhood ideology, were important in their labor force participation considerations.

The labor force participation choices women made often resulted in experiences that reinforced or contradicted their beliefs about motherhood. Thus, the behavior of these mothers often caused them to reflect on their reactions to the intensive motherhood ideology. Yet, as the analyses of these stories will show, the labor force participation choices of these mothers were directly affected by their motherhood ideology. In many cases, mothers "had always known" how they would balance work and family. And even in cases in which motherhood ideology was not the only consideration, preexisting beliefs about motherhood were entered into the cost-benefit analysis these mothers performed. Thus, as predicted

by Therborn (1980), ideology provides the set of role directives. Ideology defines what exists, what is good, and what is possible. Within this ideological framework, mothers make employment decisions. As we shall see, as confirmed by both qualitative and quantitative data, motherhood ideology is a strong predictor of maternal labor force participation.

As noted in Chapter 4, measures of motherhood ideology have obviously been absent from the theoretical and empirical models developed to predict the labor force participation of mothers with young children. As a result, in addition to examining the role of a number of variables on maternal labor force participation, this chapter will highlight the impact of motherhood ideology on the process by which mothers with young children seek to balance work and family.

Any model that one proposes for explaining maternal labor force involvement, as noted in Chapter 4, naturally rests on a set of assumptions. Many models of maternal labor force participation begin with the assumption that women will stay at home, if at all possible, while their children are young. Mothers with young children, it is assumed, will seek paid employment only when there is a need for their economic production or when the benefits of employment more than exceed the costs of this employment. The benefit that receives the most attention is the ability to provide income. The assumption of my model, as presented here, is that mothers will attempt to make labor force decisions that are consistent with their beliefs about appropriate roles for mothers. When this is not possible, other factors, such as those outlined previously, will become important in the labor force decision of mothers with young children.

A complex picture emerges from the data gathered to reveal the relative importance of motherhood ideology in maternal labor force participation. Motherhood ideology, or beliefs about motherhood, was important in almost all the cases I studied. However, the importance of motherhood ideology relative to other factors varied depending primarily on the strength with which women held on to an ideological position.

Conformists

As a conformist, Cheryl believed strongly that a mother's place is in the home raising her children. Although Cheryl understood that some mothers must work, she reserved this option for single parents. She believed that any mother who is married should be able to find a way in which to raise her family on the income provided by her husband. She pitied single mothers because she understood that they must work, but she still believed that children raised in single-parent households are disadvantaged

by not having their mothers at home. In addition, Cheryl held a traditional gender role strategy, believing fiercely in the doctrine of separate spheres. As Cheryl's comments will illustrate, there was really no decision process for many conformists. These mothers believed so strongly that they should remain at home full-time that rather than evaluating the costs and benefits to employment versus staying at home, they sought solutions that would allow them to remain at home with their children.

Cheryl felt that staying at home full-time was the arrangement that was ideal for her family. She felt so strongly about providing parental care that they lived on a relatively low income (less than $20,000 per year for a family of soon-to-be five), and she would be willing to live on less. She found it difficult to discuss alternatives her family could take to bring in more money. She was not willing to work outside the home during the hours her husband was at home because she felt it was critical that spouses have time together and that families have time together. She blamed the decline of the American family in part on the fact that families spend too little time together. Interestingly, she felt that she needed to be at home full-time not only to provide parental care but also to provide a less stressful life for her family. Finally, she believed that it was very important that she be at home and her husband be at work because she felt that although some men could be good at taking care of children, they are, in general, less nurturing than women. Men, she argued, have an ego-driven need to be the provider for the family. She felt that it would cause problems in the family if the man could not assume the provider role. Cheryl not only identified with the role prescribed by intensive motherhood ideology, but in addition, she pursued a traditional gender strategy (see Hochschild, 1989). Cheryl wanted to live in a traditional family arrangement.

Cheryl had always known she would stay at home full-time caring for her children. She never attempted to juggle a job and her family responsibilities. And despite leaving a job she really enjoyed, she believed that she belonged at home. When asked about the costs and benefits of staying at home full-time, in particular how they related to her career, she said,

> There is [loss to her career], but I know that if I were there [at a job], I would feel like I was losing out here [at home]. So it's both give and take, and it's something that I know I can do down the road when they're older. We could work together as a family and do it [computer graphics]. So I just see it more in the future.

When I probed Cheryl about the future and the possibility of her returning to the labor force, she indicated that she is unlikely to ever return to the labor market. I wondered how she could seem so sure of this at the young age of 25. She indicated that she had two reasons for never return-

ing to the labor market. First of all, she planned to homeschool her children (two women in the group expressed this desire), and this would keep her at home. She planned to homeschool her children until they earned high school degrees. Second, her fertility intentions were quite open. She had no plans for limiting her fertility; she and Paul would keep on having children until she stopped conceiving. Given Cheryl's open-ended fertility, coupled with her intentions of homeschooling through high school, it appeared she would keep busy for several decades.

Cheryl was unable to see a time in the future when she would need to or be able to return to the paid labor force. In fact, as her earlier comment reveals, she planned to deal with the loss she felt in giving up her career within her family. She would pursue her interest in computer graphics with her children, presumably as part of the homeschooling curriculum. Only two of the conformists anticipated having such large families. However, they all mentioned the desire to remain active in the lives of their children even after their children entered school. For example, they desired to be at home when their children were, both after school as well as during school breaks. Furthermore, they expressed a desire to be room parents and chaperone their children's field trips. Adopting this particular model of the mother role, these women found it hard to imagine how employment, even part-time, could be combined with supervising their children even when they reached school age.

Among other themes, one of the issues that sets the conformists apart from the others is their notion of what they are providing for their children. It became very clear early on that the women I have categorized as conformists felt very strongly and very consistently that one of the most important things they were providing for their children was their own care. It was quite common for these women to comment that they were taking care of their children so that their children would know who mom was. They were concerned that young children who were put in child care would not know the difference between the baby-sitter and mom. It was also common for these women to talk about the whole experience of being at home as providing for the needs of the family. In terms of the various provider roles (Perry-Jenkins & Crouter, 1990), there was very little overlap of roles by gender among the families of conformists in this study. These women preferred a traditional family structure, one in which the man was the sole economic provider and in which they were the sole child care provider. Instead of feeling compelled to take on a coprovider economical role, they preferred a situation in which they provided additional solo child care while their husbands worked extra hours or took additional jobs in order to meet the financial needs of their families.

Many of the conformists considered philosophically the issue of maternal care, discussing issues of relationship building and trust, an often

discussed topic in the literature (both lay and academic) regarding the psychological development of young children. When discussing the importance she attributed to being able to do the menial tasks of child care, such as diaper changing, Cheryl responded with the following:

> Well, when they need something, they kind of look to me to take care of them. It's kind of a relationship-building thing too; they trust me. They know that mommy's going to take care of them when they have messy pants or when they need food. So, they have security built in that. When they are at home, they know mommy's going to take care of it.

Finally, Cheryl believed that one of the most important contributions she made to her family involved reducing stress. Despite the difficult job it is to care for young children—a role Cheryl described as among the most challenging of careers—she felt, when comparing her situation with that of working mothers, that she was providing a less stressful lifestyle for her family by being home full-time. In fact, a structural outcome of the traditional family arrangement, according to Parsons and Bales (1955), is a less stressful home life. Cheryl described this lifestyle as a benefit of her choice to stay at home full-time:

> When I look at other families and they both work full-time and they have kids—when they get home, they're so tired that they're really stressed out having to deal with the kids. And the kids want to be with them, so they get more exhausted. And they don't get any time to themselves and to handle those things. . . . The stress level is incredible. Also finding correct day care and the problems with that, and there are a lot more questions. They definitely have more stress.

All of the conformists indicated that they chose to stay at home because they could provide better care than anyone else for their children. When asked how they felt about paid child care, they said that they distrusted others, felt others would employ different philosophies, and suggested that their child would be lost in the cracks in a group day care situation. And finally, it was common for these women to talk about child care and child rearing as the responsibility of the parents. They were all critical of the choice to be a working mother. They were particularly sympathetic, however, toward the plight of single mothers. They all felt one should work and put children in child care rather than be on welfare. However, they were concerned with the issue of responsibility. For these conformists, responsibility for children was a key component to their definition of the mother role, and thus, taking care of one's children came to be defined as the necessary measure of good and bad motherhood. Cheryl had this to say:

I feel that if you have a child, it's your responsibility to care for them and it's your job to do those diapers and to raise them from the very beginning. I think it's very easy for somebody to take their child to a day care, and they're not doing any of the work, then, all day long. I think it's easy for somebody to, say, pawn their child off on a day care provider where you don't necessarily do it yourself. Because having a baby is the easy part; it's the raising and doing the work that needs to be done that's the hard part. . . . I mean, is a child going to be better off if they have a new bike rather than having you home?

These women felt, without a doubt, that though they were undertaking very difficult and sometimes tedious work, they were engaged in the most important job they could do—that of raising their children.

Cheryl's case illustrates very clearly that the primary influence on her decision to remain at home with her children was intensive motherhood ideology. Cheryl did not consider her family's economic need, the occupational options available to her, the cost or availability of child care, or her husband's work schedule when she decided to remain at home full-time. Rather, from the very beginning, she believed that staying at home was the most appropriate way for her to be a good mother, and thus she acted in a way that was consistent with her motherhood ideology. The case of Cheryl illustrates the power of the dominant ideology embedded in the doctrine of separate spheres. Applying Therborn (1980), the dominant motherhood ideology defines only one option, that of the stay-at-home mother, as existing, as good, and as possible. Cheryl conformed to the dominant motherhood ideology of the contemporary United States, including the belief that in order to be a good mother, one must stay at home full-time even if the family is burdened in other ways by this arrangement. As Cheryl's statements suggest, there is nothing more important that a mother can do for her children than stay at home with them. This is the best and perhaps only possible way that a trusting relationship will build between mother and child, according to intensive motherhood ideology.

Nonconformists

Like Cheryl, Emily had always known how she would balance work and family. Whereas Cheryl established her self-identification on being a mother, Emily identified herself both as a mother and as a professional. She indicated that she gained self-esteem from her career and that she felt her career was important to her sense of self. When I asked her which was more important to her, the financial benefits or her identification

with her career, she indicated that it was clearly her identification with her career.

> I worked really hard and went back to school to get my master's degree. I had wanted it for a long time, and I worked really hard to get it. That was very important to me. I saw it as my identity.

This statement could be construed as suggesting that Emily's continued employment was a result of her educational attainment. However, Emily's statement does not suggest that she remained employed because she held an MBA or because her high level of human capital brought her more returns in the labor market. Rather, her statement suggests that she remained employed because it was part of her identity. In addition, the two other nonconformists were not as well educated as Emily, nor were they any more well educated than many pragmatist mothers. Emily's drive to continue to pursue her career was sustained both by her beliefs about appropriate roles for mothers and by the potency and salience of her professional identity.

So strong is Emily's identity as a professional, career woman that she indicated that the only reason she had considered leaving her job was that her family was relocating. She described herself as a workaholic. And despite indicating that her child was the most important thing in her life, she had experienced difficulty adjusting to the role of mother. She stated that she had to learn to reorganize her life in order to get out of the office by 5:00 or 5:30 each evening, and she still had evening meetings two nights per week.

Despite being as committed to the job as her male colleagues were, she worried about the way she was perceived by others in her office. She and her husband still argued over the amount of time she spent at work. Emily felt pressured by her family to work less and by her colleagues to work more. Furthermore, because of the gendered norms regarding child care as well as gender bias in the workplace, Emily believed that being a working mother is more difficult than being a working father.

> It was something that my husband and I had to work through because one of the things is that I used to be a real workaholic. I very seldom left here before 6 o'clock. Most often at nights it was closer to 7 o'clock because what I found after I had a full day of meetings, it was my time to decompress. . . . My desk used to be cleared off every night before I went home. Almost without fail, it used to be cleared off, and I would feel ready to start the next day. Now when I couldn't do that, it used to cause fights. . . . And John [her husband] and I would oftentimes have conversations. . . . He said to me, "You know, when the baby's born . . . people here work very hard." So that provided me with a lot of discomfort initially. I felt,

how am I going to get my work done? But I manage for the most part. I mean, I've been doing this now for almost a year since I came back. And most often, I do leave at 5, and I get home by 5:30 or a few minutes later. John's still more reliable than I am. Plus the fact that when you're a woman and you're in a position like this, you have all the personal maintenance. I have to get my hair done every 3 weeks. I have to get a manicure every 2 weeks. I've got personal business, my dinner commission meetings. Once a month I have a dinner meeting. . . . We've had some arguments over it. He said, "Well, you know you said you were going to be home, but it's turning out that you're probably gone two nights a week on average, sometimes three." I then cry about the difference between men and women and how it's not fair. And I wish I didn't have to put on makeup and get my hair done. And if life were as simple as it is for men, it would be great.

Emily's statement clearly raises several key points. First, Emily's comments suggest that mothering is no more "natural" than fathering. In fact, Emily had a more difficult time transitioning into the role of mother than her husband had into the role of father. It was Emily's husband, who held a more demanding job, who regularly relieved the nanny in the evening while Emily remained at work. The nonconformists not only reject the dominant motherhood ideology, they also reject the belief that parenting roles are naturally gendered. Emily adopts, essentially, a social constructionist view of gendered parenting roles.

Second, Emily's comments clearly highlight a common problem for working mothers and fathers. Emily felt pressure to keep the same schedule and work the same number of hours she did before Max was born. She also felt the need to keep pace with the hard-working culture of her office. Emily was, after all, in a high-ranking administrative post, and she believed that she had to balance work and family so as not to lose credibility at work.

Finally, Emily's statement speaks loudly about gender differences she perceives in parents' attempts to balance work and family. Mothers and fathers do, in fact, face different challenges when balancing and weaving work and family. Although there is evidence that men who take advantage of the Family Medical Leave Act face repercussions at work (Barnett & Rivers, 1996), these may be even greater for women, especially for women who work in male-dominated settings. Mothers must work harder to be taken seriously at work. Yet, women are "allowed" the option of staying at home. In contrast, fathers may be rewarded for involving themselves in their families but chastised for leaving the workplace for the life of a stay-at-home father.

Very clearly, gender ideology and beliefs about motherhood and fatherhood define distinct roles for mothers and fathers. These definitions influence labor force participation decisions among men and women as

well as determine the criteria against which men and women will be judged both at home and at work. This power not only to define roles but to judge actors illustrates the fact that intensive motherhood ideology is dominant in the discourse and wields the power associated with hegemonic ideologies as noted by Therborn (1980). Furthermore, as noted by Wolf (1991), the cost to women, in both time and money, to attain the beauty necessary to climb the corporate ladder seriously impedes women's progress, whereas it has little effect on men's corporate climb.

Finally, Emily's comments indicate that she was committed to working in order to set an example for her son. Her mother worked off and on while she was growing up, and she felt that she had more respect for her mother as a result.

> My mother worked for a while when we were young. And in some ways, I looked at her differently. I had, I guess, a little more respect for her than I might have otherwise. In fact, then she went through a phase where she didn't work. And I want him to . . . I don't ever want to have a job that is so demanding that I'm on the road and I have late-night meetings, and I have my child saying to me, "Mommy, why don't you spend more time with me?" But I also want him to know that even though he's critically important to us, it's important for us to have our lives too, and that makes us better able to enrich him intellectually, emotionally, financially.

As a nonconformist, Emily rejects the dominant ideological construction of motherhood. She indicated, for example, that she felt that it was "not very important" that a parent be at home full-time with his or her child. It was as if Emily would never consider a situation in which either or both parents were responsible for taking care of their children all day. Furthermore, in contrast to women such as Cheryl, who preferred maternal care if at all possible, Emily felt that it was important to balance the needs of the parent (in this case, her needs) against those of her child. Hochschild (1989) notes that one strategy career women employed to resolve the job-family conflict was to redefine and minimize the needs of their children. These redefinitions related primarily to the child's physical needs, such as simpler meals and fewer baths, but occasionally involved the emotional needs of their children as well. For Emily, the opportunity to pursue her own interests was critical. She did not believe it was necessary for her to provide full-time parental care because her ideology did not dictate this as the means to being a good mother.

> If you're talking about the rest of it [meaning the costs and benefits to her working full-time], I think quality time is far more important with children. I think it's much healthier. . . . I know if I have Max all day, I need a break, and John feels the same way. And we've felt that way ever since he was very young. It doesn't mean that we don't love him or anything else.

> You know you get . . . especially when you've had your own lives for as
> long as we had before we had him . . . you really value that time, and
> children are very demanding. So I would much prefer . . . the positive thing
> to me is the quality time. Some people might say, "Well, the negative thing
> is you don't have as much time, as much quantity with him." That's far
> less important to me. I want to be happy when I'm with him. I want to
> enjoy the new things he's doing.

Emily did not feel that she needed to give up her career and all her personal
time in order to care for her child, as Cheryl did. She did not feel that she
had to rearrange her schedule so that she and her husband could both
work and provide parental care for their child, as some innovators did.
Nor did she feel particularly conflicted about combining her roles as career
woman and mother, as some pragmatists did. In fact, she suggested that
perhaps her success in combining work and family was due to the fact that
she relied on high-quality child care and took time for herself. She viewed
her child care situation as *coordinated care*, as described by Uttal (1996).
Emily viewed her nanny as a partner in providing care for Max.

Applying Therborn's (1980) discussion of ideology to Emily's non-
conformist strategy raises several key issues. First, alternative motherhood
ideology asserts that what exists includes a mother's sense of entitlement
to pursue her own interests while relying on paid child care in order to
do so. So strong was Emily's conviction that the formula for being a
good mother included the continued pursuit of her own interests that she
expanded this directive to include personal and professional interests that
did not produce or directly contribute to the production of a paycheck.
When we discussed her plans for the time after her relocation, her de-
scription of her ideal included the continued employment of a full-time
nanny, which would afford Emily the option to work part-time and pur-
sue her leisure activities as well.

> But in my fantasy, my fantasy would be that I would work maybe 2 or 3
> days a week, that I could golf 1 or 2 days a week for about 5 hours or so,
> and then come home and spend time with Max.

Emily's statement could be read to suggest that nonconformist strategies
are limited to upper-class women who can afford such leisure as ballet
lessons and golf. However, I selected Emily's statement because it sug-
gests that the economic utility of a nonconformist's individual pursuits is
unimportant. Nonconformists believe that they are entitled to pursue
social and leisure activities and that these pursuits make one a better
mother. Thus, "what is good" extends beyond the realm of economic
production.

Based on the information presented in Chapter 3, it is clear that Cheryl
and Emily live very different lives and hold very different beliefs about

appropriate roles for mothers. However, the process by which they, and other mothers like them, determined their level of labor force participation is virtually identical. Like Cheryl, Emily was also very clear about her labor force participation decision. Although Emily contributed a substantial amount of income that was used to enhance the economic well-being of her family, Emily and other nonconformists spoke throughout our conversations together primarily about their beliefs regarding appropriate roles for mothers, about their motherhood ideology. Like the conformists, the nonconformists were not sensitive or reactive to other factors that we typically associate with maternal employment decisions. Emily indicated that she was not employed primarily for economic reasons or because of the occupational opportunities available to her or because she was able to find high-quality, affordable child care. She did not seek employment because of her husband's schedule or because her child had reached some magical age. Rather, Emily sought employment first and only *post facto* developed strategies such as employing a nanny—a coordinated care provider (Uttal, 1996)—in order to raise her child in a manner consistent with her definition of a good mother.

Pragmatists

When examining the situation of the pragmatists, who make up the majority of the sample of mothers I interviewed, it becomes obvious why most other empirical studies of maternal employment have found support for a variety of factors influencing maternal labor force participation choices. Presumably, pragmatists represent the majority of contemporary U.S. mothers. Therefore, their mechanisms for balancing and weaving work and family are more well represented in most samples than those of any other group, and the factors that influence their labor force participation decisions are evidenced in the growing literature on maternal labor force participation.

Pragmatists neither wholeheartedly conform to nor reject the dominant motherhood ideology. Nor are their labor force participation decisions directed entirely by their beliefs about appropriate roles for mothers. Rather, pragmatists relied on their ideology as only one factor in the complex process by which they determined their level of labor force participation. Unlike either the conformists or the nonconformists, most pragmatists viewed their choices as far more complicated, and thus, they weighed a variety of factors as they determined whether to seek employment or to stay at home raising their children. These factors included economic need, occupational opportunity, the availability and affordability of child care, and their spouse's work schedule.

Perhaps the most interesting issue surrounding the labor force partici-
pation of the pragmatists is that the actual labor force participation levels
varied due to changes in the factors. As a result, pragmatists can be found
among the ranks of the employed as well as among those staying at home.
At the individual level, they move in and out of the labor force, change
jobs, and experiment with their child care arrangements more frequently
than any other type of mother. An examination of the situation of Tammy,
a pragmatist, and Cheryl, a conformist, demonstrates the power of a
model that includes motherhood ideology over models based exclusively
on economic need or structural factors. Though both mothers stayed at
home full-time, interpreting their behavior through the lens of mother-
hood ideology improves our understanding. Cheryl's reasons for staying
at home are based entirely on motherhood ideology, whereas Tammy's
are based on the results of pragmatic decision making.

FACTORS INFLUENCING LABOR FORCE DECISIONS

As noted, pragmatists consider a variety of factors in the process of devel-
oping solutions to work-family conflict. Pragmatists are sensitive to
fluctuations in each factor as well as to changes in the salience of each
factor. We will consider the importance of the following factors: economic
need, noneconomic issues, motherhood ideology, structural factors, and
role identification. The case of Tammy illustrates how changes in various
factors and in the relative importance of the various factors in her life
ultimately led to changes in her labor force participation status. Actual
changes in the variables as well as changes in the potency or salience of the
factors emerged frequently as part of the history of employment and child
care each pragmatist gave during the course of her interview.

Economic Need

As discussed in Chapter 3, although Tammy was staying at home full-
time when I interviewed her, she had returned to work immediately after
the birth of her first child. After a relatively short maternity leave, Tammy
went to work part-time. At the time of the birth of their first child, Tammy
and her husband had considered both the costs and benefits of her re-
turning to work versus keeping her at home. There was no clear solution
to the job-family conflict for Tammy's family. Although they considered
a variety of options, Tammy and her husband were feeling the economic
squeeze at the time their first child was born, and they both agreed that it
would be in the best interest of the family for her to return to work.

Tammy did not, however, remain employed. A variety of forces oper-
ated near the end of her first year back at work that caused Tammy to

reevaluate her decision to return to work full-time. These factors included less reliance on Tammy's income, difficulties with her child care provider, virtually no part-time professional occupational options, and her changing feelings about appropriate roles for mothers.

For Bobbi, the issue was not so much whether to combine working and raising children but rather how to combine these two roles. From an economic standpoint, she did not have the option of staying at home full-time. Furthermore, though her family could have lived on half her salary, her job also did not facilitate working part-time. Like Tammy, she had tried working part-time but found she was putting in full-time hours (to get the job done) for part-time pay. Therefore, she soon decided to commit to a full-time work schedule. Bobbi was very clear about the ways in which she perceived the options she had for providing income for her family.

> Theoretically, we could have cut back our lifestyle to the point where we could have lived on his income. But we didn't want to do that in the sense of, you know, where that would mean we would have to live, or the type of debt we would have to acquire, or what we wouldn't be able to offer to our children, as far as that went. We weren't willing to make those sacrifices.

Noneconomic Benefits

It was clear from speaking with Tammy that the economic squeeze had not been the only factor that had contributed to her decision to return to the labor force. When I asked her why she returned to work, where, incidentally, her salary had been increased as had her vacation benefits (which were unlimited and unrestricted), she replied:

> For Neil [her husband], it was the money. For me, it was the job; it was more the job. Because I was getting into it. I was their first employee they ever hired, so I was like the receptionist, and the filer, and the claim payor, and the salesperson . . . I mean I did everything. And then to see this whole thing . . . like you walk in and there are rows of desks and offices and people and typewriters and computers and its like, I can't believe we did this. . . . I just can't walk away from this. I mean, wouldn't it be great to retire from a place like this and walk through here and say I was the first one?

For Bobbi, there was really no question about whether or not to return to the labor market after the birth of her children. However, to suggest that she was working only in order to supply the necessary income for her family is to misunderstand how she felt about her job. Bobbi had this to say about the noneconomic benefits of her job:

> I actually, most of the time, enjoy my job. I like getting out and interacting with other people, and I think that's definitely a benefit, and a lot of my

friendships are coming from work. And I think . . . I don't know this, but from talking to friends and stuff, I suspect that it's a lot harder . . . I think I get a lot of my own self-worth and a lot of my definition from my job, and I think that would be harder to do in a home environment. I don't necessarily know that to be true.

Motherhood Ideology

Though employed full-time, Bobbi did not reject the dominant mother-hood ideology as Emily does. Rather, she adheres to the ideal of the stay-at-home mother. However, as a pragmatist, motherhood ideology is only one of several factors she considered. She chose not to stay at home as Cheryl did because the benefits of her employment outweighed its costs. Bobbi discussed her ideals regarding the provision of parental care. She very clearly felt that had they been able to afford for her to stay at home at least part of the time, she would have wanted to do that. When asked to speculate on what she would do if she could afford to quit her job, she indicated that she would find staying at home full-time rather difficult and would probably work at least part-time.

She and her husband had discussed the option of his staying at home full-time. Bobbi's husband did stay at home full-time for 8 months when they were relocating for Bobbi's job. They were able to arrange for her husband to have a long stretch of time before he started his new job.

He found out that he didn't think he could do that on a full-time basis. . . . I would have been thrilled if he had decided that he wanted to do that . . . because I think there's a real benefit to having parents at home with their children. And if it can't be me, then I would be thrilled that it would have been him.

Bobbi did feel strongly that parental care is important, though she was in no way driven by the ideology of staying at home to the extent that Cheryl and other women were.

Structural Factors

Structural factors such as child care availability and occupational options played a significant role in the labor force participation decisions of prag-matists. For women who choose to be involved in the labor force while they have young children, the most common problematic thread seems to be coordinating the work situation and the child care situation. Child care arrangements played a key role in the labor force participation outcomes of the pragmatists. In many cases, child care either contributed to or sub-stantially relieved the stress experienced by the pragmatists. In the case of

Tammy, the child care arrangements were simply not working out. By the time she quit her job, the second family day care situation was beginning to be stressful, and she was feeling significant pressure at work.

In the case of Bobbi, however, her return to work was stressful not just because it was hard to leave her child, but also because she initially found it very difficult to juggle work and family. She found it overwhelming, for example, to get up and dressed in the morning before work and then wake and dress her child. Seeing no way that her family could make the adjustments to live on her husband's income the way that Tammy's family did, Bobbi elected to employ a nanny who came to her house every morning and cared for the children. This greatly reduced Bobbi's stress because she was able to spend time with her children in the morning without having to worry about getting the chores done. Instead, the nanny arrived and proceeded with the morning routine, dressing the boys, getting their breakfast, and so forth. Whereas Tammy's child care situation created a great deal of stress, Bobbi's child care arrangement contributed significantly to reducing her stress.

Some pragmatists even indicated that there were benefits to child care.

> There's the good of knowing how to interact with other children. If another child takes a toy from him, he doesn't just give it up and cry. He just kind of, "this is mine," and he'll try to keep it for himself for a little while. So he is learning how to interact with other children and holds his own, whereas a child who is home with nobody else around won't learn that much. . . . He benefits from being away from his parents, interacting with other children and other caregivers. I think a child who stays at home always with a parent is not getting a full view of the world. It might be a little difficult when he goes off to school and figures out that the world is a lot bigger than my mom and dad.

THE PART-TIME IDEAL

Many mothers, especially those who are middle and upper middle class, use some babysitting or enroll their children in part-time preschool programs even if they are not employed. This limited use of child care is considered by many in the United States to be appropriate for preschool children (Hayes, Palmer, & Zaslow, 1990; Zigler & Lang, 1991). This particular belief played a role in the desire most pragmatists had to pursue their occupational and professional goals part-time. Part-time employment allowed them to limit their child care use to a level comparable to that of many stay-at-home mothers.

Although both Tammy and Bobbi idealized part-time employment, neither was able to find part-time options within her careers. There were,

however, quite a number of women in the sample who did settle on part-time employment. Interestingly, part-time employment was primarily an option for women doing wage work. The women in my sample who were able to work part-time were employed as a legal secretary, a research assistant, a school-bus driver, a waitress, and a school-lunch worker. An additional two women who held salaried positions were able to cut their hours back from full-time. Despite the fact that neither Tammy nor Bobbi was able to find a balance between work and family that matched their actual ideals, each of them came to be as satisfied with their arrangements as either Cheryl or Emily, who were both able to strike a balance in which their realities and ideals were consistent.

Given the importance of this ideal of part-time employment, however, many employed pragmatists, especially those employed full-time, experienced high levels of role conflict (which manifested itself primarily as feelings of guilt). Tammy, for example, felt overwhelmed by her dual roles. She was experiencing role conflict, which can be characterized as the inability to play multiple roles simultaneously without sacrificing her ability to play each role as well as she would have played it had she only been playing one.

> I was crabby when I was working. I was crabby at work because I knew that I should be doing more here, but I couldn't do any more here. We were eating frozen foods . . . not that we've upgraded our food at all since. All I could focus on was the negative of everything. Everything that I was thinking about was all negative. At work, in my mind, I was always getting up in these meetings and leaving. And when you're being paid on a salary basis . . . comparatively speaking to what these other people at work were making, I was making a lot more than they were, and I was checking out. . . . I felt guilty about everything. I felt guilty about not being with Trey, not being able to do stuff with him. I felt guilty in the night when he would wake up and my first emotion was anger. *Go back to sleep, I have to get up in the morning!*

Because the pragmatists engaged in a cost-benefit analyses in which motherhood ideology was only one component, their behavior was often not consistent with their motherhood ideology. As a result of this inconsistency, most of the pragmatists expressed feelings of guilt. Clearly, those pragmatists who felt the least amount of guilt were those working part-time. In fact, pragmatists employed part-time rarely mentioned feeling guilty. Mothers who were "timing out" or working full-time experienced the highest rates of guilt in the whole interview sample. Despite having an employer who allowed her to set her own hours and have unlimited vacation, Tammy did not feel comfortable about how she was performing her job.

When I asked her about pressure she felt from colleagues in relation to her job performance, she responded, "There was one other woman and she was like older. All the other ones were men whose wives all stayed at home and took care of their kids." Tammy found herself in a system that worked best for employees with stay-at-home wives. This is similar to the story Hochschild (1989) relates regarding her own life. Hochschild aspired to be both the mother chauffeuring the children and the father with the briefcase waiting to be picked up from work. She felt, in many ways, that she was neither.

The strengths of these women's identifications with their career roles were also important. Some women who were employed expressed the following sentiment:

> Well, I thought that I would love to do what my mother did and just raise a pack of kids at home full-time, but then I realized that's not really what matched with me. And then going to school full-time for four years to become a medical technician, I had a career and I couldn't see staying home full-time. So then I had to try and figure out what do I really want to do. (Kerry, a pragmatist who was not profiled)

How do we interpret the fact that some mothers experience guilt and role conflict only when stress is present in the workplace or in the family and others experience these emotions under more typical circumstances? Furthermore, why do some employed mothers drop out of the labor force when they experience role conflict and others do not? As noted by Barnett and Rivers (1996) and Hochschild (1997), not all mothers experience role conflict or guilt about their employment. The answer lies in considering the impact of two factors: economic need and motherhood ideology. Clearly, some mothers who experience role conflict cannot afford to quit working. Single mothers and many mothers in two-parent families find themselves in this situation. However, as we will discuss in Chapter 6, sheer economic pressure probably affects fewer mothers than is popularly believed.

Motherhood ideology has a great deal of influence on the ways in which role conflict is experienced and in the solutions that mothers seek to minimize the conflict. Barnett and Rivers (1996) report that employed mothers are healthier, presumably both physically and emotionally, than previously believed, and the data presented here suggest that guilt and stress are not related to employment status, but rather to the degree to which one is able to find an employment status that is consistent with one's motherhood ideology. Because pragmatists are the most likely to experience slippage between their ideals and realities, they experience more stress and guilt than other mothers in the

sample. In other words, it is not any particular employment status that causes guilt, but rather guilt is a result of experiencing cognitive dissonance.

Cognitive dissonance, a term from social psychology, refers to the experience of having cognitions that are dissonant, or in conflict. Cognitive dissonance theory tells us that when an actor experiences cognitive dissonance, he or she will desire to reduce the dissonance by either changing the cognitions or changing the behavior. Many examples of this are seen among the pragmatists. Because they are particularly sensitive to structural variables, such as employment opportunity and child care availability, as well as to economic need, pragmatists reported many changes in both child care arrangements and employment in response to their fluctuating needs. In addition, cognitive dissonance theory suggests that pragmatists will change their child care arrangements or employment situation or status in an attempt to reduce role conflict and feelings of guilt and cognitive dissonance.

However, as noted by cognitive dissonance theory, the actor may choose to change his or her cognitions in order to achieve cognitive agreement. There was very little evidence in these data that this occurred regularly, although Bobbi's situation illustrates this exception. Bobbi had idealized part-time employment that would allow her to spend more time with her children, but her economic circumstances required that she remain employed full-time. As Bobbi was unable to adjust her material conditions, it seems that she adjusted her cognitions in order to reduce cognitive dissonance. She did not report feeling guilty about being a working mother, nor did she report any significant role conflict. In fact, she had experienced role conflict earlier, but once she hired the nanny, she was able to reduce significantly the level of role conflict that she experienced. These data suggest that mothers will first attempt to deal with cognitive dissonance by changing their situation. When this is not possible or it does not result in a reduction of cognitive dissonance, then mothers will adjust their beliefs about appropriate roles for mothers in such a way as to reduce or eliminate cognitive dissonance.

Innovators

Finally, it is important to examine the ways in which the innovators determined whether to be involved in the labor force or to stay at home full-time. As a group, the innovators, as noted in Chapter 3, varied in their beliefs about what exists and what is good. As a group, however, they differed from all the other mothers I interviewed in their beliefs

about what is possible. Pragmatists perceived a limited range of what is possible based on the cost-benefit analysis of their circumstances. In contrast, innovators perceived a much wider range of possibilities that would allow them to maximize their desires. When pragmatists felt imbalance in their circumstances, they turned to other standard solutions. When innovators felt imbalance, they changed their circumstances in innovative, unique ways.

FACTORS INFLUENCING LABOR FORCE DECISIONS

Economic Need

The women in this chapter differed substantially in their economic need for working. However, economic need played a rather important role in the labor force participation considerations of many of the innovators, such as Jean. I began by asking Jean to discuss her decision to be employed. Jean told me that she worked because her family needed the money and because she had always worked. Jean earned $10,000 to $20,000 per year working full-time and her husband earned $20,000 to $30,000 at his full-time job. A total family income of $30,000 to $50,000 per year, though slightly higher than the median household income in Wisconsin, is only a modest income for a family of eight. Jean's family very clearly depended on her income.

When I visited her at home, it seemed they were barely making ends meet. Of all the homes I visited, hers was among the smallest. Though several women in the sample, such as Cheryl, lived as modestly in rented apartments, Jean's home was the smallest home owned by any of the women I interviewed. This household of eight lived in a three-bedroom home, a tight space for the size of their family. The house was brimming with furniture and toys, as if every available spot were filled with something. Jean indicated that the primary reason she worked was in order to provide income for her family, but she also said that if her husband could support the family, "I'd still like to work so that I'd have some kind of income coming in. I don't want to depend on him."

Haley admitted that she no longer had an economic need to work. However, at the time that Haley became a mother, her family relied on her income as a legal assistant. In fact, at that time she earned more than her husband. Haley, much like Cheryl, believed strongly in the provision of parental care.[1] She said that she had always known she would stay at home full-time once she became a mother.

> I want to be a mom. I grew up knowing that I would graduate from college, I'd get a job, I'd get an apartment, I'd get married, I'd work a little bit, and then I'd stay home with my kids. That is what I have always intended to do. That's my goal in life, and some people may frown upon that and think that I'm a stupid idiot for doing that. Sorry, I think that's important and that's what I want to do.

What separates Haley from women like Cheryl is that she had found a way to combine working and staying at home full-time. Although Haley and Cheryl defined what exists and what is good almost identically, they differed substantially in their beliefs about what is possible. Several years before becoming a mother, Haley approached her boss about telecommuting, or working from her home. He was very open to the idea, and Haley had been telecommuting for 5 years or so. She had two children, and she planned to have two more. Working as a legal assistant, she prepared legal documents and filed legal records. With the aid of a modem, a fax, and voicemail in her employer's office (which was in Washington state), she could work as a legal assistant 15 hours or so per week from her home in the Midwest. Because Haley was the primary care provider for her children, she worked mostly during her children's naps and at times when her husband was home, such as at night and on the weekends. Haley began this work in order to provide necessary income for her family during a relocation. Anticipating the onset of her childbearing, she continued telecommuting to be able to work and be at home full-time. She continued to work not so much out of economic need but rather because it was "too easy."

> I want to keep doing it because it works and it's good money. . . . He's [her husband] making enough money that we'd be OK. Before, I had to. But it's also so easy. . . . Maybe I'll give it up someday, who knows. I think about it sometimes, but then it's like, well, look at how much money I'm making!

Haley and the other innovators were unique in their ability to find creative ways to provide supplemental or necessary income and also function as stay-at-home mothers. The innovators could see a broader range of "what is possible" relative to the other mothers.

The relative importance of economic need as compared with other justifications for working varied among innovators. However, they all indicated, regardless of their reasons for working, that they continued to be employed and foresaw their continued employment in part because it was "so easy." Without the burden of arranging child care or the guilt of utilizing it, being employed and being a good mother was an easy combination.

Motherhood Ideology

Ideology also played a strong role in the choices the innovators made. Innovators identified themselves, unequivocally, as stay-at-home mothers. They believed strongly in providing parental care. Their commitment to providing care for their children was as strong as that of Cheryl. Haley noted:

> It was just something that I had always felt strongly about . . . that if you are going to have a family, you stay home with your kids. . . . And it was something that we had talked about and agreed that no matter where you would have to live, I would stay home. . . . I would be willing to lose the house. I'd be willing not to have a car because we did that. I'd be willing . . . right now, we get all of their clothes at a consignment store. I mean I think you just . . . you make do with what you have. So if it means that you go on a tighter budget, that's what you do. I mean, we're fairly careful with what we do. If it means not taking vacations, and we don't take fancy vacations, you wouldn't go on vacations. To me, I would sacrifice anything to stay home with them.

Many of the innovators can best be described as adhering to an intensive motherhood ideology in terms of what exists and what is good. When we discussed what these women would be willing to sacrifice in order to stay at home with their children, they indicated that they would do anything. However, they were more likely to suggest that they would try additional ways to provide income and parental care rather than tighten their budgets, sell their houses, or live on less, setting them in distinct contrast to women such as Cheryl in their views of what is possible.

There is some variation in the beliefs about motherhood among the innovators. Kate is the primary example of an innovator who did not adhere as rigidly to the intensive model of the stay-at-home mother. Kate indicated that she could not see herself staying at home full-time without being able to pursue her own interests. Although she placed a great deal of value on avoiding paid child care, she did not desire what she perceived to be the lifestyle of a stay-at-home mother.

As a business owner, Kate enjoyed interaction with adults, she had the opportunity to socialize, and she felt intellectually challenged. Furthermore, by continuing to work and owning her own business, Kate had a strong career identity. She enjoyed getting out of the house, although she was seldom away from her daughter. Rather, they got out of the house together. "At one time I wanted to work for money, but I think the first thing would be self-esteem, for sure . . . and social interaction. . . . I always thought it would be neat to say I'm an owner."

Like the other mothers who "stay at home full-time," Kate felt that it was important for her daughter's development that she be raised primarily by her parents. However, unlike women such as Haley, Kate did not see herself exclusively in the role of the stay-at-home mother. Like the pragmatists and nonconformists, Kate worked because she wanted to pursue her career and also because she could not see herself at home full-time.

> I'm working because I like the independence. I think I'm always going to have to work because I don't think I could sit at home. Like I said, I've been taking off a lot in the summer. The 2 days I stay home, I feel guilty. I don't think I'm the type of person to sit home.

Kate was unique among the innovators in her resistance to intensive motherhood ideology in terms of what exists and what is possible.

There is no question that the notion of caring for one's children in one's own home was important to these women. In fact, the desire to provide constant parental care and avoid paid child care was the critical component of the motherhood ideology held by innovators. The commitment these women had to providing maternal care varied. Haley, for example, felt strongly that mothers were the best care providers for their children. Other mothers, such as Jean and Kate, felt that parental care was critical but that father care was defined as "good care" just as was care by mothers. In contrast to the other ideological positions, the beliefs of the innovators provided less direction in terms of how they should behave as mothers than the beliefs of either the conformists or the nonconformists. They also differ from the pragmatists in that they did not determine how to balance work and family using a cost-benefit analysis. Rather, their belief that children should be cared for within the family directed their behavior. Furthermore, the innovators were not constrained, as the pragmatists were, by the standard range of possibilities for combining work and family. Rather, like Merton's group of the same name, these innovators developed unique means for attaining both the cultural goal of accumulating material wealth and the goal of staying home with their children.

Many innovators also defined the role of father as including responsibility for the daily care of his children. As a result, innovators expressed the sentiment that father solo care was in fact good for the father and the children. They came to actually prefer sharing parental roles rather than simply relying on their spouses as the best child care option when they could not provide the care themselves. Jean had this to say about the benefits of father care,

> Well, with Tim [the father] spending mornings with the girls, that has helped them all have a good relationship. A lot of quality time. I see that

when he comes home, they get so excited. . . . And they cried when dad went to work today.

Children in these types of families were given opportunities to be cared for exclusively by their fathers. Although the innovators who chose nonoverlapping shifts utilized the most paternal care, all of the innovators relied on their husbands for some child care. No other families I interviewed provided as many opportunities for paternal care as did these.

Although the innovators did not experience feelings of guilt associated with their situations, many of them experienced stress. Mothers did report experiencing stress that was associated specifically with the process of balancing and weaving work and family in these innovative ways. As was noted in Chapter 3, the mothers who worked from home or took their children to work with them found their clients, partners, and business associates to be very supportive of their arrangements. Stress, of course, did arise when the demands of both mothering and employment were in direct conflict. When this occurred, these mothers had to make choices that sacrificed either their behavioral ideals associated with employment or those associated with mothering. Apparently, this happened infrequently, as it was seldom mentioned. However, many of these mothers recognized that these stresses were likely to increase as their children aged and were less easily entertained.

Innovators who engaged in nonoverlapping shift work did, however, experience high levels of stress associated with this arrangement. As noted in Chapter 3, Jean lived on very little sleep. In addition, she and her husband had very little time together because of their nonoverlapping work schedules. The vast majority of the time, one parent was home while the other was at work or asleep. Because each parent depended on the other for child care while he or she worked or slept, their lives as a family were ruled by the daily schedule. If one parent worked late or spent a few minutes socializing after work, he or she might impede the other's ability to get to work or to sleep on time. Living this kind of hyper-scheduled existence was associated with stress that was experienced by both parents in households engaging in nonoverlapping shift work.

Innovators engaged in nonoverlapping shift work also experienced stress that resulted from the fact that they, and their partners, engaged in a great deal of solo child care. When mothers like Jean were not at work, they were often at home taking on all the child care responsibilities while their partners were at work. As a result, they and their partners regularly pulled double shifts, working one shift at their place of employment, followed or preceded by a shift at home. As a result of this situation, many mothers engaged in nonoverlapping shift work indicated that they

sometimes felt like single parents because they often engaged in and took on the responsibilities of parenting alone. (I explore this issue of solo child care among nonoverlapping shift workers in greater depth in an article that is forthcoming in *Families in Society*.)

Summary of Qualitative Data

This chapter has focused on the process by which mothers with young children along with their families determine the degree to which they will participate in the labor force while their children are young. Most of the empirical research on maternal labor force participation has focused on employment status differences among mothers. However, these data suggest that what differentiates mothers from one another is not their employment status but their beliefs about appropriate roles for mothers, their motherhood ideology. Beliefs range from conforming to intensive motherhood ideology to rejecting this model and adopting an alternative motherhood ideology. The largest group of mothers, the pragmatists, neither conforms to nor rejects intensive motherhood ideology completely. Pragmatists engage in cost-benefit analyses in which they consider economic need, child care availability, occupational options, and their beliefs about motherhood in their labor force participation decisions. Their sensitivity to this potpourri of changing factors is often characterized by instability in labor force participation. Finally, innovators are mothers who share a common distrust and unwillingness to rely on paid child care providers but who feel entitled to pursue their own interests as long as they can do so and still provide parental care for their children.

In Chapter 4, I outlined the current models that seek to explain variation in maternal labor force participation. I argued in Chapter 4 that all the current models ignore the role of motherhood ideology in predicting maternal labor force participation despite a theoretical literature that identifies variation in motherhood ideology. This theoretical literature points out that differences in beliefs about motherhood are related to the range of acceptable roles for mothers within various communities. For example, Hill-Collins (1994), Romero (1992), and others note that motherhood ideology that endorses maternal labor force participation is more widely accepted in communities that have historically had higher rates of female labor force participation. Thus, I proposed in Chapter 4 that motherhood ideology be added to existing models that include structural variables and economic need in an attempt to better explain maternal labor force participation rates.

The data in this chapter have shown, unequivocally, that motherhood ideology is important to the process by which mothers with young children determine their level of labor force participation. For two groups of mothers, conformists and nonconformists, motherhood ideology is the primary factor that predicts their involvement in the labor force.

Therefore, these findings suggest that in order to better predict maternal labor force participation, models should include economic need, the structural variables that others have identified, and measures of motherhood ideology. In the same way that Merton's (1975) typology explains strategies for attaining cultural goals, the typology presented here identifies four distinct strategies mothers utilize for attaining two cultural goals that are often in direct conflict: earning income and caring for one's children. Therefore, in the same way that Merton's typology can be used to predict deviance, this typology can be used to more accurately predict maternal labor force participation.

These qualitative data were gathered as part of a larger study that also included a survey. Next, I would like to review the results of quantitative analyses that examine the role of motherhood ideology in the model used to predict the labor force participation of mothers with young children.

Quantitative Data

One of the most interesting aspects of working on this project has been to compare the findings of the qualitative interview data with the quantitative survey data. Methodologists, and feminist methodologists in particular, suggest that knowledge is advanced when researchers triangulate methods. This study was designed to do just that, to rely on different methods and different measures in order to advance our understanding of motherhood ideology and the role it plays in the labor force participation decisions of mothers with young children. As one would expect, the qualitative interview data are rich. The quotes that have been presented in this chapter and the previous chapters allow us a look inside the lives of the 30 mothers with whom I conducted interviews. Nothing is perhaps more powerful in understanding a mother's beliefs than a statement such as, "Is it better that your child has a new bike rather than having you at home?"

However, as rich and detailed as is qualitative data, its weakness, from a research perspective, is its limited generalizability. It is hard to know how representative any mother is of mothers more generally. Nor can we speculate from interview data about the distribution of the various types of mothers in the U.S. population. This weakness of qualitative data can

be addressed, however, by examining the quantitative data that is generated using survey methodology. Furthermore, one purpose of the survey was the development of a scale to measure motherhood ideology. A variety of statistical techniques were employed to distill an eight-item scale from the 20 or so measures of motherhood ideology that were developed for and included in the survey. In order to avoid undue burden to the reader, I have put the specific details of both the sampling and measurement of the survey in Appendix D. Please refer to Appendix D for a complete discussion of the quantitative methodology utilized for this project.

RELATIONSHIP BETWEEN MOTHERHOOD IDEOLOGY AND
MATERNAL LABOR FORCE PARTICIPATION

My hypothesis from the beginning of this project was that motherhood ideology would predict maternal labor force participation. The quantitative analyses performed as part of this study attempted to test empirically the model that I developed based on the qualitative analysis. Analysis of variance, which is used to examine mean differences among various groups, was used to test the relationship between motherhood ideology and labor force participation. Results from this analysis showed that, indeed, employed mothers are more likely to reject intensive motherhood ideology than their stay-at-home counterparts. Chi-square analysis confirmed the relationship that was demonstrated by the qualitative data. Mothers who hold the most intensive motherhood ideology are all staying at home, whereas those who adhere to alternative motherhood ideology are all employed. Obviously, this was expected. Those mothers whose motherhood ideology scores fell in the middle of the range are as likely at the time of the survey to be employed as to be staying at home. Again, this confirms the analyses in the qualitative portion of the study that focused on the pragmatists. Given this interesting finding regarding the pragmatists, future researchers would be wise to examine more closely the employment trends among pragmatists. I would predict that among all mothers, pragmatists would experience the most changes in labor force participation status. (The results of both the ANOVA and chi-square analysis are presented in Appendix E.)

Clearly, I was interested in examining the role that motherhood ideology played, relative to other factors, in predicting the labor force participation of mothers with young children. Regression analysis is a statistical technique that allows the researcher to examine the effect of a series of independent variables on a dependent variable. Regression analysis predicts change in the dependent variable based on change in the independent variables. This analysis technique allows for the simultaneous testing of a

series of independent variables such that one can see which variables explain more of the change, or variance, in the dependent variable. Using the literature on maternal labor force participation and the findings from the qualitative analysis to guide me, I used regression analysis to test the effect of a series of independent variables on the dependent variable *number of hours engaged in paid employment.* The independent variables entered into the regression equation included availability of affordable child care, availability of high-quality child care, educational attainment of the mother, number of children in the family, mother's occupation, spouse's income, and motherhood ideology.

First, I tested the typical model, which relies on structural and human capital variables to explain maternal labor force participation. (See Chapter 4 for a discussion of the theoretical models that are posited in the literature.) The first regression model included availability of affordable child care, availability of high-quality child care, educational attainment of the mother, number of children in the family, mother's occupation, and spouse's income, which represents economic need. In the first regression model, availability of high-quality child care, educational attainment of the mother, mother's occupation, and spouse's income were significant, with the latter two variables contributing the most to explaining the variance in the number of hours mothers were engaged in paid employment. Next, I added the scale measure of motherhood ideology to the model. This resulted in the two human capital variables, educational attainment of the mother and mother's occupation, losing significance, whereas availability of high-quality child care and spouse's income remained significant. Motherhood ideology explained the greatest proportion of the variance in the hours mothers spend in paid employment.

In addition, the model that included this measure of motherhood ideology was better able to predict changes in maternal labor force participation as measured by the adjusted r-square. The first model, which included the structural and human capital variables, reinforced the picture painted in the literature, showing the importance of the same factors others have identified. However, when motherhood ideology was added to the model, something that other empirical research had not done, the importance of several of the structural and human capital variables declined and the model was dominated by the impact of motherhood ideology. In addition, the overall power of the model improved, explaining more of the overall variance in number of hours employed. This finding further substantiates my argument that models used to predict or understand maternal labor force participation are improved when they include measures of motherhood ideology. Both quantitative and qualitative methods, used in combination, confirm my original hypothesis.

In sum, these regression analyses confirm that motherhood ideology is an important predictor, alongside several structural variables, of maternal labor force participation among mothers with young children. This chapter has relied on both qualitative and quantitative data in order to expose this process.

In addition to motherhood ideology, economic need and child care emerge as the most important factors that impact maternal labor force participation. In the next chapter, we will examine more closely the ways in which economic need is defined and how these definitions are related to motherhood ideology and to labor force participation. In Chapter 7, we will investigate the different child care solutions that various mothers sought.

Summary of Main Findings

- Structural and human capital variables that have previously been identified as important in predicting maternal labor force participation were important in this study.
- For the conformists and nonconformists, almost a third of the mothers interviewed, motherhood ideology was the single most important predictor of labor force participation.
- For the pragmatists, just under half of the mothers interviewed, the decision process was complex and can best be described as a cost-benefit analysis in which a series of variables, including motherhood ideology, were weighed.
- For the innovators, who constitute slightly less than a third of all the mothers interviewed, motherhood ideology was critically important. However, they innovated strategies for weaving work and family rather than feeling constrained by the standard options.
- Quantitative models that predict the labor force participation of mothers with young children are stronger when they include measures of motherhood ideology as well as structural and human capital variables.

Note

1. She was the only innovator who actually expressed a preference for maternal care above paternal care.

6

"Are Children Better Off If They Have New Bikes Rather Than Having You at Home?" Motherhood Ideology and the Construction of Economic Need

The previous chapter illustrated the role that economic need played, relative to other factors, in the labor force participation decisions of mothers with young children. In this chapter, I will explore the process by which mothers with young children and their families assess their level of economic need. The data discussed in this chapter will demonstrate that motherhood ideology is important not only in labor force participation decisions but also in the process of constructing economic need. In fact, both the process and the outcome of constructing economic need differ by the motherhood ideology of the mother.

The Economics of Employment

The majority of people who are employed consider economic gain to be one of the major benefits to their employment. Since the dawn of the Industrial Revolution, which ushered in the doctrine of separate spheres, men's primary responsibility has been as economic provider whereas women's primary responsibility has been as caretaker of the family. Men were enticed to leave home and family and come to work by the lure of economic gain. As our economy shifted to a market-based, currency economy it became essential for families to have money, and men were primarily responsible for providing it. As a result of the gendered nature of the doctrine of separate spheres, women's involvement in paid employment was limited, though single mothers, nonwhite mothers, and lower-class mothers continued to work for pay. As noted in Chapter 4, when mothers were employed, it was assumed to be in response to economic need. This notion is further supported by perception studies with college students that demonstrate that they most often attribute maternal employment to economic need (Etaugh & Study, 1989).

As was discussed in Chapter 5, mothers make labor force decisions for a variety of reasons, only one of which is economic need. However, economic need emerged repeatedly during the interviews as an important factor in labor force participation decisions. Economic need, however, is very difficult to measure and operationalize. Furthermore, though one can identify a minimum level at which economic need exists, it is primarily defined subjectively rather than objectively.

Assessing Economic Need

What is the process by which individuals assess their economic need or desired standard of living? Within a particular culture, we can see averages and patterns that suggest what is necessary to live at the minimum level. For example, in the United States, we have the poverty level, a standard calculated by the federal government. The poverty level is calculated to be the minimum income necessary in order to live. The actual calculation is defined by multiplying by 3 the actual cost of purchasing a minimally nutritional diet as defined by the U.S. Department of Agriculture. Once this line has been established, a family's income is compared to this line in order to determine their eligibility for federal and state

income support programs, such as TANIF, commonly referred to as wel-fare. However, many have shown that setting the poverty level at this rate ignores differences in the cost of living across regions of the United States as well as between rural and urban settings. Furthermore, as Edin and Lein (1997) point out, when actual families attempt or are forced to live at this level, they are unable to provide their families with the basic necessities.

The subjectivity of standard of living goes beyond problems in defin-ing poverty. The concept of relative deprivation suggests that at the individual level, one's assessment of his or her standard of living is in part a function of comparisons with one's reference groups. If one is living at a level that is similar to those across one's reference groups, then one is likely to be satisfied with that standard of living. However, if one is living substantially below others in his or her reference groups, then he or she is likely to feel deprived. Who among us did not grow up hearing "When I was young, we were lucky to have . . ." from our parents as we asked for the latest gadget? We know that indoor plumbing is a luxury in many developing nations, whereas we consider the household without adequate indoor plumbing to represent the poorest of the poor in our culture. There is no question that life in the United States at the begin-ning of the 21st century can be characterized as the age of consumerism and materialism. Members of the United States own and consume a dis-proportionate share of the world's wealth and resources. It is within this culture of consumerism that Eggebeen and Hawkins (1990) and others examine the rise in women's labor force participation.

Women's Labor Force Participation

As was noted in Chapter 1, women have always been employed. Further-more, low-income families and minority families have often been dual-earner households or could even be characterized as households in which the mother was the breadwinner. However, since the 1970s, the rate of women's—and particularly, maternal—labor force participation has risen dramatically, so that women and men are currently about equally represented in the labor force. As Chapter 3 discussed, the primary ex-planation for this rise in the labor force participation rate of mothers with young children has been economic need. Eggebeen and Hawkins (1990) examine the "economic squeeze" that has resulted in the dra-matic rise in dual-earner households over the last two decades and challenge the explanatory power of this paradigm.

In their study of the change in rate of maternal labor force participation, Eggebeen and Hawkins (1990) examined the labor force participation rate of mothers whose husbands earned an adequate income, defined as twice the poverty level, and compared it to mothers whose husbands earned wages that were deemed less than adequate. They found that the maternal labor force participation rate was actually higher in families in which the father earned an adequate wage than in those in which the father earned a lower income. Eggebeen and Hawkins explain this surprising finding by considering the context in which families are constructing economic need and the culturally sanctioned options families have for reaching their economic goals.

What forces were operating in the contemporary United States that would drive women whose husbands were earning an adequate wage into the labor market? Eggebeen and Hawkins (1990) point to two key factors: the rise in women's wages and the rise in expected standard of living in the United States. Reskin and Padavic (1994) consider the rise of women's labor force participation to be attributable to systematic changes in the U.S. economy. They note that the gendered wage gap has been slowly diminishing since 1975. This is a result, maintain Reskin and Padavic, of two factors:

- the rise of women in the labor force
- the systematic decline of men's wages over time.

I will argue that the rise in women's wages (a direct outcome of the rise of women in the labor force), the systematic decline in men's wages, and the rise in expected standard of living all contribute to the process of constructing economic need and the process of weighing costs and benefits of maternal employment.

MORE WOMEN AT "WORK"

The rise in the rate of women and mothers who are employed has changed the landscape of the labor market. The major change, of course, has simply been that at the beginning of the 21st century, the U.S. labor force is populated with a virtually even distribution of men and women. However, as Reskin and Padavic (1994) discuss, the composition of the labor force often masks the segregation that characterizes the U.S. labor market. They note that in 1990, the index of segregation, which represents the percentage of women or men who would have to change jobs in order to achieve integration, was 53. Thus, 53% of women would have to be "relocated" into different jobs in order to achieve an integrated labor force in the United States. One outcome of such extensive

sex segregation in the labor market is the wage gap. Currently, women are earning only 71 cents for every dollar earned by men. However, Reskin and Padavic (1994) note that the increased presence of women in the labor force has resulted in more and more women working in traditionally male occupations. Although the labor force remains highly segregated, the movement of women into these male-dominated fields has resulted in a slow narrowing of the gendered wage gap.

MEN'S WAGES DECLINE

The wage gap is not continuing to narrow, however, simply because of the increase in women's wages. Rather, as discussed by Reskin and Padavic (1994), systematic changes in the U.S. economy have resulted in a decline over time in men's real wages. This decline in men's real wages over time has resulted primarily from the slow shift in the last three decades from a U.S. economy based in manufacturing to one based in service. The manufacturing economy that dominated the 1950s and 1960s provided high-paying, unionized manufacturing jobs. Living in this economy meant that many families could achieve a middle-class lifestyle with only one wage earner. Because men's wages in manufacturing were so high, many families relegated the father to the breadwinner role while the mother stayed at home raising the children. As the manufacturing component of the U.S. economy began to decline, however, jobs were either eliminated or moved overseas.

Over the last 25 years, the U.S. economy has transitioned from being dominated by manufacturing to being dominated by service-based industry. This transition opened up new jobs for women, who have traditionally been denied positions in manufacturing and relegated to service occupations. However, service sector jobs, because they have traditionally been filled by women and because they are seldom unionized, pay lower wages.

This transition to a service-based economy has thus affected the wage gap in two important ways. First, men's real wages have declined as they have been forced to take service-sector jobs to replace the jobs lost in manufacturing. Second, though women's wages have not necessarily increased, women's wages have begun to approach the rate of men's deflated wages (see Reskin & Padavic, 1994, for an extensive discussion of these changes in the U.S. economy).

It is important to examine the effect of this phenomenon on families. Clearly, a decline in men's real wages means that traditional families that rely exclusively on men's wages face economic hardship. As a result, many

two-parent families have begun to depend, as female-headed households always have, on the economic support that women are able to provide. More and more two-parent families can be characterized as dual-earner instead of single-earner households. Second, as the gap narrows between men's and women's wages, the potential impact of women's labor force participation on families' total household incomes increases. Thus, families will consider women's labor force participation more seriously as many families may see their total household incomes increase by 50% to 100% with women's employment.

THE RISING STANDARD OF LIVING

When considering the rise in women's labor force participation and the degree to which this change is attributed to economic need, we must consider the narrowing of the wage gap along with the ever-increasing expected standard of living for U.S. families. Moreover, the rising standard of living that Americans expect must be considered within an historical context.

In the 1950s, most middle-class households had one indoor bathroom and one car. Many middle-class households in the United States purchased their first television set in the 1950s, and most had telephones on a party line they shared with their neighbors. When I was growing up in the 1970s and 1980s, middle-class families in the United States lived in bigger houses that typically had two bathrooms (middle-class families with more than two bathrooms were still unusual). It was more common by the 1970s and 1980s for a family to own more than one car, though many homeowners still had single-car, detached garages. When I ask young, middle-class adults what they expect out of life, the majority report that they expect to be middle class or upper middle class, and they expect to live in the same manner in which they were raised. Most not only hope but expect to own a three- or four-bedroom, multiple-bathroom home, drive late-model vehicles, and take regular family vacations. Not unlike my own personal experience, the standard of living seems on a perpetually rising trajectory.

Returning to Eggebeen and Hawkins' (1990) explanation of their results, it is useful to consider the ways in which expected standard of living and wage potential interact. Eggebeen and Hawkins argue that though some families rely on women's economic contributions in order to provide for the basic needs of the family, the rise in women's labor force participation is driven primarily by the rising expected standard of living and the decline in men's real wages. The only way in which the typical two-parent family in the United States can attain its economic

goals is to move from a single-earner to a dual-earner household. Eggebeen and Hawkins explain,

> The need to provide basic necessities for the family has declined over time as a motive for White married mothers' labor force participation. Over the same time, desires to achieve and maintain a higher standard of living have increased. Couples' choices to enjoy the fruits of a prosperous economic system and the products of a technologically advanced society, and to enjoy them at a younger age, are responsible for this important trend. (p. 56)

The analysis in Chapter 5 identified the various factors, including economic need, that affect women's labor force participation. However, as Eggebeen and Hawkins (1990) note, in many cases economic need is perceptual, not actual, and it is subjectively rather than objectively constructed. The qualitative data generated from the interviews allow us to glimpse the process by which economic need is subjectively constructed. These data thus expand on the initial findings of Eggebeen and Hawkins by focusing not only on the outcomes of various constructions of economic need but also on the actual process of constructing it.

The Actual Construction of Economic Need

As was discussed in Chapter 5, motherhood ideology is a powerful predictor of maternal labor force participation. For many mothers, the impact of motherhood ideology is stronger even than economic need. The focus of this chapter is on the process by which mothers with young children construct their economic need. The examination of the data will show three things:

- Economic need is subjectively rather than objectively constructed.
- Motherhood ideology plays a powerful role in the ways in which economic need is constructed.
- Motherhood ideology plays a critical role in defining possible solutions when the problem of economic need arises.

I will argue that motherhood ideology impacts maternal labor force participation both directly and indirectly. Motherhood ideology directly affects maternal employment by establishing behavioral expectations, as was shown in Chapter 5. Indirectly, motherhood ideology affects maternal employment through economic need. Economic need loses some of its influence on maternal labor force participation when intensive motherhood ideology renders it insignificant. It is this process that will be examined in this chapter.

MOTHER'S STATEMENTS

The most effective way to frame our discussion about the construction of economic need is to examine statements made by the mothers whom I interviewed. I asked Cheryl what she was willing to live without in order to stay at home raising her children. She responded,

> I was willing to give up a house. I was willing to give up a new car. I was willing to give up buying new clothes. We live on a very tight budget. . . . I'm not really materialistic . . . boy, that's a harsh word, but . . . I don't mind that I got my couch at a garage sale. It doesn't bother me. I can't just go to a store and . . . sometimes that can be difficult if you go out with friends and they can go purchase new clothes and things and you can't because you don't have the money. So there are times when it happens. And vacations, we don't really do vacations.

When I asked Haley to discuss the role that economic need played in her labor force participation, she responded in this way:

> We didn't want to have to move again. What we really wanted to do was get into a big house so that we wouldn't have to move in 10 years. So the definite benefit was because I was working, . . . we were able to get into the house because of the money I was making.

This set of statements suggests that there is a difference in the process by which mothers assess their economic need and their strategies for dealing with the economic squeeze when it occurred. I will argue that motherhood ideology is the link to understanding these differences. When these quotes are examined through the lens of various ideologies of motherhood, it appears that in its various forms, motherhood ideology affects the construction of economic need as well as mandates a range of strategies for dealing with economic need when it is present.

These data illustrate the two possible ways in which to construct economic need based on one's beliefs about appropriate roles for mothers.

Dominant Motherhood Ideology/Doctrine of Separate Spheres. Those mothers who adhered or conformed to the dominant motherhood ideology believed that staying at home full-time with one's children was more important than any economic benefit derived from employment. Mothers should engage in activities that are described by the expressive role in order to be good at mothering.

Alternative Motherhood Ideology/Revision of the Doctrine of Separate Spheres. Those who resisted the dominant motherhood ideology or

subscribed to an alternative set of directives regarding appropriate roles for mothers believed that part of being a good mother was providing income for the family.

> Mothers should act in ways that meet the expectations of both the expressive and instrumental roles in order to be good at mothering.

Both the process of constructing economic need and the strategies mothers employed to manage the economic squeeze varied across the four groups of mothers. What follows is a systematic analysis of the variation in process and strategy.

Conformists

In their construction of economic need, the conformists in this sample differ in two main ways from all other mothers.

1. The belief that staying at home full-time is far more important than any economic security gained by working outside the home.
2. Economic need is constructed around the spouse's income rather than around beliefs about what is needed in order to live.

MOTHERHOOD IDEOLOGY: STAYING AT HOME IS THE ONLY WAY TO BE A GOOD MOTHER

Conformists' adherence to intensive motherhood ideology resulted in the belief that in order to be good mothers, they must stay at home raising their children. In addition to financial sacrifices, these mothers were willing to make many other personal sacrifices as well, such as leaving jobs they enjoyed. For many, though not all, the financial sacrifices of these families were substantial. In listening to these mothers speak as well as by meeting with them in their homes and having a chance to survey their living conditions, it became apparent that being at home with their children was worth virtually every financial sacrifice. Cheryl's living situation (described in Chapter 3) reflected her commitment to staying at home full-time. Her home was modest and furnished, according to Cheryl, with items obtained secondhand. All the conformists, regardless of the socioeconomic level at which they lived, indicated that they would not choose to go on welfare, as they conceptualized it, and would work instead of doing so. However, they were willing to, and many did, live on very little in order to stay at home full-time with their children. Cheryl's quote presented at the beginning of this section confirms her dedication to the range of possibilities as defined by intensive motherhood ideology. In

Therborn's (1980) terms, Cheryl adjusted her material conditions in order to remain in line with the set of expectations defined by the hegemonic motherhood ideology.

The power of the dominant motherhood ideology was far greater than simply directing the construction of economic need and labor force participation options. The dominant motherhood ideology also contributed to the conformists' views of mothering in the context of economic need. Motherhood ideology defined clearly what existed, what was good, and what was possible at this intersection of motherhood and economic well-being. Conformists, for example, found it hard to understand why other mothers they knew or speculated about would work simply so that their families could buy houses, buy new cars, take vacations, and so forth. Cheryl's comment speaks so clearly to this issue that it is worth requoting a portion of that which was quoted in Chapter 5:

> I feel that if you have a child, it's your responsibility to care for them and it's your job to do those diapers and to raise them from the very beginning. . . . Because having a baby is the easy part; it's the raising and doing the work that needs to be done that's the hard part. . . . I mean, is a child going to be better off if they have a new bike rather than having you home?

Cheryl's comments clearly indicate that her conception of motherhood centralizes caregiving. Her comments were extremely typical of conformists who believed fiercely that the work of mothering was the day-to-day care of their children. They were reluctant to give up even the less glorious tasks, such as diapering, to another caregiver, as these provide a moment for socialization. Furthermore, Cheryl suggested that by relying on the mother for basic needs, such as diapering, the child is forging a bond of trust with the mother. She believed that to pass even these mundane tasks on to someone else so that she could work to earn money with which to buy more material goods was to sell her child short and to shirk her duty as a mother.

BUDGETING TO LIVE ON ONE INCOME

It is not simply the level at which these women placed their need for income that set them apart from the other mothers I interviewed but rather how this level was established. As McMahon (1995) examines the process of identifying with and accepting motherhood among new mothers, this chapter examines the process of assessing economic need and responding to it. Conformists constructed their economic needs to match the incomes of their spouses. Rather than looking for ways in which to earn more money, they found ways to live on the incomes their spouses could provide.

These women did far more than clip coupons and buy "off brands" at the grocery store. The majority of them used cloth diapers they washed themselves in Laundromats, bought their children's clothing at second-hand stores and garage sales, and found unique ways to save money. For example, Cheryl follows a series of menus set out a month at a time. She does the grocery shopping at the end of each month. On the first Saturday of every month, she devotes the whole day to cooking. She prepares all the entrees for the month, a total of 14 different meals that are rotated twice per month. Then each day of the month, she simply heats up the main dish and prepares fruits and vegetables to accompany the main item. She does this, she says, so that she can buy in bulk, thus saving money each month on items such as meat, pasta, and rice. She also suggests that reducing trips to the grocery store helps to reduce impulse purchases. Finally, planning and cooking meals in advance reduces their desire to eat out.

Clearly, all these strategies—buying at the Goodwill, Cheryl's cooking strategy, and living in modest housing—allowed these families to reduce their economic need and live on the wages of a single earner. I was interested, however, in hearing these mothers discuss other solutions to the economic squeeze. Therefore, I asked the conformists what they would do if they determined that they needed more income in their households. Most were reluctant to address this issue. For the most part, they responded by indicating that they would review their budgets and tighten their belts.

I persisted with this line of questioning, pointing out that perhaps they could not tighten their budgets much more, and I further prompted these mothers by suggesting hypothetical solutions that included returning to the paid labor force. Interestingly, these mothers proposed an alternative to the set of strategies that I suggested. They indicated that they would encourage their spouses to take second jobs rather than go to work themselves. For some of the conformists, especially those with limited human capital, this attitude was partially a recognition of their limited earning potential in the labor market. However, it also reflected their preference for traditional marital arrangements.

Most of the conformists believed strongly that the traditional family form was superior to all other arrangements. For example, Cheryl stated that she believed that many of the problems of the 1990s, such as drug abuse, crime, and homosexuality, were a direct result of the breakdown of the traditional family. Furthermore, though this arrangement limited their families' access to economic resources, it also allowed them to preserve the traditional division of labor. Four of the five conformists discussed the option of their spouses taking on second jobs or overtime hours in order to meet the economic needs of the family while maintain-

ing the mothers' presence at home. Two of the families actually employed this strategy; for example, one of the husbands regularly worked 68 hours per week, roughly 10 hours every day of the week.

Intensive motherhood ideology, which led to this particular process of constructing economic need, exists among mothers in a variety of social-class locations. Several mothers in moderate- and higher-income families expressed the same sentiment as Cheryl. The case of Cheryl, however, illustrates most profoundly the effects of this ideology on children and families. Whereas middle-class conformists certainly sacrificed income by staying at home full-time—living more modestly, in smaller homes, driving older cars—the sacrifices made by lower-income families were extreme. Yet, mothers such as Cheryl willingly made these sacrifices because they believed that staying at home full-time was the most important advantage they could give their children. It was the only possibility they perceived to meet their obligations as good mothers.

Nonconformists, Pragmatists, and Innovators

The construction of economic need for the nonconformists, pragmatists, and innovators was substantially different in two main ways from the conformists' construction:

1. They believed that part of being a good mother was providing income for the family if this would help provide the children a nicer place to live and more enrichment opportunities such as camp and a college education.
2. They constructed their economic need first. Then, they determined if this need could be satisfied by a single wage earner.

MOTHERHOOD IDEOLOGY: PROVIDING FINANCIALLY FOR THE FAMILY IS PART OF BEING A GOOD MOTHER

Because the absolute level of economic need varies so tremendously among the mothers, it is difficult to argue that all those who are employed were providing necessary income for the family. I did, however, speak with each employed mother about the importance that economic need played in her employment decisions. For some of them, economic need was central to their considerations; it was the driving force behind their employment. For others, economic need was secondary. Though they and their families enjoyed the added income that their paychecks provided, they were employed primarily for noneconomic reasons such as simply believing that they were entitled to work outside the home if they

chose to do so. Finally, for many pragmatists, economic need was one of many factors they considered. Pragmatists who stayed at home full-time did so because their spouses' incomes were deemed adequate. Had their spouses' incomes dropped, these stay-at-home mothers would have sought employment. And many did plan to return to the labor force once their children reached school age.

The economic impact of maternal employment varied from one extreme to the other. Bobbi was the main breadwinner in her family, whereas Emily's income contributed a relatively small proportion to her family's total affluence. Most of the interviews with mothers who were employed included a great deal of discussion about the impact that their incomes had on their families. Bobbi provided at least 5 times the income her husband contributed to the family. She clearly identified the effect of her income contributions on the family. Again, revisiting Bobbi's statement first quoted in Chapter 5:

> Theoretically, we could have cut back our lifestyle to the point where we could have lived on his income. But we didn't want to do that in the sense of, you know, where that would mean we would have to live, or the type of debt we would have to acquire, or what we wouldn't be able to offer to our children, as far as that went. We weren't willing to make those sacrifices.

Many of the employed mothers who were not contributing the same proportion toward their total household incomes as Bobbie was nonetheless spoke about the standard of living their families were able to attain because they were employed. Haley, whose quote appeared at the beginning of this discussion, talked about how her income allowed her family to buy the house they wanted.

Economic Need as a Rationalization for Employment

Haley's quote also reflects how mothers rationalize their own employment. As suggested earlier in this chapter, as well as in Chapter 4, economic justifications for maternal employment seem the most palatable to those who are evaluating the employment of mothers with young children. Even the conformists indicated that they could understand the employment of single mothers whom they described as having to work. The previous comments of Bobbi and Haley suggest that, regardless of the percentage these mothers contributed, contributing financially to their households and to their children's welfare was important to them or was part of the way in which they justified their employment.

Although there is a strong correlation between one's motherhood ideology and one's employment status, the two are not inextricably linked.

As noted in Chapter 5, no highly traditional mothers in this sample were employed and no nontraditional mothers stayed at home full-time. However, mothers whose motherhood ideology scores fell in the middle of the range were as likely to be employed as to be staying at home. These mothers came from both middle- and upper-middle-class families. In contrast to the situation of the conformists, whose beliefs about appropriate roles for mothers dictated that they stay at home no matter how poor they were, the pragmatists and innovators saw a broader set of appropriate roles for mothers. Thus, these mothers carefully considered their options to stay at home or enter the workforce. And, though many chose to seek employment, some also chose to stay at home. Interestingly, it was the process by which they constructed economic need, assessing their needs first, that played a major role in their decisions about labor force participation.

"I Can Afford to Stay Home"

Despite living on household incomes that were at least twice that of the low-income stay-at-home mothers, such as Cheryl, all the high-income mothers who chose to stay at home indicated that they had discussions about whether or not to stay in the labor force or stay at home after the birth of the first child. In comparison with the conformists, these pragmatists made the choice to stay at home once they and their spouses had determined that this could be done without a substantial change in lifestyle. When I asked mothers such as Tammy to help define where their standard of living was and what they would do to preserve it, most women answered much as Tammy did:

> We wouldn't ever go to the point of selling the home. We wouldn't do that. I wouldn't sell the farm in order to . . . but as far as if it meant rummage saling for toys and clothes, then yes, in a heartbeat I would do that in order to be able to stay at home.

In fact, as discussed in Chapter 3, Tammy did return to work when her first child was born. After having difficulty with child care, she and her husband discussed the possibility of her staying at home, but after analyzing their budget, they determined that they could not afford to live on only one income.

> Then Eric's financial mind was going again, and I think he got all psyched out about house payments and it was going to be so much more expensive. We lived in a real small, little house in So he said it would probably be better if I did go back to work then, since we were building this house and stuff.

During her first year back at work, however, Tammy had trouble with her child care providers. After struggling with two different providers, Tammy and her husband reassessed their financial situation, coming to the conclusion that they could afford for Tammy to stay at home. But, Tammy reiterated, she would not have chosen to stay at home, even under these conditions, had her spouse's income not provided them the upper-middle-class lifestyle they desired for their boys. Many mothers experienced child care difficulties. As a pragmatist, Tammy engaged in a reevaluation of her situation in response to these difficulties. She indicated that she was willing to make some sacrifices. However, she was not willing to give up her house. Perhaps more important, Tammy's child care hassles were the impetus for the reevaluation that ultimately resulted in her exit from the labor market. Her exit from the labor force was not in response to the dominant motherhood ideology that dictated that mothers find a way to stay at home.

Other stay-at-home pragmatists echoed the same sentiments. Another pragmatist who was staying at home full-time confirmed Tammy's sentiment:

> Just knowing that we had money, and retirement was important, being able to go out and do whatever we wanted to, buy whatever we wanted to buy. When I was pregnant we were still getting two brand-new cars. . . . We sat down at the computer, and we did this budget—not that we follow it—there are months where the credit card gets used. . . . Jeff is very financially good, but there's months where we want that, so we are going to get it. We are not neglecting ourselves or anything; we are still having fun, just staying home more instead of every other weekend at a hotel.

Although the pragmatists were willing to lower their standard of living in order to stay at home, they were not willing to live in poverty to do so. The pragmatists believed that economic stability was an important component of successfully caring for their children.

Clearly in stark contrast to the conformists, mothers who remained employed and others who chose to stay at home considered the long-term economic ramifications of their decisions. Despite living on at least twice what some families such as Cheryl's lived on, these mothers were not willing to live on less. Furthermore, many of them did return to work initially and began staying at home only after they experienced conflict between work and family and thus reassessed the economic needs of their households. Often, these reassessments led to changes that might include dropping out of the labor force temporarily. However, these mothers did not hold an ideology that dictated that they should remain at home regardless of the economic or noneconomic costs of doing so.

"I Work Because We Need the Money"

As stated previously, the economic situations of the mothers in this sample varied tremendously. The spouses in the sample earned between $10,000 and $250,000 per year. Many employed mothers indicated that economic need played a prominent role in their decisions to remain in the labor force even while their children were young. Many expressed feeling the pressure of the economic squeeze. These discussions ranged from simply talking about the desire to get ahead with rising child care costs and saving for a college education to Cheryl's sharing her elaborate cooking system. However, individual families interpreted their material conditions differently. But more important than simple individual differences is the fact that none of the mothers were simply greedy, setting ever higher standards of living for their families. Rather, they believed that the role of mother includes both the expressive, or nurturer, and the instrumental, or provider, functions.

One mother who worked as a medical technician spoke about the standard of living she and her husband believed was necessary and was facilitated by her continued employment. She and her husband each earned $20,001 to $30,000 for an annual household income of $50,001 to $75,000.

> I still think it comes down to income for the most important reason that I work. We pack away a lot of money for the future, for college—I think about that already—and to pay this house off. It will be paid off before this little guy gets into college, so we have money for him to go to college. We are very money driven for the future, not for . . . well, of course like I said, it's nice to know we don't have to count our pennies so closely, but it's also nice to know that we are able to put away for our retirement and his education.

Cheryl's statement that it is better to have a mother at home than a new bike clearly emphasizes the importance of motherhood ideology in the construction of economic need. Conformists often criticized employed mothers whom they perceived as working in order to live in big houses or drive the latest model sport utility vehicles. Furthermore, they believed so strongly that the essence of their roles as good mothers was to stay at home that they gave up material goods many of us would consider necessary. Therefore, they could not justify or understand a mother who was employed for any reason other than to stay off welfare. They pitied single mothers whom they perceived as lacking the option of staying at home. But as is evidenced by Cheryl's remarks, they loathed mothers who were employed just for their own self-actualization or to be middle class. In

contrast, all other mothers believed it was their responsibility to seek employment that would better their child's life chances. These mothers believed it was their duty as a parent to provide the safest, most comfortable, most enriching lifestyle that they could afford.

Nonconformists, pragmatists, and innovators were not thinking about how to live on one income, but rather about whose work was necessary in order to provide a certain standard of living, including nice houses and college savings accounts. In families in which it seemed impossible or impractical to meet these expectations on one income, then both parents remained in the labor force. Furthermore, most of these mothers believed the role of mother encompassed both the entitlement to pursue one's own interests and the responsibility to provide income for the family when this is necessary.

In this chapter, I have argued that conformists construct their economic need, and therefore their own need for employment, very differently from mothers who do not adhere entirely to the dominant motherhood ideology. There were class differences among the groups of mothers, as one would expect between single- and dual-earner households, and differences in the rate of maternal employment among the groups of mothers. What differentiated the conformists from other mothers was the content of their motherhood ideology and the process by which they used this ideology to construct economic need and thus determine their level of labor force participation. Conformists constructed their economic need around the incomes that their spouses were able to earn. Though in some cases this income was quite low, these mothers were not willing to go into the labor market and leave their children in the care of anyone else, including their spouses, in order to contribute toward their total household income. Instead, they adjust their standard of living in such a way as to be able to live on one income.

The nonconformists, pragmatists, and innovators all discussed economic need as well. For some of these mothers, such as Emily, economic need was not their primary motive for working. These mothers would, and did, continue to pursue their careers regardless of the amount of income generated by their spouses. However, they were also quick to point out the contributions that their salaries made to the family. All employed mothers spoke about the economic roles they filled in the family. The prevalence of this type of statement suggests that economic need, however it is defined, remains an important justification for maternal employment.

The majority of pragmatists and innovators I interviewed were sensitive to economic need. For these mothers, the decision to return to employment while their children were young rested in large part on their

assessment of their economic situation. Though the income levels of these women and particularly their spouses varied greatly, their process for constructing economic need was the same. These women and their spouses determined the standard at which they desired to live and then they determined if this standard required one or two incomes. Mothers for whom economic need was the primary factor determining their labor force participation stayed at home part- or full-time if their husbands could provide the necessary income on which to secure their desired standard of living. Others, whose spouses' incomes did not provide the standard of living to which the family aspired, entered the labor force full- or part-time in order to provide necessary income. It is important to note, however, that even when economic need was the primary factor related to maternal labor force participation, other factors, such as occupational options, potential wages, husband's scheduled hours, and the availability of affordable child care also played a role.

Motherhood ideology played a critical role in the labor force decisions as well as in the assessments of economic need for most mothers. Those who were employed believed that they were in fact fulfilling their roles as mothers by providing for the economic needs of the children. The income they generated contributed to their families' ability to obtain better housing, provide enrichment activities, and create college funds for their young children. They believed that their contributions were not only important but also necessary and that if their desired standard of living could not be secured by one income then they should seek employment. In these families, both parents shared instrumental roles. In contrast, conformists believed that in order to fulfill their roles as mothers, they should focus only on the expressive functions of the family. Therefore, they should remain at home raising their children, regardless of the financial strain this put on their husbands' incomes. In many cases, this arrangement required that their husbands work second jobs or overtime hours in order to meet the economic needs of the family.

The next chapter will explore the various ways in which employed mothers chose to provide care for their children while they worked. In addition, the role of fathers in providing child care will be examined.

Summary of Main Findings

This chapter has explored the process of constructing economic need in two-parent families with young children. The data presented here demonstrate clearly that the process of constructing economic need is strongly

related to the beliefs about appropriate roles for mothers. Mothers who adhere strongly to intensive motherhood ideology constructed their economic need around the incomes generated by their spouses. Those who reject all or part of intensive motherhood ideology engaged in an assessment of economic need, based on available income and standard of living, as well as the noneconomic costs and benefits of employment, before considering labor force exit or participation.

In this chapter, I have utilized the depth of qualitative interview data to extend the argument of Eggebeen and Hawkins (1990). Eggebeen and Hawkins' data showed that women's labor force participation rates were higher in families in which the man earned an "adequate" wage than in those in which the man earned a lower income. They suggested that this unexpected phenomenon was a result of the constantly escalating material goals especially characteristic of white, middle-class U.S. families. The data in this chapter confirm two important points. First, economic need is clearly a perception rather than an objective reality for most U.S. families. Second, maternal labor force participation is correlated with the perception of economic need rather than its objective reality.

Qualitative data also allow us insight into the findings of Eggebeen and Hawkins (1990). Not only is economic need perceptual, but also there are two distinct mechanisms for constructing economic need among the mothers whom I interviewed. These processes are strongly related to beliefs about appropriate roles for mothers, or motherhood ideology. Conformists construct economic need in such a way as to eliminate the need for their employment. Nonconformists sought employment for a variety of reasons, including self-fulfillment, and remained employed even when it was clear that their families did not need the money. Yet, even when nonconformists appeared to lack the economic push to work, they were quick to cite the economic benefits of their employment. Thus, they clearly saw the links between their employment and economics. Similarly, pragmatists and innovators constructed their economic need around the standard of living they desired to achieve for their families. Once this standard was established, these families assessed their ability to meet it. If possible, these families achieved their desired goals as single-earner households, for this allowed them to provide parental care for their children. If, however, it was not possible to meet their desired standard-of-living goals on a single income, these families sought dual-earner solutions. Thus, these qualitative analyses offer insight into the mechanisms whereby families establish economic need and strategize to meet their economic goals. And they support the argument in Chapter 5 that motherhood ideology plays an important role in defining appropriate strategies for defining and dealing with one's material conditions.

The following points summarize the process of constructing economic need in two-parent families:

- Economic need is subjectively rather than objectively constructed.
- Motherhood ideology plays a powerful role in the ways in which economic need is constructed.
- Motherhood ideology plays a critical role in defining possible solutions when the problem of economic need arises.

Conformists

- Intensive motherhood ideology mandates that mothers address the nurturing of their children and leave the strategies for generating income to their spouses.
- Economic need is constructed around the spouse's income.
- Intensive motherhood ideology mandates that when economic need arises, the only possible solution is for men to seek additional employment or overtime hours and for families to live on less.

Nonconformists, Innovators, and Pragmatists

- Rejection of all or part of intensive motherhood ideology results in the belief that being a good mother involves attention to both child care and providing for the economic needs of the child.
- Economic need is constructed around the desired standard of living.
- This alternative construction of the role of mother results in a variety of strategies for dealing with the economic squeeze. When the economic squeeze was experienced, these families responded by putting both wage earners into the labor force part- or full-time until economic needs were satisfied.

7

"He's Got to Learn That
the World Is Not Just He Alone":
Solving the Child Care Dilemma

Beliefs about child rearing and child care are contested terrain in contemporary U.S. culture. Legal battles rage all over the United States. Custody cases, such as pro-basketball player Pam McGee's, as well as wrongful death suits, as in the tragic case of Matthew Eappen and the British au pair, hinge on the specific child rearing and child care beliefs that are present in the culture. The individual practices that mothers with young children employ as they attempt to meet the needs of their children are judged against these ideals. When practices run counter to the prevailing ideology, parents run the risk of losing custody of their children or being found responsible for the death or injury of a child that resulted at the hands of a paid child care provider.

Raising children is a very difficult, time-consuming, stress-producing process that is, in the estimation of many Americans, the most important task in which adults engage. The responsibility of raising children is cultural specific but also culturally mandated by ideologies of motherhood,

fatherhood, and parenting. Ideologies of motherhood and of child rearing define what exists, what is good, and what is possible as the set of strategies for caring for one's children. In this chapter, I will summarize the existing literature on child care and review the ideologies of child rearing that were introduced in Chapter 2. I will demonstrate that ideologies of child rearing infiltrate or are incorporated into ideologies of motherhood. Thus, these beliefs about child rearing and motherhood combine to define child rearing strategies for the four types of mothers. Child care choices, like employment decisions, are influenced by a variety of factors, including the limits imposed by various ideologies.

Since the mid-1970s, when it became more common, especially within white, middle-class America, for mothers to be in the labor force while their children were still young, researchers have tried to understand various issues related to child care. Many studies have asked about the types of child care that are utilized by families (e.g., Hertz & Ferguson, 1996; Leibowitz, Waite, & Witsberger, 1988; Lueck, Orr, & O'Connell, 1982; O'Connell & Rogers, 1983; Presser, 1986, 1988). Others have focused on issues such as predictors of child care ideals (Mason & Kuhlthau, 1989); child care costs and maternal employment (Brayfield, 1995); responsibility for securing child care (Hochschild, 1989; Leslie, Anderson, & Branson, 1991); child care patterns (Folk & Yi, 1994); shift work and child care (Garey, 1995, 1998; Presser, 1986, 1988); and meanings of child care (Garey, 1995; Hertz & Ferguson, 1996; Uttal, 1996).

As previously mentioned, many studies have examined the types of child care that families utilize. Zigler & Lang (1991) provide an extensive discussion of types of child care and the pros and cons, as they define them, of each type. They note that "affordability, location, suitability for the age of the child, and hours of operation are all considered. . . . Within these restrictions, they [parents] might be able to choose what form of child care they prefer" (p.13). This suggests that child care choices are mitigated initially by structural variables and only later by preference.

Several qualitative studies of child care choices speak more precisely to the ways in which personal preferences are related to child care choices. Garey (1995, 1999) analyzes the child care strategies of nightshift nurses. She notes that this choice, working the night shift, is driven in large part by the nurses' ideals regarding child care, specifically their desire for parental care. By working the night shift, they are able to be home for their children during the day and thus reduce or eliminate their reliance on nonparental child care. Uttal (1996) explores the meanings of child care in interviews with employed women. She notes that child care can be seen as falling into three main categories: custodial care, surrogate care, or coordinated care. Custodial care is defined as

care that is supplemental in nature. The mother retains the role of primary socializer but depends on another person to provide care while she is working. Surrogate care is defined as care in which the child's relationship with the care provider closely resembles that between the child and the mother. Finally, coordinated care is defined as care that is shared with another person. The mothers acknowledge that they are still the primary socializers but that the care provider-child relationship resembles the child-parent relationship.

Hertz and Ferguson (1996) examine child care choices among dual-earner couples. They note that all couples prioritize work or family as they develop their primary orientation. They then manipulate work and child care in order to achieve the desired balance. Garey (1999) rejects this notion of an orientation toward work or family as binary and oppositional. Rather than viewing these spheres of life as in conflict or mutually exclusive, Garey proposes a model that focuses on the ways in which these spheres are interconnected. She argues that all families must focus on both employment and child rearing. Individuals and couples develop strategies that allow them to weave these tasks together without making either work or family more important than the other. In this chapter, I will examine the role of ideology in defining "appropriate" solutions to the child care dilemma as well as illuminating various strategies for weaving work and family.

Conformists

As noted in Chapter 2, intensive motherhood ideology not only dictated beliefs about roles for mothers but also established the notion that staying at home raising one's children was essential for the children. Intensive motherhood ideology defined care by the mother as the only option that existed for good mothering and good child rearing. Chapter 5 delineated Cheryl's belief that mothers and their children will bond only when they are in contact with one another on a constant, uninterrupted basis. She feared for children who were cared for by people other than their mothers, suggesting that these children and their mothers would not establish close bonds. She even went so far as to suggest that a young child might not be sure which adult is the mother and which is the child care provider. Finally, she felt that children would only learn to trust and depend on others by having their needs met in a consistent manner by the same person.

Noted child development specialists such as T. Berry Brazelton (1992) and Penelope Leach (1994) indicate that children develop trust by hav-

ing their needs met in a consistent manner and by living in an environment that is stable and routinized. The question is whether the environment needs to include only one caregiver or whether a child can develop into a healthy adult in a stable situation that includes several different care providers.

For Cheryl and other conformists, intensive motherhood ideology also defined very specifically the role mothers play as teachers of their children. Cheryl and her husband both believed that parents are their children's first teachers. Indeed, most parents feel charged with the responsibility for imparting knowledge and moral instruction to their children. Recognizing that when children are cared for by others, they are likely to be influenced in a variety of ways, Cheryl and Paul believed that this could result in cognitive dissonance for children. They believed that the only way to ensure that children are taught the principles that their parents endorse is for children to be socialized by their parents. Second, the only way to ensure that the child will receive consistent, rather than contradictory, lessons in the way to live is to restrict the responsibility of socialization to the parents. In other words, children must be socialized by their parents, and only their parents. All the parents with whom I spoke, as well as all the parents I know, agree with the first principle. Most all parents believe that in order to socialize a child in accordance with one's own morals, the parent must take an active role in the socialization process. Where differences in child-rearing beliefs arise is with regard to the role that others play in socializing children.

Beliefs about the appropriateness of others in socializing children vary tremendously. I will explore in more depth the beliefs of the pragmatists, nonconformists, and innovators, but simply put, most mothers believed that children benefit from some experience with other care providers. How long or how often children should be in the care of others varied. But all these mothers agreed that children should spend some time in the care of others. Conformists, on the other hand, believed so strongly that children need to be socialized exclusively by them that all these mothers stated that even other family members, real or hypothetical, were not adequate "substitute" care providers. Several of the mothers stated specifically that fathers were not adequate substitutes, either. In Uttal's (1996) terminology, conformists worry that child care that is custodial will not adequately meet the needs of the child. In situations of surrogate care, conformists worry about the child confusing the child care provider with the mother. Finally, though many nonconformists and pragmatists define their child care strategies as coordinated care, conformists reject the notion that child care can resemble a truly shared endeavor among providers.

HOMESCHOOLING

As noted in Chapter 3, two of the five traditional mothers planned to homeschool their children. In fact, Cheryl and one other mother had already begun researching the homeschooling movement in the local area, and both had already invested in some curriculum aids. Initially, I had not included any questions regarding homeschooling in the interview schedule. I was unfamiliar with the homeschooling movement, and it did not occur to me that parents of 18-month-old children would be making plans for schooling. When the issue arose for the first time, I asked several questions and was actually shown some materials that a conformist was using with her older child. When the homeschooling issue arose the second time, this time with Cheryl, I decided that this issue needed further investigation, and Cheryl and I had quite a lengthy discussion.

The homeschooling movement is one that is growing around the United States. Many states have homeschooling conventions; parents can purchase prepackaged curricula; and in the community in which I was conducting interviews, there is an extensive network of homeschooling families. In this community, families chose homeschooling primarily for two reasons. First, some parents feel that the school system is not academically rigorous enough for their children. These parents believe that they are able to offer instruction that is significantly more rigorous and consistent with the abilities of their children. Second, some parents believe that the school system will socialize their children in morally dangerous ways. Both of the conformists with whom I spoke were attracted to homeschooling for the latter reason.

Cheryl noted that she was concerned about the moral issues that would be ignored in the school setting. She also worried that in the school setting, her children would be exposed to ideas and beliefs that contradicted her own. Specifically, she mentioned sexuality issues such as homosexuality, premarital sex, and birth control. Neither of the conformists who were pursuing homeschooling had completed college—in fact, one of these mothers had not attended college—nor did they ever mention issues of academic rigor. Thus, it was clear that their attraction to homeschooling was based in their beliefs about appropriate roles for themselves and others in child socialization. Finally, though both women were affiliated with religious groups that had grade schools in this community, neither considered this a viable educational option. For these conformists, the issue was not simply that they control the messages that their children received. They believed that it was their sole responsibility to socialize their children into adulthood.

These data suggest that conformists adhere to the entire set of principles associated with the ideology of intensive mothering. This ideology defines good mothering around the principle that children will thrive when and only when all the caretaking, nurturing, and responsibilities associated with them are assigned to their mother. The only way in which intensive mothering can be achieved is by mothers devoting themselves exclusively to the care of their children. Intensive motherhood ideology eliminates maternal employment and alternative caregiving as viable options for mothers.

Innovators

The innovators also held very clear beliefs about child care. Some of the innovators, such as Haley, adhered closely to the ideology of intensive mothering. She agreed with Cheryl that children should be socialized exclusively by their parents. Not all the innovators shared this belief. However, all the innovators did believe it was important to have an active role in raising one's children. The innovators strongly believed that children ought to be cared for primarily by family members, but this care need not be provided exclusively by mothers. Innovators were more secure in the belief, at least hypothetically, that there were other people, certainly within one's family, with whom they had common moral beliefs. Grandparents, nieces, and aunts could be important care providers for young children. In addition, unlike Cheryl, all the innovators believed that fathers bear a responsibility for shared caregiving. However, like the conformists, the innovators had a profound distrust of paid child care.

MATERNAL VERSUS PARENTAL CARE

There is no question that the notion of caring for one's children in one's own home was important to the innovators. However, the commitment these women had to providing maternal care varied. Haley, for example, felt strongly that mothers were the best care providers for their children. Other mothers, such as Jean and Kate, felt that parental care was critical but that fathers could be good care providers just as mothers could be.

Furthermore, the women whose spouses shared parenting responsibilities frequently stated that father solo care was in fact good for the father and the children. They came to prefer sharing parental roles rather than simply relying on their spouses as the best child care option. Lori, a mother of twins who works a nonoverlapping shift, expressed the sentiment this way,

> Well, with Jim [the father] spending mornings with the girls, that has helped
> them all have a good relationship. A lot of quality time. I see that when he
> comes home, they get so excited. . . . And they cried when dad went to
> work today.

Children in these types of families were given opportunities to be cared
for exclusively by their fathers. And although the women who worked
nonoverlapping shifts utilized the most paternal care, all the innovators
made work-family arrangements that required both parents to take an
active role in child rearing. No other families I interviewed provided as
many opportunities for paternal care as did these.

These data suggest that innovators accept a modified form of the ide-
ology of intensive mothering. Innovators, for the most part, believe that
children should be cared for primarily by their parents, but it is not nec-
essary that this care be provided by the innovator herself. Innovators
construct the range of possible strategies for providing good care for
their children as including all possible combinations of mother and fa-
ther care. This innovative approach to providing care for one's children
was unique to the innovators. It is interesting that among all the moth-
ers, only the innovators sought approaches to solving the child care
dilemma that included the child's father in the process. All the other
mothers, including those who rejected the ideology of intensive mother-
hood, did not identify fathers as partners in the care of their children.

CREATING OR TAKING ADVANTAGE OF PREEXISTING PATTERNS
TO WEAVE WORK AND FAMILY?

When analyzing these data, it is sometimes difficult to determine when
the innovators designed employment that was consistent with their ide-
ology and when they simply took advantage of conditions that existed
prior to their childbearing. Clearly, there were instances of both. Jean's
situation—she engaged in nonoverlapping shift work—suggests that her
employment patterns lent themselves to the provision of parental care.
Primarily, she was taking advantage of a situation that existed before her
children were born. Her family had long been one in which the parents
had worked opposite shifts. In contrast, Lori, who also engaged in
nonoverlapping shift work, discussed the process of selecting her em-
ployment pattern in order to maximize her beliefs about child care.

> We had many, many years to talk about when we had kids. And we had
> decided we would do some kind of combo. After I had the girls, I was off
> for 3½ months, and I went back part-time. That was ideal. . . . I can't do
> that with the job I have now . . . so I worked out a flextime schedule where

I work 10 hours a day 4 days a week. That was the next best thing to working part-time. That way, I get late afternoons with my girls. And because Jim [her husband] is home with them in the morning, he gets to see them. Otherwise, he'd only see them on the weekends. And he just didn't want that.

Many innovators were able to continue with an employment pattern that they had developed before their children were born. As was noted in Chapter 3, Haley had intentionally begun telecommuting even before she became pregnant in order to create a situation she would be comfortable continuing once she became a mother. Others, such as Kate, looked for ways to change their employment patterns so as to be able to continue working while still caring for their children. For women such as Kate, then, it seems as if their notions of motherhood preceded their child care choices. These women created situations that matched their ideological positions.

WHICH COMES FIRST, BELIEFS OR BEHAVIORS?

Empirical work suggests that cost, quality, hours of availability, distance from home and work, and a personal reference are strongly correlated with child care choices (Brayfield, 1995). Very few studies have attempted to determine whether parents adjust their ideology to justify their child care situation or whether parents choose child care that matches their ideology. There is little empirical data to suggest that parents rationalize their use of child care; rather, it seems that most often women's ideological positions precede child care choices (Mason & Kuhlthau, 1989). As was the case in Garey's (1995, 1999) work with nurses working the night shift, the data presented here strongly suggest that mothers attempt to arrange child care that is compatible with their motherhood ideology. In the vast majority of cases, these mothers had selected child care with which they felt comfortable, whether they stayed at home or paid someone else to care for their children. Seldom did it seem that a mother had adjusted her ideology to match or justify her child care situation.

However, in the same way that one's experiences in childhood and early adulthood contribute to the development of one's motherhood ideology, a mother's experiences as a mother also influences her motherhood ideology. Conformists who spend time around other conformists found their motherhood ideology reinforced. Similarly, employed mothers received support for their continued employment from their coworkers and from other working mothers. Those mothers who had experiences with specific child care providers were likely to develop more positive

assessments of these child care providers than those who had little or no contact with specific child care providers. Those with limited experience with paid child care providers indicated that they acquired most of their knowledge about various care providers from the media or other second-hand sources. The relationship between motherhood ideology and child care preference is complex. As with many social phenomena, it is difficult to determine the ordering of beliefs and behavior. However, these data suggest that for conformists, nonconformists, and innovators, all of whom hold fiercely to specific beliefs about appropriate roles for mothers, behavior is a direct outcome of ideology. In contrast, the picture is far less clear for pragmatists, whose behavior can best be described as a reaction to a series of factors.

As noted in Chapter 5, the pragmatists engaged in a cost-benefit analysis involving a variety of factors and experienced change and instability in their labor force participation as they responded to changes in these factors. The child care stories of the pragmatists reflect their changes in labor force participation.

Pragmatists

Child care posed some interesting challenges for the pragmatists. As Chapters 3 and 5 made clear, it was not uncommon for the pragmatists to recount stories of difficulty they had experienced with child care providers. In all these cases, the mothers changed child care situations in order to solve problems. In a few cases, such as the case of Tammy, child care problems eventually led to a reevaluation of the employment situation of the pragmatist. Ultimately, Tammy decided to take some time out of the labor force.

In fact, the situations of both Tammy and Bobbi illustrate that the way in which child care is resolved is critical to mothers' successes in balancing and weaving work and family. Tammy's difficulties in securing child care with which she felt comfortable ultimately led her to take some time out of the labor market, and Bobbi's success in securing child care with which she felt comfortable was a key factor in her success in remaining employed.

Pragmatists used a variety of mechanisms for providing child care for their young children. A handful of pragmatists, such as Tammy, were "timing out," or dropping out of the labor force temporarily to stay at home with their children until they reached school age. Bobbi was the only pragmatist to employ a nanny to care for her children. As noted in

Chapter 5, Bobbi felt that the convenience of having someone come to her house made balancing and weaving work and family easier. One pragmatist relied on family members, her mother and mother-in-law, to provide care for her child while she worked. I was surprised to interview only one mother who relied on a relative to provide child care, given that so many mothers expressed a preference for this child care arrangement. These data suggest that having a relative care for one's child is a desirable but frequently unattainable option. Finally, the vast majority of pragmatists relied on family-home day care (care in the provider's home) and child care centers to provide child care for their children.

Applying Uttal's (1996) system of categorizing child care arrangements divides the pragmatists' child care strategies into three types. Many pragmatists defined paid child care as custodial, something simply to fill the gaps while they were at work. Those who did so were especially committed to part-time employment as the ideal strategy for weaving work and family. None of the pragmatists who defined child care as custodial would have sought full-time employment because custodial child care would be incompatible with their definitions of good mothering. Pragmatists who were employed full-time were more likely to define child care as coordinated, with a few defining their child care arrangements as surrogate care. Pragmatists who believed in the benefits of group child care clearly defined child care as coordinated.

Conformists and innovators considered group settings, such as home day care and child care centers, as the worst possible child care situations. However, pragmatists selected group settings because they believed them to be safer and because they believed their children benefited from interaction in this type of setting. Kelly, a pragmatist, was quoted earlier regarding the benefits she associated with the day care setting. It is useful to revisit her statement in this discussion:

> There's the good of knowing how to interact with other children. If another child takes a toy from him, he doesn't just give it up and cry. He just kind of, "this is mine," and he'll try to keep it for himself for a little while. So he is learning how to interact with other children and holds his own, whereas a child who is home with nobody else around won't learn that much. . . . He benefits from being away from his parents, interacting with other children and other caregivers. I think a child who stays at home always with a parent is not getting a full view of the world. It might be a little difficult when he goes off to school and figures out that the world is a lot bigger than my mom and dad.

As a group, pragmatists shared with each other the common thread of dealing with child care issues. Most pragmatists also shared the belief

that their children benefited from being in a child care situation. In fact, unlike either the conformists or the innovators, pragmatists and nonconformists all felt that their children needed the kind of socialization that is provided in a group setting. Pragmatists who were timing out stressed that they believed it was important for them to find social outlets for their young children. In the same way that the majority of pragmatists idealized meaningful, self-fulfilling, part-time employment, they idealized high-quality, education-based, part-time social experiences for their children. As a result, those mothers who were timing out anticipated enrolling their young children in preschool programs when they were age appropriate, and most of their children were actively involved in both formal and informal play groups. These two features—(a) instability in child care arrangements due to instability in employment patterns and (b) the belief that child care is beneficial to children—distinguish the pragmatists from the other mothers I interviewed.

Unlike any of the other mothers I interviewed, the pragmatists are relatively unaffected by ideologies of child rearing. Though they idealize this part-time child care strategy, it is only one of the factors that are important in the solutions they seek to the child care dilemma. Their strategies for selecting appropriate child care mirror their strategies for determining their level of labor force participation. It is the pragmatists that Brayfield (1995) is describing in her work—mothers who are sensitive to a set of structural factors that play heavily into their child care selections. These factors include cost, availability, convenience, perceived and actual quality, and location of child care. As with factors affecting labor force participation, factors affecting child care choice are relatively unstable, and thus, changes in them often result in changes in child care solutions. For the pragmatists, labor force participation and child care choices are interconnected. Changes in or difficulties with one lead to changes in the other. Not driven exclusively by any mandates or ideological principles, the pragmatists are pragmatic when they select child care solutions.

Nonconformists

The nonconformists I interviewed were even more convinced of the positive outcomes of child care on their children. They did not believe that they were responsible for providing all the care for their children. In fact, they did not believe that they were, on a full-time basis, the best care providers for their children. All the nonconformists defined their child

care arrangements as examples of coordinated care. They believed strongly that they and the child care provider were a team dedicated to caring for and socializing their children. Nonconformists rejected the tenets of intensive motherhood ideology that prescribed stay-at-home mothering as the only manner in which to be a good mother. Alternative motherhood ideology defines good child care as a wide range of options that include but are not limited to care by the mother. In fact, Emily believed she was a better mother when she did not spend all her time with her young son. She indicated that she was a better parent when she felt enriched by adult interactions.

As a result, nonconformists put considerable resources into finding the most appropriate providers and compensating them well. Two of the three nonconformists utilized child care centers for their children. These women indicated that they chose child care centers for the educational benefits, the opportunities for their children to play with others and have socializing experiences, and safety reasons. (Many employed women indicated a preference for child care centers based on recent local instances of drug problems in family day care homes.) Emily, like Bobbi, employed a nanny who does not live with the family. Only a handful of people in the sample utilized nannies. Like Bobbi, Emily cited the convenience of the nanny; she did not have to get up and get herself and her child ready to leave each morning. Emily was able to spend quality time with her son each morning instead of struggling to get him out of the door. She also indicated that a nanny seemed to be a good choice for young children, due to the one-on-one nature of the nanny arrangement. I suspect that other mothers' choices not to use a nanny may have been a result of an inability to supervise the nanny, a safety concern, and the high cost of employing the nanny. Bobbi and Emily each paid over $1,000 per month for the nanny to care for her young child full-time.

Although proponents of intensive motherhood ideology defined nonconformists as bad mothers, putting their needs for employment ahead of their children's needs to be cared for, Emily's comments suggest that this is not the case at all. As Garey (1999) describes, full-time employed mothers weave work and family. The nonconformists were very concerned about the care and socialization their children received; they simply did not believe that the strategy of stay-at-home mothering was the only or even the best strategy to meet their children's needs. In addition, the nonconformists did not believe, as noted in Chapter 6, that staying at home in poverty was better than employment that required paid child care.

Though Emily was not using a preschool at the time of our interview, she and the other nonconformists felt that preschool experiences were good for young children. Two other nonconformists, Kiki and Jennifer,

cited the benefits they saw to their children's being enrolled in preschool programs, and Emily in particular indicated that she fully intended to enroll her son in a preschool program by age 2. She felt that preschool programs were of great benefit to children, and this in effect became another way in which her income provided an opportunity for her son.

> I think they're advantaged when they have some organizational structure to their day, when they have some kind of programmed learning, whether that be the experience of going on a fieldtrip or whether it be rough play, playground play, versus quiet time. You know, learning that organization and that kind of schedule—I think that's important. Where he is right now, he pretty much has free reign. He can do whatever he wants. If he's in the mood to be quiet, he'll be quiet. If he's in the mood to be noisy and run around, he'll do that. But they have to learn that the environment has a place in their life that will impose some restrictions. . . . He's got to learn that the world is not just he alone.

Emily was particularly articulate on this point, but I believe that the other nonconformists and many of the pragmatists shared this sentiment. They saw some organized child care as an asset to their children's development rather than as a detriment. Furthermore, as noted by Uttal (1996), nonconformists believed that paid child care providers could be and are active and important partners in the socialization of their children.

Responsibility for Child Care

One of the more interesting aspects of discussing child care issues with mothers is the issue of responsibility. The literature is clear that responsibility for child care remains a particularly gendered phenomenon. Women have been, for the most part, charged with making the child care arrangements, transporting the children to and from child care, arranging vacation and sick leave when either the child or the provider is sick, and in many cases, paying for the child care out of their paychecks (Barnett & Rivers, 1996; Hochschild, 1989, 1997; Leslie, Anderson, & Branson, 1991; Peterson & Gerson, 1992). This was clearly the case for the mothers I interviewed. The majority of the employed pragmatists and nonconformists recounted *their* roles in selecting and handling the day-to-day aspects of child care. This is changing, as more and more men become involved in taking over or participating in the responsibilities of arranging for the child care. It is no longer uncommon to see fathers dropping their children off or picking them up from child care settings.

However, though many fathers were engaged in dropping children off or picking them up, these mothers perceived the responsibility for dealing with child care providers as resting entirely on their shoulders.

An interesting discussion that ensued in some of the interviews concerned the financial responsibility for child care. Emily, for instance, indicated that she paid her husband her salary, and from that, he deducted the child care costs. She was able to spend her remaining money however she chose. Apparently, his income was used to pay the other bills. This was not a common statement among the women I interviewed, but most of the employed women, when discussing the income they earned, tagged on statements about the economic costs of working. In other words, these women assessed the value of their income after deducting the costs of child care. This caused some women to wonder why they worked. In addition, many women indicated that they could only afford to work if they kept their family sizes small, that it would not pay for them to work if they had to pay child care bills for several children. These kinds of statements and reflections suggest that these women operate under the assumption that caring for the children is primarily their responsibility, and that if they do not provide care, they must pay for its provision. Therefore, if they choose to work and pursue their own interests, they need to be able to earn enough income to cover the child care costs incurred as a result of their employment.

Clearly, this notion is based on the intensive ideology of motherhood. Despite Emily's rejection of the ideology of intensive mothering, it was she who spoke so definitively about her responsibility to pay for child care. I think that she still believed that the responsibility for child care belongs with mothers. Among nonconformists, this belief may represent the last bastion of the power of motherhood ideology. As dual-earner families become more common, it would be interesting to investigate further the degree to which this construction of child care as women's responsibility is expressed in this economic manner. It can be argued, perhaps, that this is part of an economically driven cost-benefit analysis of employment and child care within individual families. However, I believe that assigning the burden of child care costs to the salary of mothers is based on ideology regarding child care responsibility and is not simply reflective of economic considerations. In fact, defining child care costs as deductions from mothers' incomes symbolizes that the primary responsibility for child care lies with women.

Clearly, child care is a critical issue that is faced by all families, single-parent, two-parent, and dual-earner. With all the media reports of abuses within child care settings or in one's home, such as the tragic case of Matthew Eappen, parents expend considerable time and energy considering the

vast array of options for taking care of their young children, be that staying at home with them or finding a qualified care provider. As with many other issues discussed in this text, the four types of mothers hold very different beliefs about child care and view the mechanisms for providing adequate child care solutions very differently. The role that motherhood ideology plays in describing what exists, what is good, and what is possible influences these mothers as they seek solutions to the issue of child care. Finally, as Emily noted, the responsibility, both logistical and financial, for securing child care remains gendered.

The role of men in taking on child care responsibilities is changing. Fathers are taking on more of the child care responsibilities (Brannen & Moss, 1987; Goldsheider & Waite, 1991). And the fathers in nonoverlapping shift work families often engaged in as much child care as the mothers did. These parents began to conceptualize this type of fathering as good for both father and children, not merely as a good solution to the complex issues of child care in dual-earner families. As we transition into the next millennium, some, such as Barnett and Rivers (1996), suggest that dual-earner families that adopt this sort of partnership approach will have the healthiest mothers, fathers, and children.

Summary of Major Findings

In this chapter, I have focused on the various ways that child care strategies are selected and created in order for mothers with young children to weave work and family together as seamlessly as possible. Not surprisingly, different types of mothers conceptualize child care differently. Motherhood ideologies define what exists, what is good, and what is possible in relation to child care strategies. Thus, specific child care solutions flow directly from specific ideologies of motherhood.

Conformists totally embrace the tenets of intensive motherhood ideology. Because intensive motherhood ideology defines good mothering as complete responsibility for meeting all the daily physical, emotional, and intellectual needs of the child, conformists were absolutely opposed to leaving their children in the care of anyone else at any time. They defined child care as exclusively their responsibility and were horrified at the prospect of turning over any of the daily care of their children to anyone else.

Innovators, too, embraced the tenets of intensive motherhood ideology. In contrast with the conformists, however, they saw several iterations to the "what is possible" directives of intensive motherhood ideology.

Most important, innovators, with one exception, believed that fathers were important, if not equal, partners in child rearing. They believed that the most important directive of intensive motherhood ideology required that children be cared for by their parents. This seemingly minor difference in the ideology of innovators as compared with conformists made significant differences in their behavior. Innovators developed and took advantage of situations, such as nonoverlapping shift work, that allowed child rearing to be shared between the mother and the father. Additionally, innovators developed and took advantage of situations that allowed them to work and care for their children simultaneously, thus meeting the definition of a good mother as laid out by intensive motherhood ideology *and* providing for the economic needs of their families.

Child care was absolutely critical for the pragmatists; it defined and was defined by their employment needs. When child care situations were positive, pragmatists were able to continue working away from home and experience success at work. When child care situations were troubled, pragmatists were forced to change providers, change employment, or quit working. The relationship between employment and child care was interconnected for the pragmatists. They fit their child care solutions to their employment needs as well as structured their employment around their child care options. When child care was successful, as in the case of Bobbi, then weaving work and family was successful. When appropriate child care solutions were not possible, as in the case of Tammy, there was extreme tension between work and family.

Pragmatists are also defined by their instability in employment and child care. Pragmatists can be distinguished from other mothers by the number of changes in their child care arrangements. Pragmatists make child care decisions much like they make employment decisions, in reaction to a variety of factors. Moreover, like the nonconformists, many pragmatists saw benefits to group child care settings. Though some viewed child care as surrogate care and thus sought part-time employment so as to limit their child care use, many believed that there were benefits to child care, defining child care as coordinated care.

Nonconformists can be distinguished from other mothers in their belief that child care is coordinated and actually better for their children. Though both the pragmatists and the nonconformists saw benefits for their children in group child care settings, all the nonconformists believed that coordinated care was fundamentally better for children than maternal care alone. Totally rejecting the tenets of intensive motherhood ideology, nonconformists believe that they are better mothers when they pursue their own interests and have time away from their children. Even the pragmatists, who saw benefits to child care, did not believe that they

were better mothers by putting their children in child care. This belief distinguishes nonconformists from all the other mothers.

Despite their rejection of the tenets of intensive motherhood ideology, nonconformists, along with all the other mothers, continue to believe that child care is primarily the responsibility of the mother. Nonconformists and pragmatists talked at length about arranging child care and worrying when it did not work. Additionally, all the mothers utilizing paid child care considered this cost as against their earnings rather than as against the total earnings of their households. Only the innovators believed that child rearing was more effective when it was shared by both parents. However, even the innovators indicated that they were responsible for arranging their schedules so that someone was home with the children at all times. Weaving work and family was clearly the responsibility of the mothers, even in families where caring for the children was evenly shared.

Conformists

- Accept the tenets of intensive motherhood ideology.
- Accept the definition of good mothering as defined by intensive motherhood ideology.
 - Good mothers devote themselves entirely to the nurturing and raising of their children.
- Behave in accordance with the single possibility defined by intensive motherhood ideology by staying at home and forgoing employment even when their families need the money.
 - They do not define fathers as partners in child care.

Innovators

- Accept a modified version of intensive motherhood ideology.
 - Accept the definition of good mothering as defined by intensive motherhood ideology and devote themselves entirely to the nurturing and raising of their children.
 - Modify the definition of good mothering to include fathers; good parents devote themselves to nurturing and socializing their children.
- Accept a wider range of possible ways to achieve good parenting.
 - Primary objective is to provide continuous, constant parental care. This may be achieved by working from home, taking the children to work, or engaging in nonoverlapping shift work.
 All these strategies require coparenting by mothers and fathers.

Pragmatists

- Accept the tenets of intensive motherhood ideology.
 - Expand the tenets to include providing economically for one's children.
- Make labor force participation decisions using a cost-benefit analysis of several factors.
 - Changes in these factors lead to instability in employment.
- Make child care decisions using a cost benefit analysis of several factors: cost, quality, availability, and so forth.
 - Changes in these factors as well as in employment patterns lead to instability in child care.
- Accept an expanded version of the definition of good mothering as defined by intensive motherhood ideology.
 - Focus on nurturing one's children and providing for their economic needs.
- Are limited by the binary, oppositional set of possibilities that are defined by intensive motherhood ideology: One can seek employment or one can stay at home.
 - Many prefer part-time employment.
 Allows for a balancing of the mutually exclusive pursuits of work and family.
 Allows for the use of custodial child care.
- Allow successes and failures in child care to directly influence labor force participation; quality child care is necessary for success in maternal employment.
- Endorse the notion that there are benefits for children in spending some time in child care.

Nonconformists

- Reject the tenets of intensive motherhood ideology and adopt instead the tenets of alternative motherhood ideologies.
- Accept the definition of good mothering as defined by alternative motherhood ideologies.
 - Good mothers assure that their children are well-cared for and nurtured; though this work is not restricted to the mother.
 - Good mothers assure that their children are provided for economically and given every opportunity to grow.
- Accept the standard range of possibilities for balancing work and family, including care by paid providers.

- Often describe their child care as coordinated; view child care as a team effort.
- Believe child care has benefits for the child.
- Believe that mothers are better at mothering when they utilize paid child care.

Responsibility for Child Care

- All mothers, regardless of their beliefs about appropriate child care providers, were responsible for providing or arranging for the care of their children. This was true even when fathers provided substantial amounts of child care.

8

The Power of Ideology
and the Ideology of Power

The charge of this study and of this book in particular has been to examine and analyze the process by which mothers with young children balance and weave work and family. Maternal labor force participation is considered by many to be one of the most significant changes in family life in the 20th century, affecting not only the family but also the changing nature of the workplace. There are several different ways in which one can attempt to answer the basic question that guided this research: "How do mothers with young children decide whether to work outside the home or stay at home while their children are young?" I set out to answer this question by conducting and analyzing interviews with 30 mothers with young children. This study has examined the strategies married mothers with young children utilized in order to balance and weave work and family.

Understanding the Issues Theoretically

STRUCTURAL-FUNCTIONALISM

Structural-functionalism focuses on the innate differences between men and women that led inevitably to role differentiation by gender. This perspective explains the much lower rate of labor force participation associated with mothers, as compared with fathers, by relying on the doctrine of separate spheres. The doctrine of separate spheres results in a clear division of labor that relegates men to the role of economic provider and women to the role of family caretaker. Structural-functionalism focuses on explaining the ways in which the relatively low rate of maternal labor force participation is functional for U.S. families.

RATIONAL CHOICE THEORIES

New Home Economics Theory

Rational choice theory assumes that people make decisions based on the outcome of a cost-benefit analysis in which all the options are considered. New home economics theory, a type of rational choice theory, assumes that families make work-family decisions in order to maximize economic utility. New home economics theorists explain women's lower levels of labor force participation by noting gender differences in marketplace human capital as well as the high economic and noneconomic costs of replacing parent care at home. In other words, more men than women are employed for three reasons: because men have higher earning potential in the labor market, because child care costs are high and often cannot be offset by women's wages, and because the value of having mothers care for their children is high. Given the gendered wage gap, it is true that most families will suffer if they do not have a male wage earner. In addition, new home economics theorists note that women's value as caretakers of the children and the home is actually higher than their value as wage earners. Thus, from this perspective, it makes good economic sense for many families for men to seek employment and for women to stay at home full-time while the children are young.

Structural Models

Rational choice theory has also launched a number of attempts at testing empirical models based on cost-benefit analyses. These models focus on testing an array of structural variables and their impact on maternal

labor force participation. One series of variables has been shown repeatedly to be related to the level of maternal labor force participation: the mother's occupational options; her level of educational attainment; the availability of high-quality, affordable child care; the number of children; and her male partner's work schedule. Mothers who have many children, little education, few satisfying occupational options, limited access to high-quality or affordable child care, and male partners who work rotating shifts or who travel frequently with their jobs are less likely to be employed while their children are young. Single mothers and those who are cohabiting but not married are more likely than not to be employed. Married mothers, presumably because they have the economic support of their husbands, are less likely to be employed while their children are young, although marital status is becoming less effective in predicting maternal labor force participation.

ECONOMIC MODEL

The economic model has been the empirical model most frequently cited to explain maternal employment. Essentially, it has been argued that women whose families are experiencing the economic squeeze will enter the labor force while those who live in families that have adequate economic resources will stay out of the labor force while their children are young. This argument has been used to explain the fact that many more single mothers than married mothers are employed. Additionally, this empirical model has been used to explain the higher rates of maternal labor force participation among nonwhite mothers, especially African Americans.

The relationship between the changing economic climate in the United States and the consequent rise in maternal employment has been clearly demonstrated. However, studies showing that maternal employment is actually higher among married women whose husbands make an "adequate" salary than among those whose husbands make low salaries have challenged this basic premise. Thus, the explanatory power of a theoretical paradigm that is limited to economic need as a predictor of maternal employment has been called into question. Finally, perception studies have shown that economic need, though it may be limited in its explanatory power, is widely perceived to be the most justifiable reason for mothers with young children to remain employed.

FEMINIST MODELS

Feminists have also theorized about and conducted empirical investigations of patterns of maternal labor force participation. Feminist theorists have focused on the inherent disadvantage for women who are not

involved in the labor force. By staying out of the labor force, women become economically dependent on men or on the state. Economic dependency reduces women's freedom to act. Marriages in which women are economically dependent further reinforce the system of gender inequality that exists in patriarchal cultures. Under these conditions, women become, in effect, both sexual slaves and house servants to their male partners.

Based on the writings of prominent theorists, much of the empirical research from the feminist perspective has focused on the ways in which gender inequality in the home and the workplace are intertwined and mutually reinforcing. The underlying assumption that arises out of this theorizing is that all women benefit from economic independence. Therefore, the focus has been on identifying the factors that inhibit the labor force participation of women, and of mothers specifically. Clearly, the cases of Cheryl and the other conformists raise the question of false consciousness. Does the dominant ideology that idealizes the virtues of the stay-at-home mother create false consciousness among mothers that results in their choosing economic dependency?

This Study

At the outset of this project, I began reading the literature on maternal labor force participation. The literature identified ideology as a factor in fertility decisions and identified the importance of gender role strategy in the division of household labor, but ideology was noticeably absent from the empirical literature on balancing and weaving work and family. Furthermore, even though nonwhite feminist theorists had written on the content of motherhood ideology among nonwhite women, motherhood ideology had seldom been included in empirical discussions of balancing and weaving work and family.

In addition, my own experiences along with my casual observations of the world of mothers with young children in which I lived suggested that motherhood ideology was indeed an important factor in their labor force participation decisions. Therefore, I set out to gather data, both quantitatively and qualitatively, on the role that motherhood ideology plays in maternal employment decisions. I have argued in this book that, in fact, motherhood ideology is an important factor in the decisions that mothers with young children make about balancing and weaving work and family. The theoretical model that I propose to explain maternal labor force participation includes economic need, occupational opportunity, educational attainment, availability of affordable child care, number of children in the family, father's work schedule, marital status, and motherhood ideology.

FOUR DISTINCT TYPES OF MOTHERS

Early in the interview process, one theme emerged quickly: There appeared to be four distinct types of mothers. These four groups of mothers differed in their mechanisms for balancing and weaving work and family, but more important, their routes to arriving at these resolutions varied. Additionally, the role that motherhood ideology played in individual mothers' decisions about employment differed.

Using Merton's (1975) typology of deviance as a model and Therborn's (1980) theory of ideology as a guide, I argued that mothers are all exposed to the dominant motherhood ideology as well as to the normative goals in the culture. Each mother responds to the dominant ideology and the normative goals in one of four ways (see Table 8.1).

As the above table suggests, we can predict the employment behavior of mothers by categorizing them based on their motherhood ideology. Conformists, those who adhere strongly to the goal of intensive mothering, are highly likely to stay at home even when this requires tremendous financial sacrifice. Cheryl's story vividly illustrates this. Nonconformists, such as Emily, who reject the dominant motherhood ideology and accept the goal of economic and individual achievement, remain employed when their children are young. Neither the conformists nor the nonconformists feel guilty about their strategies for balancing and weaving work and family because within each group, their ideology and their behavior are consistent.

Pragmatists, on the other hand, accept the dominant motherhood ideology, yet they also accept the goals of economic and individual-level achievement. Because they perceive fulfilling, well-paying, part-time employment as allowing them to meet both of these goals, they idealize this arrangement. Practically speaking, however, this arrangement is seldom available. Therefore, pragmatists engage in a series of rational choice decision processes that maximize the tenets of both goals and minimize the violations of both goals. For pragmatists, therefore, structural variables, economic need, and motherhood ideology are considered simultaneously. The outcome of this cost-benefit analysis defines their behavioral options. Pragmatists such as Tammy stay at home full-time while their children are young because they can afford to and because they are unable to find satisfying part-time work and high-quality child care. Others, such as Bobbi, remain employed full-time because they cannot afford to stay at home full-time, their occupational options are plentiful, and they have found affordable, high-quality child care. Because the pragmatists engage in behavior that often violates the tenets of one of their goals, they experience high levels of ambivalence and guilt.

Finally, the innovators, much like Merton's (1975) innovators, remain committed to the goals, both the dominant motherhood ideology and

Table 8.1 Comparison of Types of Mothers

Type of Mother	Response to Ideology	Solution to Work-Family Conflict	Affect Regarding Decision
Conformist	Conforms to dominant motherhood ideology (intensive mothering).	Exits the labor market permanently and stays at home full-time, even if this means tremendous financial sacrifice.	Stress with financial status. Satisfaction with decision.
Nonconformist	Refuses to conform to dominant motherhood ideology. Adheres to principles of alternative motherhood ideology. Conceptualizes motherhood to include instrumental and expressive roles. Adheres to the goals of economic and individual achievement.	Remains employed as she feels responsibility to provide economically for her children. She also feels entitled to pursue her own interests. Finally, she feels her children benefit from being cared for by others.	Stress with job and balancing work and family. Satisfaction with decision.
Pragmatist	Conforms both to the dominant motherhood ideology and to the goals of economic and individual achievement. Thus, she engages in a rational choice process, weighing many structural factors, economic need, and motherhood ideology, in determining her level of labor force participation.	Idealizes fulfilling, well-paying, part-time employment. Since this exists relatively rarely and her level of labor force participation depends on the outcome of a cost-benefit analysis, she may be employed full- or part-time or stay at home while her children are young.	Only those able to attain the ideal are satisfied. Others feel stress associated with juggling and weaving, with the loss of career, or with being at home. High levels of guilt.
Innovator	Conforms to the dominant motherhood ideology but rejects normative paths for balancing work and family	In an attempt to preserve the goals of motherhood and economic well-being, she creates ways to remain employed while using no paid child care. Possible strategies include nonoverlapping shift work, working from home, and taking the child to work with her.	Stress associated with balancing or weaving. For those engaged in nonoverlapping shift work, stress that arises out of solo parenting and marital disruptions. Satisfied with arrangements.

economic and individual success. However, innovators reject the legiti-
mate means to each goal and create a new system for attaining these
goals. Simply put, they find ways to remain employed and to provide
constant parental care for their young children. Because the innovators
retain their commitment to both the goals, they do not feel either cogni-
tive dissonance or guilt. Often, however, they experience stress that is related
to balancing and weaving work and family in unconventional ways.

This study has clearly demonstrated that adding ideology to the theo-
retical model that predicts maternal labor force participation improves
our ability to explain the variance in maternal paid employment. This is
useful because it allows us to understand more clearly the factors that are
important to mothers with young children as they determine how to bal-
ance work and family.

The improvement of the model also aids employers, pediatricians,
mothers themselves, and others in proposing effective strategies for bal-
ancing and weaving work and family. For example, most government
and corporate proposals to ease the work-family conflict are focused in
two areas: flexible work schedules and child care solutions. For many of
the pragmatists, improvements in these two areas may in fact ease a tre-
mendous amount of the stress associated with balancing and weaving
work and family. Solutions such as telecommuting, which is on the rise,
may alleviate the guilt that the pragmatists report experiencing as this
solution would produce options similar to those that the innovators cre-
ated for themselves or were able to take advantage of. However, there is
little, it seems, that can be done to encourage labor force participation
among the conformists or discourage it among the nonconformists. For
these mothers, ideology is the driving force behind their decisions.

MEASUREMENT ISSUES

From a scientific standpoint, the most important contribution that this
model makes to our understanding of the ways in which mothers with
young children balance and weave work and family may be seen in mea-
surement. Both the qualitative and the quantitative data, which are
summarized in Chapter 5, show that the theoretical model that I propose
here—one that includes measures of economic need, structural and human
capital variables, and motherhood ideology—explains the most variance
in maternal labor force participation. Therefore, I would suggest that fu-
ture studies focusing on women's labor force participation include a variety
of measures such as marital status and economic need, which are typically
measured, as well as measures of motherhood ideology.

The data presented here show that the best system for categorizing
mothers with young children may not be employment status. In fact, it

was frequently the case that the employed mothers had less in common with each other than the mothers within the analytical categories I proposed, those based on beliefs about motherhood. Therefore, I suggest that when using women's employment status as an independent variable, one also measure motherhood ideology and perform analyses with this as the independent variable. I would suggest that in many cases, it is more useful. For example, studies have investigated the differences in women's attitudes regarding gendered issues, such as abortion, using employment status as the independent variable. It would be interesting to see the relationship between motherhood ideology, measured with a multiple-item indicator such as the one I am developing from the quantitative data, and attitudes about such gendered phenomena. Though motherhood ideology and employment status are highly correlated, studies that measure each separately would allow the researcher to tease out the independent effects of each variable. These data strongly suggest the addition of multiple-item measures of motherhood ideology as both the independent and dependent variable in a variety of studies designed to examine women's labor force participation.

Reasons and Causes

Much is learned by considering what women themselves say about what is important to them as they balance and weave work and family. The whole point of this book has been to show that in many cases, material conditions that are similar result in different employment outcomes because of beliefs held by mothers. One advantage to interviewing women in their homes and offices is that I was able to make observations about the material conditions of these mothers. This allowed me to independently compare their descriptions of their lives with what I observed. For example, Cheryl indicated that she and her family were experiencing the economic squeeze. Based on our notions of relative deprivation, many in the United States believe that they are "poor." However, my visit to Cheryl's home confirmed that she and her family did in fact live on the economic edge. When I was able to compare Cheryl's situation with Tammy's, it was immediately apparent that economic need and other material conditions were experienced differently by different women. Observing the material conditions in which the women lived allowed me to compare the impact of various factors on both labor force participation decisions and the development of the reasons women cited for these decisions.

The relationship between reasons and causes of behavior is complex. In many cases, the reasons that people cite for their behavior are, in fact, causes. However, in some cases, reasons are not really causes but justifi-

cations. Often, causes are not articulated as reasons because they are either taken for granted or simply not recognized. The pragmatists are an excellent example of this. Tammy's story is an example of how some reasons that mothers cite are in fact causes but other causes that remain unarticulated affect labor force participation considerations, too. Tammy, who returned to work shortly after the birth of her first child and then decided to stay at home, cited her family's economic situation and child care problems as the reasons why she decided to quit her job and stay at home. However, when one listens to Tammy, it becomes apparent that she adheres rather strongly to the ideology of intensive motherhood. In other words, Tammy believes that she should stay at home unless her income is absolutely necessary for her family's economic well-being. During several changes in employment status, Tammy adjusted her reasons to be in line with her labor force participation decisions, which were caused primarily by structural factors such as economic need, occupational flexibility, and the availability of high-quality child care.

What is interesting is not necessarily whether the reasons mothers articulate for their labor force participation actually cause their labor force participation, but rather the relationship between their reasons and the actual causes. In many cases, the reasons that women cite may actually be rationalizations, or attempts to bring one's beliefs in line with one's behaviors and thus eliminate cognitive dissonance. Future research that examines women's articulated reasons and compares them with causes associated with social location and opportunity structure may help to illuminate the social-psychological process of dealing with cognitive dissonance and the development of rationalizations when cognitive dissonance occurs.

Are reasons simply post hoc rationalizations for behavior, or can they be causes of behavior? Can we expand our understanding of phenomena by examining articulated reasons for behaviors? I would argue that yes, beliefs or articulate reasons can be causes of behavior, and we can expand our understanding of phenomena by listening to respondents' reasons for their actions. In addition, I would suggest that the strength of interview methods is the ability to ask respondents to articulate their reasons for their behavior. When we rely exclusively on social location and opportunity structure indicators, we may miss beliefs and ideology that affect behavior. One purpose of this book has been to demonstrate that in many cases, material conditions, opportunity structures, and social location do not predict employment outcomes. For many mothers, their beliefs about motherhood, their articulated reasons, are the best predictors of employment. This is particularly true for the conformists and nonconformists. Furthermore, though it answers a different question, much can be learned about people's own attributions for their behavior.

These data clearly indicate that the process by which mothers with young children negotiate balancing and weaving work and family varies across the different groups of mothers. Although we are always searching for a streamlined model with which to predict human behavior, the reality is that most human behavior is messy and cannot easily be explained by a streamlined model. In fact, these data suggest that the standard structural models that use social location and opportunity structures to explain maternal labor force participation are useful for predicting the labor force participation of the pragmatists, who account for half the sample.

However, the outliers—the conformists who adhere strongly to the ideology of intensive motherhood, the nonconformists who reject the ideology of intensive motherhood, and the innovators who reject the standard means to weaving work and family—do not behave in ways that can be predicted using the standard models. In these cases, the model that I propose, one that incorporates one's ideology of motherhood, is more successful at predicting maternal labor force participation. Thus, I suggest a two-pronged approach. The most heuristically pleasing model of predicting labor force participation, that which relies on social location factors such as marital status, race, human and social capital, and economic need, as well as on opportunity structures such as occupational options and the availability of child care, will accurately account for the labor force participation decisions of many mothers. However, the explanatory power of this model will be limited in predicting the labor force participation decisions of several types of mothers. Thus, a model constructed primarily around ideologies of motherhood will be more accurate.

We must continue to explore the relationship between motherhood ideology and patterns of balancing and weaving work and family. In addition, this study calls for increased examination of the relationship between articulated reasons and other causes for behavior.

THE ROLE OF FATHERS

One of the shortcomings of this study has been the heavy reliance on the reports of mothers and the exclusion of reports by fathers regarding the means for balancing and weaving work and family. So, the data can really be used to speak only to the issue of balancing and weaving work and family from the perspective of mothers rather than from both parents' perspectives. Ideally, both individual and joint interviews would be conducted with mothers and fathers. As studies that have focused on fathers have shown, the role of fathers in balancing and weaving work and family has changed over the last several decades. Therefore, although

this study has expanded our understanding of labor force participation decisions, gathering data from the perspective of fathers would be useful.

It is important to consider what this study can contribute to our understanding of the ways in which families balance and weave the competing needs of work and family and what the role of men, from the perspective of women, is in this process. Since the dawn of the industrial revolution and the ushering in of the doctrine of separate spheres, men's roles in the family have revolved around providing economically, disciplining, and advising. Mothers have been assigned to the role that involves caretaking. The interviews that I conducted suggest that this remains the arrangement in many contemporary U.S. families.

The complex situations that were described by the innovators, and which I witnessed, were testaments to the growing and changing role of men in families. The innovator fathers represent an adaptation that resembles families of the more distant past. In these families, the ability of the women to do paid work is absolutely dependent upon the fathers' willingness to participate in cooperative child rearing. This may be the most obvious in families that engage in nonoverlapping shift work, like Jean's, but Haley also worked for pay in the evening after her husband came home from work. Fathers such as the spouses of Jean and Haley are heavily involved in ways that are different from the role of U.S. men of the 1950s and 1960s, especially those of the middle class, in which the doctrine of separate spheres was particularly well enforced.

The men in the conformist, nonconformist, and pragmatist families were much less involved, and their involvement was much more indirect. In the case of the conformists, the mothers reported that they and their husbands both believed that the best family form was the traditional one. The conformists and their husbands accepted and adhered to the traditional construction of the roles of mother and father. I asked mothers such as Cheryl if they felt they were forced or required in any way to stay at home. The conformists all indicated that they wanted to stay home. They fully endorsed, as did their husbands, the doctrine of separate spheres. Cheryl and other conformists also indicated that they and their spouses had discussed this issue before they were married. As a result, they viewed the decision to remain at home as one that had been made prior to marriage and one in which they and their spouses were in perfect agreement.

The nonconformists, like the conformists, indicated that their husbands also supported their decisions about balancing and weaving work and family. The nonconformists, when prompted, indicated that their spouses in no way forced or required them to work. In the case of Emily, for example, her family did not even need the income she was earning. Rather, the fathers encouraged their nonconformist wives to pursue their

own interests. As was noted in Chapter 5, Emily's husband encouraged her to renew her interest in ballet after they relocated and before Emily determined the new direction her occupational pursuits would take.

The picture that emerges from analyzing the statements of the nonconformists suggests that their husbands were supportive of their decisions to remain employed. In this way, the experiences of the nonconformists are similar to those of the conformists. On the other hand, the nonconformists did not indicate that their husbands would in any way be disappointed in them if they had decided to take some time out of the labor force. The nonconformists' husbands were supportive of the decisions made regardless of the outcome of those decisions, suggesting that the experiences of the nonconformists were in fact very different from those of the conformists. Cheryl's husband, for example, would not have supported her decision had it resulted in her returning to the paid labor force. In contrast, Emily's husband appeared to be supportive of the choices Emily made regardless of their outcome.

I will admit that I was surprised at the high level of agreement among spouses. I had expected that some women would report that they felt pressured into a particular labor force participation choice. I interpret the high level of agreement among the conformists and nonconformists to reflect the strong adherence these mothers had to an ideological position. The conformists and nonconformists indicated that they had "always felt this way." Thus, these mothers presumably explored their beliefs about balancing and weaving work and family early in relationships and married men who supported their ideological beliefs.

Taking a closer look at the comments of nonconformists leads to the perception that the decision about how to balance and weave work and family was primarily the mother's decision. Although their spouses were supportive of their decisions—in fact, Emily's husband took on some of the child care responsibilities while she attended evening meetings—the decisions themselves were consigned to the nonconformists alone. For example, as noted in Chapter 5, Emily reported that she was responsible for paying for the nanny. Emily turned her income over to her husband, he deducted her child care expenses, and then she was free to spend the remaining money. This is yet another example that suggests that although the nonconformists were supported in their decisions about balancing and weaving work and family, they were also responsible for working out the details. This parallels the findings of many others who have noted that even when fathers are involved in family life and are supportive of their wives, the wives themselves continue to bear the responsibilities for either caring for the children themselves or making the child care arrangements. Emily's responsibility for paying for child care is symbolic of the fact that she had a greater responsibility than did her husband for ensuring that their son was well cared for.

The situation of the pragmatists illustrates yet a different set of relations between the parents. The perceptions and comments of the pragmatists suggest that labor force participation decision making was arrived at jointly, between husband and wife, in these families. The pragmatists, like the nonconformists, were often solely responsible for the day-to-day implementation of the family plan, arranging for child care and sometimes paying for it out of their own wages. But the process by which they arrived at the decision to remain in the paid labor force or stay at home was undertaken along with their husbands. Because the pragmatist engaged in a rational choice, cost-benefit analysis in order to determine whether or not she should remain employed or stay at home full-time, it is logical to conclude that she would engage in this cost-benefit analysis with the input of others. These others would likely include spouses, friends, coworkers, and other family members. Additionally, because rational-choice decision making often relies on "data," it is also logical to conclude that pragmatists would consult with these others in the process of compiling this data.

The degree to which the pragmatists' husbands were involved fathers varied. Some fathers took primary responsibility for the day-to-day details of child care by, for example, dropping off the children or arriving home to meet the sitter. Other fathers were very uninvolved in the day-to-day processes surrounding the balancing and weaving. As one might conclude, the mothers who perceived their husbands as partners in child rearing were happier.

Although this type of day-to-day involvement differed from the traditional to the egalitarian, using Hochschild's (1989) terms, the decision process can be characterized as an egalitarian partnership. When prompted, none of the pragmatists indicated that they were in any way forced or required to work or to stay at home. They all perceived that both they and their spouses had an active voice in the decision process. The couple, together, considered data and input from other sources, and together, they decided what was best for the family.

The situations of the innovators required that the husbands be very involved in the day-to-day workings of the family and child care, especially in families that engaged in nonoverlapping shift work or families in which the mother worked at home. Thus, the innovators reported having supportive husbands. In terms of the actual decision process, however, many of the innovators' husbands may have been ambivalent. Although many innovators indicated that their decisions were reached through mutual discussion, others suggested that they themselves made the decisions about how to balance and weave work and family, and the fathers became involved at the point of implementation of the preferred strategy. Clearly, not only did the innovators' arrangements require the support of their husbands, but also, in order for the arrangements to

work, fathers needed to be actual partners who shared the responsibility for child care. Fathers in innovative households were by far the most involved in their families.

As this discussion illustrates, fathers' involvement in child rearing varies tremendously across the groups. Although I did not systematically investigate fathers' child-rearing behavior, the data from mothers that is presented here suggest to me that fathers' child-rearing strategies are also rooted in a variety of factors, including fatherhood ideology. Additionally, the data presented here, as well as empirical studies of fathers reported in the literature, suggest that there are a variety of forms of fatherhood ideology just as in the case with motherhood ideology. I would strongly suggest that the content and power of fatherhood ideology be further investigated. Also, it would be interesting to explore the ways in which motherhood and fatherhood ideology are configured within heterosexual couples, as Hochschild (1989) does with regard to gender strategy.

I would like to close this discussion of fathers by noting what I believe is a major difference between the roles of fathers and mothers. Without hard data to support this, I would suggest that the level of involvement of parents in their children's lives is perceived very differently according to the gender of the parent. Because our parenting ideology continues to be dominated by the norms associated with the traditional family model, men's behavior continues to be evaluated relative to the norm of the traditional breadwinner father, and women's behavior is evaluated relative to the norm of intensive mothering. Women are publicly chastised for deviating from the intensive model of motherhood, as noted in Chapter 2, whereas men are rewarded for deviating from the traditional role of the father. Women are expected to take care of the house and the family, and therefore, when they do, they are not recognized for these efforts. It is, however, noted when they do not take on these responsibilities. On the other hand, as a result of the doctrine of separate spheres, men are rewarded for any amount of house or family work in which they engage. My observations suggest that women's reference group is the model of the stay-at-home mother, whereas men's reference group is the model of the breadwinner father. As a result, women, 67% of whom are employed, often feel as though they come up short, whereas men, especially involved fathers, feel as though they deserve accolades.

TURKEY COOKIES

I would like to illustrate this point with an example from my own life. Last November, one of the room parents from my son's second-grade class called. She asked me if I could bring a treat for the Thanksgiving celebration that his class was having. Of course, I said yes. As the week

of Thanksgiving approached, I asked other mothers if they had any suggestions for a creative treat to bring for Thanksgiving. One of the other mothers from my son's class suggested turkey cookies. A turkey cookie is constructed by "gluing," with chocolate icing of course, a striped fudge cookie to an Oreo. The striped cookie serves as the tail and the Oreo as the base. Then, a chocolate mint is "glued" to the Oreo for a head and a candy corn is "glued" to the mint for the beak. They are really cute. Because I was the room parent for my daughter's class and responsible for her Thanksgiving snack, I decided to make 50 turkey cookies, enough to feed the children in both classes. The night before the Thanksgiving parties, I was up until midnight making turkey cookies. As I was grumbling in the kitchen, my husband questioned my motives. "Why are you going to so much trouble? Why don't you just pick up something cute at the bakery?"

Both my deciding to construct turkey cookies and my husband's reaction to this endeavor illustrate poignantly several very important points about gender and parenting. First, I am a career woman. At work, I am respected for my career successes. However, on the elementary school terrain, I am evaluated based on my mothering. Because I have internalized intensive motherhood ideology, I evaluated my own performance on this particular mothering task in reference to all the other Thanksgiving treats that would be contributed by other mothers. I came to the conclusion that if I really wanted to be taken seriously as a mother, I was required to deliver a creative, labor-intensive treat that would meet the standards set by mothers who stay at home full-time.

My own internalization of intensive motherhood ideology created in me a sense of guilt, a sense that I had better show that I could compete with those who are not employed. In addition to my desire to be perceived as a successful mother of elementary school children, I also felt that my own evaluation of myself rested on my ability to produce this creative snack. In my evaluation, my ability to produce this creative snack reflected my commitment to motherhood, not my ability to be creative with snacks. Although I am a reasonably good cook, I am not at all creative in this sort of way. Yet, it did not occur to me that my success at this task reflected my creative ability. To me, it clearly reflected my commitment to my children. The guilt that I hold because I am an employed mother reared to the surface and kept me working well into the night to produce what I considered to be the kind of snack that stay-at-home mothers make.

Second, this interaction between my husband and me speaks very loudly about the gendered nature of parenting ideology. My husband believed that agreeing to bring any treat at all was a testament to my parental commitment to my children and their school experience. He felt that it

was, in fact, going beyond the call of duty to volunteer at all. Further-more, he considered it preposterous that I thought I had to stay up half the night creating this snack when I could have picked up something at the bakery. Given that men's parenting behaviors are evaluated next to those of other men, he felt that he would be successful if he simply brought something he had picked up at the last minute. Men, he said, would never feel guilty and go to so much trouble. This is, I think, because their standard is that of the employed parent. When fathers manage to get off work to attend an afternoon sporting event or a field trip, they are ap-plauded. Yet, this behavior is expected of mothers, whether they are employed or not. Thus, the turkey cookie episode illustrated, in my house-hold, the differential expectations of fathers and mothers. And it verified in my own analysis just how susceptible most mothers are to tenets of intensive motherhood ideology.

Finally, the turkey cookie episode is an example of "doing gender" (West & Zimmerman, 1987). My own determination to produce a home-made snack was an action designed to create a gendered sense of self, that of a good mother, as defined by intensive motherhood ideology. My husband's actions were also an example of doing gender. His inaction and the lack of concern he felt about the snack were congruent with at least one definition of a good father. Each of us behaved in specific, scripted ways that both reflected and created gendered parenting.

Divisiveness Among Mothers

The turkey-cookie story illustrates far more than my own insecurities about being an employed mother. It illustrates far more than the pressure I personally feel to compete with stay-at-home mothers in "snack com-petition." I think it is indicative of a much more serious and pervasive issue. Both anecdotal stories and informal interviews as well as the data collected for this project suggest that there is a growing tension between mothers who are employed and those who choose to stay at home. Walzer (1998) refers to this as the "mommy wars."

For their part, stay-at-home mothers tell me and write in letters to parenting magazines that they feel that they must pick up the slack for employed mothers. Because of the flexibility inherent in the academic schedule, I volunteer weekly at my children's school and drive frequently on their fieldtrips. Although some of the mothers who are volunteering and driving are employed, the vast majority are mothers who stay at home. Often, the discussion turns into a complaining session in which the stay-at-home mothers report that they feel burdened because they are always the ones to drive on fieldtrips, volunteer in the classroom, and bring in the snacks. They complain that employed mothers just do not

carry their portion of the load at school. Employed mothers, they contest, want all the privileges for their children, but they are unwilling to help to make the special events happen.

For their part, many employed mothers often report that they feel guilty that they are unable to leave work for afternoon fieldtrips. They comment that they feel so overburdened by work and the proverbial "second shift" at home that they simply do not have the time to engage in turkey-cookie construction. They feel guilty when they arrive for a class party with food that they have just picked up at the bakery and see all the homemade treats the other mothers have contributed. Finally, they frequently say that they feel resented by the stay-at-home mothers.

This conflict between employed mothers and stay-at-home mothers was strongly evident in the interviews that are reported here. Emily believed that mothers like Cheryl were depriving their children of necessities and overvaluing their own contributions at home. Cheryl, on the other hand, argued, "I mean, is a child going to be better off if they have a new bike rather than having you at home?" She and the other conformists believed that employed mothers were selling their children short and ignoring their responsibilities as mothers.

Unfortunately, this conflict between employed mothers and those who stay at home cannot be dismissed. First, these data illustrate two important points, that employment status is dynamic and that employment and staying at home full-time are not necessarily mutually exclusive. The cases of the pragmatists point out that many mothers are engaged in a constant reevaluation of their employment status. Given their sensitivity to economic need and structural factors, they are likely to experience changes in employment status throughout their children's youth. Many pragmatists timed out when a baby was born, then returned to work part-time, then full-time; then, they timed out again when another baby was born, and the cycle repeated itself. For these pragmatists, employment status is anything but static. Moreover, the cases of some of the pragmatists and all the innovators illustrate the nonmutual exclusivity of employment and staying at home. Some pragmatists worked part-time and all the innovators were employed and stayed at home—they did both!

Second, as with most issues affecting minorities, an ideology that serves to pit one group of mothers against another serves only to weaken the position of all women. When women are resentful and critical of each other's choices, they will fail to support each other in these choices. For example, employed mothers may not support stay-at-home mothers in their fight for an equitable division of household labor or access to resources. Employed mothers may suggest that if stay-at-home mothers want shared roles at home, they had better be willing to go to work.

Likewise, stay-at-home mothers may be less sympathetic to the fight for longer and more adequately funded maternity leaves and more flexible work schedules because they believe that mothers who want to be with their children should just stay home.

The conflict, as we enter the 21st century, is not limited as it may once have been to stay-at-home mothers and employed mothers. With a growing number of women choosing to remain childless, the situation has now grown to include all three groups of women. Employed mothers are particularly vulnerable to tension with women who are choosing childlessness. Recent workplace discussions that have been made public suggest that some women who are choosing childlessness feel discriminated against by family-friendly policies that they perceive as advantageous to those who have children at the exclusion of those who do not. In fact, on my own campus, there has recently been agitation over just these sorts of policies, including the funding for the building of on-site child care, the financial burden to the university in contributing to family health insurance premiums, and tuition remission. Again, I would argue that this sort of division only serves to weaken the power of all women. As we women continue the painstaking climb to be recognized for our merits, not our wombs, and yet be equitably treated despite our ability to reproduce, our divisiveness only harms all of us. Until we recognize the links between home and work, between employment, fertility, and motherhood, we will not achieve equality in any realm. Until women support and affirm each others' choices, we will continue to shoulder the burden of the second shift, and we will continue to earn 70% of men's wages and face workplace discrimination.

One of the themes that has run through this book is that of evaluating the various strategies that mothers with young children employ to balance and weave work and family. Women evaluate their own choices. Women evaluate the choices of other women. And, experts and nonexperts make claims in public forums about motherhood in general, as well as commenting on the mothering of specific, high-profile mothers. Many evaluations, both public and private, reflect the belief that balancing and weaving work and family is a private, individual matter for mothers, and sometimes fathers, to negotiate. When mothers are not successful in balancing and weaving, they are blamed, often by other women. This divisiveness among groups of women both reflects and recreates this notion that balancing and weaving work and family is an individual endeavor.

This attention to individual behavior diverts attention away from the role that social structure plays in balancing and weaving work and family. As long as issues of mothering and balancing and weaving work and family are defined as individual issues and women's issues, then those in positions of power in the culture will not have to address the structural

constraints that inhibit successful balancing and weaving of work and family, such as the lack of high-quality, affordable child care, responsible family leave policies, and accommodations in the workplace. Moreover, as long as stay-at-home mothers and childfree women view balancing and weaving work and family as problems reserved for employed mothers, then divisiveness will continue to build. Women will lack the power to define these issues as structural issues, and structural solutions will not be proposed. Inequalities at work and home are intertwined and will not be eliminated unless we recognize this relationship. One final comment: Therborn (1980) suggests that ideology exists to serve those in power. As long as the links between home and work continue to be obscured by gender ideologies, women will not be able to resolve the dilemmas posed by gender inequality.

The Power of Ideology

In Chapter 2, I discussed the role that ideology plays in directing behavior. Therborn (1980) notes that ideology defines what exists, what is good, and what is possible, and he postulates that within a given culture, there may be several different ideologies regarding any one of a variety of social issues vying for hegemonic position. The ideology that is held by those in power or that which is beneficial to those in power will reign in the dominant, hegemonic position. Thus, those in power control ideology. Also, because those in power control systems of discourse, the dominant ideology will be pervasive, whereas alternative ideologies that threaten the power structure will have fewer avenues for dissemination and thus will be less accessible.

The power in ideology is not simply that it exists and is controlled by those in power but also that ideology, by defining what exists, what is good, and what is possible, defines behavioral expectations. Thus, controlling ideology is a way to control behavior. In Chapter 2, I argued that in the United States at the beginning of the 21st century, the motherhood ideology holding hegemonic position is that of intensive mothering. Despite strong pockets of resistance to this ideology, contemporary mothers, simply by living in this culture, are exposed to this dominant form of motherhood ideology. Thus, the labor force decisions of mothers with young children will be affected by this dominant motherhood ideology.

Ideology is controlled by those in positions of power, and Therborn (1980) argues that the hegemonic form of ideology benefits those in power. In addition to the outcomes of this hegemony that are discussed above, ideology can also result in false consciousness; thus, mothers will be likely

to accept the dominant ideology even when this is against their own self-interest. In a culture dominated by the ideology of intensive motherhood, some mothers will trade economic independence to stay at home because they believe this is in their best interest. The question of whose interests are best served by the model of intensive mothering is contested terrain. However, as long as the ideology of intensive mothering retains hegemony, it will affect the labor force participation decisions of mothers with young children and subject their decisions to evaluation by themselves and others.

Ideology has the power to dictate behavioral expectations, and it also has the power to result in self-imposed and external judgments of behavior. A mother who is employed because she believes it is in her self-interest may view her decision as selfish because of the ideology of intensive motherhood that she has internalized. The vast majority of mothers today are employed, thus suggesting that the strength of intensive motherhood ideology has weakened. Despite this weakening, the experiences of guilt among employed mothers, especially pragmatists, as well as examples of court cases and public commentary that penalize or criticize employed mothers suggest that intensive motherhood ideology remains dominant. Those who successfully resist the dominant ideology may still experience negative affect and cognitive dissonance as a result of the power and dominance of the hegemonic ideology that results in its internalization.

CHANGING IDEOLOGY?

The degree to which ideology changes at the micro level was addressed in Chapter 5. I argued that an individual may adjust his or her adherence to a particular ideology when the material conditions change such that a shift in ideology is warranted. For example, a mother who reluctantly returns to work because of an increased need for income may come to adhere less to traditional beliefs about motherhood than while she was staying home. This change in ideology may be an attempt to rationalize her change in employment status, or it may result from various influences at work. For example, she may experience self-fulfillment at work, or she may develop friendships with women who are pragmatists and nonconformists. Both of these influences could result in a modification of her own beliefs about motherhood. Similarly, a mother who decides to stay at home after initially returning to work may become more committed to intensive motherhood ideology than she had previously been. She may find self-fulfillment and rewards in being at home that increase her commitment to the tenets of intensive motherhood ideology. However, it is illogical to assume that huge swings in ideology are likely. Whereas a

nonconformist may become more pragmatic or a pragmatist may become more conforming, it is unlikely that a nonconformist will adhere to intensive motherhood ideology.

Based on Therborn's (1980) argument, ideology at the macro level can also undergo change. In fact, one ideological perspective may replace another. For example, Hays (1996) traces the content of motherhood ideology across the 20th century and demonstrates that the ideology of intensive mothering replaced a less intensive ideology of child rearing that had existed during the agricultural and early industrial periods in the United States. However, these sorts of shifts are only likely when they will benefit those in power. One of the most interesting questions that this study has raised for me is the degree to which the four responses to balancing and weaving work and family reflect a shifting in motherhood ideology at the macro level. Clearly, this type of interview sample cannot be used to estimate the actual prevalence of any strategy for balancing or weaving work and family in the larger U.S. population. However, the distribution of the mothers among these four types begs the question of whether motherhood ideology is currently shifting in the United States.

Thirty or 40 years ago, when women's labor force participation rates were at their lowest, at around 32%, the majority of mothers with young children were conformists. In this sample, only one sixth ($n = 5$) of the mothers were categorized as conformists. At the other end of the ideological continuum, only one tenth ($n = 3$) of those interviewed were categorized as nonconformists. The small percentage of nonconformists suggests that outright rejection of the ideology of intensive motherhood has not become dominant. However, the shift away from conformity to being pragmatic or innovative reflects some shift in ideology. With most mothers in this sample being characterized as pragmatists ($n = 14$) or innovators ($n = 8$), it is possible that this phenomenon represents movement from the conforming strategy to the nonconforming strategy, with most mothers occupying a middle space on the continuum. If this is the case, the eventual outcome of the shift would result in the majority of U.S. mothers being identified as nonconformists.

Alternately, the current material situation in the United States has produced a situation in which most mothers are pragmatists or innovators. Perhaps, the shift is not from one extreme position on the continuum to the other but rather reflects the moderating of intensive motherhood ideology with no movement toward dominance by alternative motherhood ideologies. If this is the case, one would expect a period when this moderated form of intensive motherhood ideology dominates and becomes hegemonic.

Because these interviews represent only one moment in time, this study cannot speak to the larger issue of ideological change at the macro level.

I cannot say whether we are undergoing a major ideological shift in which one form of motherhood ideology will displace another in the dominant position. We may have moved into a period dominated by mothers who are less influenced by ideology of any kind and are acting in innovative and pragmatic ways that depend less on ideology. This issue, as well as the state of fatherhood ideology, is clearly worthy of exploration and further study.

As Children Grow

When I first began this study, I was a mother with two preschool-aged children. As I write this final chapter, my children are in the fourth and second grades. I am now a mother in the throes of raising elementary school children. Four years ago, I truly believed that the issues I was exploring were limited to mothers with young children. I thought that balancing and weaving work and family would become easier as my children grew and required less supervision. I can confidently say that I could not have been more wrong! What I now see is that although the process of balancing and weaving work and family changes as families enter new stages, it is in no way eliminated. In fact, certain issues are much harder. For example, our elementary school day runs from 8:45 A.M. to 3:15 P.M. This hardly conforms to the work schedule of most employed parents. Also, the children are off for 2 weeks around Christmas, 1 week in the late spring, and 2½ months during the summer. Not even a university professor has this much time "off." These vacations do not even include the various holidays, teacher workdays, and quarter breaks that are scattered throughout the school year. In North Carolina, school is closed when it threatens to snow. Occasionally, school is also closed when it is too hot. Most employed parents do not work for companies that close under these conditions.

With most mothers and fathers employed during standard hours, the solution to achieving a balancing or weaving of work and family is not simply to encourage fathers to be more involved in the daily care of children. These issues require solutions at the structural as well as the individual levels. As both a scholar and a mother, I have read very little on the issues that face families with school-age children. Thus, I strongly recommend that future research and social policy debates consider the issues facing families as their children grow up.

This study has answered my initial research question. I now understand more clearly what factors are considered as mothers with young children decide whether to stay at home or return to the paid labor force. My hunch that motherhood ideology somehow mattered was confirmed.

The power of intensive motherhood ideology to affect maternal labor force participation, to create guilt within employed mothers, and to influence custody cases illustrates the power of ideology about which Therborn (1980) wrote.

This study has also raised several important questions about measurement, ideological shift, and changes in families as the children mature. What I know is that there are as many different stories as there are mothers and that balancing and weaving work and family continues to be one of the most complex and important issues that families of the new millennium must resolve. Finally, as we move toward ways in which to combine work and family, we need to be mindful of ways in which various strategies adversely affect or benefit each member of the family as well as the workplace. I would argue that conceptualizing the strategies as either balancing or weaving will move us past the notion that women cannot have it both ways. In fact, women can be successful professionally as well as in their roles as mothers when they are supported by partners, family, friends, child care teammates, and those in their workplace in their efforts to seamlessly weave work and family.

Appendix A

Interview Schedule

This interview, which should last approximately 60 to 90 minutes, will explore in more depth how you and your partner (if you have one) arrived at your current arrangements regarding caring for your children. I am interested specifically in what kinds of things were important to you in determining how to provide care for your children.

All your responses will be held confidential. In all probability, there will be publications based on the results of this study, but they will not contain identifying material.

I would be happy to answer any questions you have now, or you may call my advisor, Emily Kane, PhD, at 263-6292 later with questions about the research.

Your participation is completely voluntary; you may stop participating at any time prior to the completion of the project.

In addition, I will be tape recording the interview so as to produce the highest-quality data and to eliminate the possibility that I will quote you inaccurately. The tape recordings will be transcribed for analysis. The tapes will be destroyed after all the data have been published. I will ask you on tape to verbally consent to this study.

I have read the above statement and give my consent to participate in this interview on tape.

signature date

In order to link your questionnaire to this interview and to be sure of the answers to the most important questions, I would like to begin by asking you a few background questions.

Are you currently married?

 yes no, if no: Are you currently cohabiting? yes no

Can you please tell me the names and ages of all the people who live in the household and what their relationship is to you?

Name: Age: Relationship:

Are you employed outside the home?

 Yes No

If yes, number of hours per week: _____

Are you a student?

 Yes No

If yes, are you enrolled as a full-time student or as a part-time student?

Do you stay at home full-time caring for your child(ren)?

 Yes No

Please review for me your child care arrangements for each child.

Please indicate whether the arrangement is regular or occurs intermittently.

Name: Age: Arrangement (is it regular or not?):

Now, I would like to ask you some questions about how you decided how to provide care for your children and what issues were important to you in your decision process.

SATISFACTION WITH ARRANGEMENTS

Overall, please describe your feelings about the ways you and your spouse/partner manage child care.

 Prompts: Do you feel satisfied with your role?

 Do you feel satisfied with his role?

If there were no boundaries (money, time, job structure), what would you change, if anything?

Prompts: work more/work less/have spouse provide more care/have different care (a center vs. home day care, etc.)

THE ACTUAL DECISION-MAKING PROCESS

In terms of the actual decision-making process:

Please describe the ways in which you and your spouse/partner decided how to have your child(ren) cared for.

When did you first discuss this (when first pregnant, right before baby was born, after baby was born, at many times, etc.)

Who would you say had more influence in your decision (your spouse/partner, you, or it was equal)?

Prompts: How do you feel about the process of deciding?
 How do you feel about the outcome of the decision?
 Have you reevaluated the situation since your child was born? (If respondent has multiple children: Have you re-evaluated the situation since your first child was born, i.e., with subsequent births?)

CHANGES IN ARRANGEMENTS

Have you implemented changes?

Has your spouse's/partner's role changed? If so, please describe the changes.

Why do you think these changes occurred?

Do you plan to continue with this same arrangement, or do you expect to change the arrangement as your child(ren) grow older?

If yes, please describe the ways in which you believe it will change (prompts: return to work, go from part-time to full-time, change from family day care to center, etc.).

COSTS AND BENEFITS OF ARRANGEMENTS

When you think about your arrangement, to whom in your family, if anyone, is it beneficial?

How and for whom (prompt relationships)?

When you think about your arrangement, do you think it is less than ideal for any family members?

For whom (prompt relationships)?

How is it not ideal?

 Prompt: Stress on child(ren)
 Stress on spouse/partner
 Stress on relationship with spouse/partner, etc.

When thinking about your child care arrangements, how would you describe them in terms of fairness to you?

 How about to your spouse/partner?

 How about to your child(ren)?

If you feel these arrangements are not exactly fair, how do you justify them?

How does your spouse/partner justify them?

In what ways does your arrangement put stress on or ease stress in your relationship(s) with your child(ren)?

How about with your spouse/partner?

If you find the relationships are stressful, how do you justify the arrangements?

 Prompts: It is best for the children.
 Breastfeeding status: Were arrangements chosen in order to be compatible with breastfeeding?
 It is all we can afford.
 It is only for a few years, etc.

SYMBOLIC NATURE OF CHILD CARE

How do you feel in your role in providing child care?

How does this role make you feel in terms of your position in the family?

What does doing child care mean to you?

What does it mean when your spouse/partner does childcare . . .

 on a regular basis?

 in a spontaneous moment?

 Prompt: Expressing love, care for me, the children, etc.

RELATIVE IMPORTANCE OF FACTORS

Can you tell me why you decided to (stay at home/work part-time/work full-time)? I am interested in what reasons you can think of for why you chose to do what you have done? What issues were part of your consideration?

What factors were important to you in arranging for the care of your child(ren)? I will write them down; can you rank them? (Prompt with

all the factors they do not cite, followed by the question, "Was this important?")

Economics: (How important is cost? How important is your income to your family? What would you be willing to sacrifice financially in order to stay at home full-time?)

Parenting ideology: (How important is it for you that your children be cared for only by parents? Mostly by parents? Other care providers are equally appropriate?)

Symbolic nature of child care: (How important is it for you to take care of your children as a way of caring for them? How does being able to do child care figure into your decision?)

Gender strategy: (To what degree is your decision making related to the duty you think you have to your children? How do you see yourself and your role in relation to your spouse/partners?)

Role identification: (How strongly are you identified with your career? With your role as a mother? Has this identification been important in your decision making?)

Have respondent try to rank factors.

What would you be willing to cut or lose in order to keep your arrangement?

Prompts: my career could suffer
 lower family income
 less time with my spouse
 less leisure time, etc.

What would you change if you could?

Finally, I am interested in how you feel about your own participation in your child's life and the participation of your spouse/partner (if she has one).

How do you feel about your child care responsibilities?

How do you feel when your spouse/partner participates in child care activities?

Prompt: not just playing with the child(ren) but also daily care tasks, such as feeding, diapering, bathing, etc.

Prompt: Do you view it simply as help—his duty—or is it also an expression of how he feels about you? Or do you feel it is more than one of these?

How do you feel when he doesn't help with daily care tasks for the child(ren)?

Prompt: If don't mention more than fairness, prompt with how he feels about me, unloved, etc.

Is there anything else you would like to share with me?

I greatly appreciate the time you have spent. As a mother, I know how precious your time is. I hope that you have learned a little bit about your own choices by thinking about them as part of this study. I will send you a set of the findings of this study if you would like it.

Appendix B

Demographics of the Interview Sample

Conformists

*Cheryl*** is a white, 26-year-old mother of three. Her husband is a pastor in a fundamentalist church. He earns $10,000 to $20,000 per year. He works 45 to 50 hours per week on a rotating shift. They both have had "some college." She stays at home full-time and earns no income.

Jordan is a white, 27-year-old mother of two. Her husband is a restaurant manager, and he earns $20,000 to $30,000 per year. He works 55 hours per week on a rotating shift. He has had "some college." Jordan has a high school diploma. They have no religious affiliation. Jordan stays home full-time and earns no income.

Amy is a white, 27-year-old mother of two. Her husband is a technical administration contractor. He works 45 hours per week during the first shift, and he earns $10,000 to $20,000 per year. He has a bachelor's

** Denotes "case study" mothers who are profiled in various chapters.

degree, and Amy has had "some college." They identify as Christian. Amy stays home full-time and is not employed.

Sue is a white, 29-year-old mother of one child. Her husband is a warehouse worker. He works 68 hours per week during the first shift and earns $20,000 to $30,000 per year. They each have had "some college" and identify as Catholic. Sue earns no income.

Ann is a Native American, 30-year-old mother of two. Her husband works 40 hours a week as a maintenance supervisor. He works during the first shift and earns $30,000 to $40,000 per year. Ann has a high school diploma and her husband has had "some college." She identifies as "other" in religious affiliation. Ann is home full-time and earns no income.

Nonconformists

*Emily*** is a white, 47-year-old mother. Emily is employed 45 hours per week as a hospital administrator. She has an MBA, as does her husband who is a hospital chief financial officer. He works 50 hours per week. Emily's personal income is $50,000 to $75,000, and her husband earns more than $75,000 per year. Their total family income is well above $75,000 per year. They both work during the first shift. They are Protestant and have one child. Emily employs a nanny who does not live in to provide care for her son.

Kiki is a white, 38-year-old mother. Kiki works 40 hours per week as a medical policy analyst. She earns $50,000 to $75,000 per year, as does her husband who is employed as the director of a medical nonprofit organization. Kiki and her husband work during the first shift. They each have had "some graduate training." Their total family income is greater than $75,000. They are Protestant and have two children; one is school age and the other is enrolled in a child care center.

Jennifer is a white, 38-year-old mother. Jennifer is employed full-time as a physical therapist. She has a bachelor's degree and earns $50,000 to $75,000 per year. Her husband is a radiology resident. He has completed his MD and works 56 hours per week while earning $20,000 to $30,000 per year. Their total family income is greater than $75,000 per year. Jennifer works during the first shift, and her husband works rotating shifts. They have their daughter enrolled in a child care center. She indicates that her religious affiliation is "other," and they have one child.

Pragmatists

*Bobbi*** is a white, 34-year-old mother. Bobbi is employed as a market research analyst 50 hours per week. She earns $50,000 to $75,000 per year to her husband's income of $10,000 to $20,000 per year in his 40-hour-per-week job as an arborist. Bobbi has a master's degree while her husband has a bachelor's. Their total family income is greater than $75,000 per year. They report having no religious affiliation, and they have two young children. Bobbi employs a nanny who does not live in to care for her children.

*Tammy*** is a white, 32-year-old mother of two. She holds a bachelor's degree, and her husband holds an associate's degree. He is employed as a contract administrator and works 55 hours per week during the first shift. He earns greater than $75,000 per year. They are Protestant. Tammy currently stays at home full-time and earns no income.

Jane is a white, 30-year-old mother of one. She was pregnant at the time of the interview. Her husband is an engineer and works 50 hours per week during the first shift, earning $50,000 to $75,000 per year. He holds a bachelor's degree, and she holds an associate's degree. They are Catholic. She currently stays at home full-time and earns no income.

Deborah is a white, 28-year-old mother of one. Her husband owns his own company. They each hold a high school diploma. Her husband works 60 hours per week during first hours and on weekends. He earns $50,000 to $75,000 per year. They are Catholic. Deborah stays at home full-time and earns no income.

Kathy is a white, 31-year-old mother. She earns $2,000 to $10,000 per year working 20 hours per week as a vocational counselor. Their total family income is $20,000 to $30,000 per year. She has a master's degree. Her husband had just finished his PhD and taken a faculty position he would begin in July 1995. At the time of the interview, he was working as a teaching assistant. They both work during the first shift. They have two children and are Episcopalian. Their children are cared for in a family-home day care.

Barb is a white, 25-year-old mother. Barb works two jobs: She drives a school bus and works as a waitress in the evenings. She works 25 hours per week and earns $2,000 to $10,000 per year. Barb works rotating shifts. Her husband works as a laborer for 60 hours a week during the

second shift. He earns $20,000 to $30,000 per year. Their total family income is $30,000 to $40,000 per year. Barb relies on a neighbor to provide child care while she is working. She is a high school graduate, as is her husband. They have three children and have no religious affiliation.

Kerry is a white, 31-year-old mother. Kerry works full-time (45 hours per week) as a medical technician during the first shift. She earns $20,000 to $30,000 per year, as does her husband who works 45 hours per week as a court analyst. He also works during the first shift, and their son is enrolled in a child care center. Their total family income is $50,000 to $75,000 per year. They both have college degrees. They are Catholic and have one child.

Renee is a white, 32-year-old mother. Renee works 32 or more hours per week as a publication coordinator, and her husband works 40 hours per week as a sales representative. They both work during the first shift, and they both earn $20,000 to $30,000 per year. Their total family income is $40,000 to $50,000 per year. Renee has a bachelor's degree, and her husband has an associate's degree. They are nondenominational and have one child. Renee relies on her mother and mother-in-law to provide care for her daughter while they are working.

Mary is a white, 29-year-old mother. She is a computer programmer with a bachelor's degree. She works 24 hours per week and earns $10,000 to $20,000 per year. Her husband, a research scientist, holds a PhD. He works 48 hours per week and earns $30,000 to $40,000 per year; their total family income is $40,000 to $50,000 per year. They both work during the first shift. They are Catholic, have two young children, and use a child care center to provide care while they are both at work.

Chris is a white, 31-year-old mother. Chris has had some graduate training and is a chemist. She works 40 hours per week and earns $20,000 to $30,000 per year. Her husband has a master's degree and works 40 hours per week as an engineer. He earns $50,000 to $75,000 per year, which is also the range in which their total family income falls. They work partially overlapping shifts. They are also Catholic and have one young child who is enrolled in a preschool program.

Becky is a white, 43-year-old mother. Becky holds an associate's degree and works in food service an average of 30 hours per week. She earns $10,000 to $20,000 per year. Her husband is a lawyer who works 60 hours per week earning greater than $75,000 per year. Their total family income is therefore also in that range. They both work during the

first shift. They are Jewish. Becky has one older child from a previous marriage and one young child from this marriage. They utilize a family-home day care provider.

Libby is a white, 26-year-old mother. Libby is a legal secretary with an associate's degree. She works 21 hours per week earning $2,000 to $10,000 per year. Her husband also holds an associate's degree. He works 45 hours per week as a lineman, earning $40,000 to $50,000 per year. Their total family income is $50,000 to $75,000 per year. They have one small child who is in a family-home day care while his parents work during the first shift. They identify as Protestants.

Colleen is a white, 31-year-old mother. She is a medical technician. She holds a bachelor's degree. Working for 24 hours per week, Colleen earns $10,000 to $20,000 per year. Her husband works 40 to 80 hours per week as a software engineer. He also holds a bachelor's degree and earns $40,000 to $50,000 per year. Their total family income is $50,000 to $75,000 per year. They indicate that they have no religious affiliation. They have one child who is in a family-home day care on a part-time basis as Colleen works the first shift and her husband works rotating shifts.

Innovators

*Jean*** is a white, 37-year-old mother. Jean works full-time as a packer for a local meat manufacturer during the third shift. She earns $10,000 to $20,000 per year. Her husband works full-time as a custodian during either the first or second shift (depending on the time of year) and earns $20,000 to $30,000 per year for a total family income of $40,000 to $50,000. Jean and her husband are high school graduates. They are Catholic and have six children. They rely on no paid child care.

*Haley*** is a white, 32-year-old mother. Haley works out of her home as a legal assistant 15 hours per week. She holds a bachelor's degree and earns $20,000 to $30,000 per year. Her husband is a lawyer. He works 50 hours per week during the first shift, earning $40,000 to $50,000 per year. Their combined income is $50,000 to $75,000 per year, and they have two children. Because Haley works from home, they rely on no paid child care. They are Catholic.

*Kate*** is a white, 31-year-old mother. Kate owns her own retail business selling dance and fitness wear. She works 30 hours per week during rotating shifts. Kate has had "some college" and earns $2,000 to $10,000 per year. Kate's husband supplies most of the family income by working as an

MIS (computer) manager 45 hours per week during the first shift. He also has had "some college." He earns $50,000 to $75,000 per year, and their total family income also falls in this category. They are Catholic and have one child. Kate takes her child to work with her each day in order to care for her.

Lori is a white, 33-year-old mother. Lori works as a secretary 45 hours a week, during the first shift, earning $20,000 to $30,000 per year. Her husband works as a welder 50 hours per week during the second shift. He earns $30,000 to $40,000 per year for a total family income of $50,000 to $75,000 per year. They each have had "some college," they are Protestant, and they have a set of twins. They use 15 hours per week of paid child care.

Laura is a white, 32-year-old mother. Laura is employed in clerical work for 30 hours per week. She earns $20,000 to $30,000 per year and has an associate's degree. Her husband works 37 hours per week as a computer operator. He has had "some college" and earns $20,000 to $30,000 per year. Their total family income is $40,000 to $50,000 per year. They are Catholic and have one child. They both work first-shift hours, but they work on different days. They rely on 4 hours per week of paid child care.

Liz is a white, 27-year-old mother. Liz provides child care in her home 40 hours per week for one child. She has had "some college" and earns $0 to $2,000 per year. Her husband provides the main income for the family. He works 25 hours per week for UPS earning $10,000 to $20,000 per year and is also a full-time student completing his bachelor's degree. He works or studies during rotating shifts. Their total family income is $20,000 to $30,000 per year. They are nondenominational and have three children. Liz, though employed, is home full-time.

Denise is a white, 33-year-old mother. Denise owns her own business; she is a creative resume designer. She earns $10,000 to $20,000 per year for working 15 hours per week and holds an associate's degree. Her husband works 45 hours per week during the first shift as an auto technician. He also holds an associate's degree and earns $30,000 to $40,000 per year. Their total family income is also in this range. They hold pagan beliefs and have one child. Because Denise works from home, they rely on no paid child care.

Stacey is a white, 33-year-old mother of two. She holds an associate's degree and works 30 hours per week in a bank. She earns $20,000 to

$30,000 per year. Her husband owns his own small business. He holds a bachelor's degree, works 50 hours per week, and earns $10,000 to $20,000 per year. Their total family income is $30,000 to $40,000 per year. One of her children is school age and the other is cared for 20 hours per week by Stacey's husband, 6 hours per week by Stacey's mother, and 6 hours per week in a family-home day care. They are Protestant.

Appendix C

Frequency Distributions for Relevant Demographic Variables Broken Down by Entire Sample, Volunteer Sample, and Interview Sample

Table C.1 Percent Distribution for Types of Child Care Utilized

Child Care	Survey Sample	Volunteer Sample	Interview Sample
Spouse	51.4%	45.2%	44.0%
Relative	16.9%	29.2%	22.0%
Nanny	10.5%	11.5%	25.9%
Family-home day care	33.5%	28.6%	11.1%
Child care center	23.7%	26.6%	32.0%
N	212	73	27

NOTE: Percentage is based on using each type of child care at least 5 hours per week. Percentages will not add to 100 due to many families utilizing more than one type of childcare.

Table C.2 Percent Distribution of Mothers' Employment Status

Employment Status	Survey Sample	Volunteer Sample	Interview Sample
Employed	73.3%	69.2%	78.6%
Not employed and looking	3.7%	6.4%	0%
Not employed and not looking	23.0%	24.4%	21.4%
N	217	78	28

Table C.3 Percent Distribution for Hours Employed for All Employed Mothers

Hours Worked Per Week	Survey Sample	Volunteer Sample	Interview Sample
1-10	8.3%	7.4%	4.6%
11-20	16.6%	16.7%	18.3%
21-30	16.6%	18.5%	27.2%
31-40	38.2%	37.1%	40.9%
more than 40	20.3%	20.3%	9.1%
N	157	54	22

Table C.4 Percent Distribution of Mothers' Racial Identification

Race	Survey Sample	Volunteer Sample	Interview Sample
White	95.3%	95.0%	96.4%
African American	0%	0%	0%
Hispanic	.9%	0%	0%
Asian	2.8%	2.6%	0%
Native American	.9%	2.6%	3.6%
N	215	78	28

Table C.5 Percent Distribution of Mothers' Educational Attainment

Level of Education	Survey Sample	Volunteer Sample	Interview Sample
Less than high school	0%	0%	0%
High school or equivalent	11.4%	12.7%	14.3%
Some college	20.9%	17.7%	21.4%
Associate's degree	15.9%	16.5%	17.9%
Bachelor's degree	24.5%	20.3%	28.6%
Some graduate school	9.5%	13.8%	7.1%
Master's degree	12.3%	16.5%	10.7%
Professional degree (MD, JD, PhD)	5.5%	2.5%	0%
N	220	79	28

Table C.6 Percent Distribution of Mothers' Personal Income

Mothers' Personal Income in Dollars	Survey Sample	Volunteer Sample	Interview Sample
0-2,000	18.9%	22.1%	14.8%
2,001-10,000	17.2%	22.1%	22.3%
10,001-20,000	26.7%	18.2%	25.9%
20,001-30,000	17.2%	16.9%	18.5%
30,001-40,000	11.5%	14.3%	3.7%
40,001-50,000	3.3%	0%	0%
50,001-75,000	3.8%	5.2%	14.8%
More than 75,000	1.4%	1.2%	0%
N	217	78	27

Table C.7 Percent Distribution of Mothers' Total Household Income

Mothers' Personal Income in Dollars	Survey Sample	Volunteer Sample	Interview Sample
0-10,000	.9%	1.3%	0%
10,001-20,000	2.4%	2.6%	3.6%
20,001-30,000	10.2%	8.9%	14.3%
30,001-40,000	20.7%	16.7%	14.3%
40,001-50,000	20.7%	19.2%	14.3%
50,001-75,000	30.4%	35.9%	35.6%
More than 75,000	14.7%	15.4%	17.9%
N	217	78	28

Appendix D

Sampling and Measurement

The women interviewed for this project came from an interview pool that was generated from responses to a mailed questionnaire. In April 1995, a survey was mailed to 450 mothers, who were randomly selected from all women who gave birth in Dane County, Wisconsin, during January, February, and March 1994. These birth months were chosen in order to assure obtaining mothers with young children (the children were between 12 and 15 months at the time their mothers received the survey) and in an attempt to avoid surveying women on prolonged maternity leaves. This 3-month period of time yielded approximately 1,000 births from which to draw the sample of 450 birth mothers. Due to confidentiality laws regarding paternity establishment, records of nonmarital births were excluded. In addition, births to mothers under the age of 18 were excluded due to issues of informed consent. Both of these exclusions were not viewed as problematic given my interest in exploring child care decision making among families who did not have restrictions on employment. Both teenage and unmarried mothers are constrained by structural factors and may not be able to make employment decisions as freely. Fifty-two percent of the women surveyed (N = 230) returned usable data. Of those 230 respondents, 80 (35%) indicated that they would be willing to be

interviewed. Appendix C contains a set of tables illustrating the demographic characteristics of the sample as a whole, the group volunteering for interviews, and those actually interviewed.

From the 80 mothers who indicated a willingness to be interviewed, I purposively selected 30 mothers with whom I arranged and conducted intensive interviews. Given the objectives of this study, the purposive sample was generated with attention to four variables of interest (all of which had been measured in the mailed questionnaire).

Work status. I sampled equal numbers of women who were not employed outside the home, who were employed part-time outside the home, and who were employed full-time outside the home.

Income (total family income, the proportion of income provided by the mother, and the proportion of income provided by the father). I sampled women whose total family incomes were among the lowest and highest in the sample and those who fell in the middle. In addition, I sampled mothers who were, in effect, primary providers, coproviders, and supplemental providers (as well, of course, as those who provided no income).

The number of children in the household. I was careful to sample mothers for whom the focal child (the birth for which the mother was sampled) was the only child and those for whom other young children were living in the household (i.e., for whom the focal child was not their first or their last child). The largest family had 6 children.

The type of child care utilized. Among women who were employed, I was careful to sample women who provided all the child care themselves, those who shared the child care with their spouses, and those who engaged paid child care providers. Paid child care included the use of nannies, relatives, family-home day care providers, and child care centers.

I scheduled and conducted interviews between May and August 1995. The interviews were conducted in the homes of the women, in the women's places of employment, or in a neutral site such as at a restaurant over lunch. The interviews were audiotape-recorded and transcribed. Although the actual interview time was between 60 and 90 minutes, I often spent up to 2 hours with these women. I interviewed many of the women in their homes while they were supervising their children. My discussions with these women were often conducted in the midst of attending to the needs of the child or children.

Based on the literature and theoretical models discussed in the book, and in order to propose a more complex model to understand mothers'

labor force participation choices, it was critical to address the following concepts. Both qualitative and quantitative measures were developed. The interview schedule is available in Appendix A. A copy of the survey may be obtained by contacting the author.

Economic need. Based on an extensive literature that focuses on the role that economic need plays in maternal labor force participation, it was critical to include measures of economic need in the study. As noted by Eggebeen and Hawkins (1990), economic need has both an objective component and a subjective component. Therefore, I focused on the actual need that the family had for income as well as the mother's perception of this need relative to the importance of other needs, such as providing maternal or parental care for her children.

Motherhood ideology. Motherhood ideology has to do with how mothers perceive the role of mother: Mothers should stay at home raising their children (intensive motherhood ideology) or continue to pursue their own interests even when they have small children (alternative motherhood ideology). As part of this section, respondents were asked to rank and evaluate care providers and give details regarding their ranking system.

Gender strategy. Gender strategy includes a discussion of the preferred family structure for these mothers. Measurement focused on gender roles with respect to the household and employment patterns.

Role identification. Role identification includes a discussion of the importance of career and mother roles to these women. The measurement focused on a discussion of the personal reasons these women reported for choosing to participate or not in the labor force.

Costs and benefits. Costs and benefits of the chosen arrangement, based primarily on the perceptions of the mothers, were explored. Mothers were asked to list the costs and benefits of their situations with respect to employment and child care choices.

The decision process. The actual decision-making process: Mothers were asked to describe the process they underwent in resolving the job-family conflict. This included a detailed discussion of the history of their labor force participation and utilization of child care. Changes these women had made or anticipated making in their labor force participation or child care were discussed.

Outcomes. This included measuring mothers' satisfaction with their past and their current child care arrangements and employment situations.

Fertility intentions. After interviewing Cheryl, my third interview, the relationship between fertility intentions and employment patterns, as noted by Glass (1992), was confirmed. In addition, Cheryl's interview suggested that fertility intentions are also related specifically to mothers' decisions about whether to pursue employment while their children are young. Therefore, though it was not originally in the interview schedule, I asked all the remaining mothers ($N = 27$) about their fertility intentions. I also asked women if their labor force decisions affected their future fertility intentions.

Demographic variables. Some of these were also measured as part of the interview: (1) household composition, (2) work status, including employment hours and schedule, and (3) child care arrangements. All other demographic variables necessary for the analysis were taken directly from the mother's mailed questionnaire. These included age, marital status and marital history, race, religion, household composition (including the number of children in the household and their ages and genders), age at first birth, educational attainment, income, socioeconomic status, and employment status (including occupation). Additionally, subjects were asked to review their employment schedule and to delineate the child care arrangements that were in place for each child in the household.

Part of this project was the development of a scale to measure motherhood ideology. Items were generated from concepts in the academic and parenting literature. The eight items include the following statements to which respondents indicated the degree to which they agreed or disagreed with each statement. Strongly agree was coded "1" and strongly disagree was coded "5." Items marked with an asterisk were reverse scored.

- Mothers who stay at home should sometimes use some paid child care in order to pursue their own interests.*
- Having a lower family income is worth it if mothers could stay at home with their children.
- Mothers of young children (3 years old and under) should only work if their families need the money.
- Mothers should not work outside the home when their children are small (under 3).
- Families benefit when mothers stay at home to care for the children.

- Though many children may benefit by having mothers who stay at home with them full-time, mothers may be hurt by this arrangement.*
- Everyone benefits by living in a household where both mother and father work outside the home at least part-time.*
- If I cannot provide for all my children's needs by myself, I feel guilty.

The range of the scale is 8 to 40 with lower scores indicating nonconforming beliefs and higher scores indicating conforming to intensive motherhood ideology. The mean score was 23.36. The reliability of this scale is .76; thus, it is believed to be a reliable measure of motherhood ideology.

This survey has several flaws that must be addressed. First, the response rate for the survey was lower than is ideal. We have no way of knowing about how the mothers who returned their completed surveys differ from those who refused to participate. Second, the survey was conducted in one county in the upper Midwest. Therefore, the sample is not representative of all mothers in the United States. Clearly underrepresented groups are even more likely to be excluded from the results than white, middle-class mothers. Again, this limits the overall generalizability of the survey. However, because the survey relied on a random sample of mothers across the county, it retains many of the strengths we typically associate with survey methods and allows us a chance to examine the relationship between motherhood ideology and maternal labor force participation.

Finally, it is important to reemphasize the fact that the survey was based on a sample of mothers who were married at the time of the birth of the focal child. Though this clearly leaves me unable to speak to the relationship between motherhood ideology and maternal employment among unmarried mothers, this does not particularly trouble me. This study focused on strategies for balancing work and family among mothers who had a partner. Because of this, I was able to examine labor force participation choices within a context where all mothers had a choice, at least theoretically. Single mothers are restricted in their choices because they are solely responsible for meeting the economic needs of their children. If anything, mothers who are married have more choices, and therefore, these choices will reflect their preferences. Thus, though this sample is not representative of the U.S. population, this bias does not significantly affect the assumptions or findings of this study. In fact, this sample creates a situation of constancy; marital status, one of the best predictors of maternal employment, is not varied. How mothers made these choices is the focus of this investigation.

Appendix E

Quantitative Data

Table E.1 Analysis of Variance of the Relationship Between Motherhood Ideology and Employment Status

Employment Status	Motherhood Ideology		
	N	M	SD
Employed mothers	157	21.66	5.7
Stay-at-home mothers	50	28.9	5.0
Total	207	23.41	6.34

ANOVA					
	SS	df	MS	F	p value
Between groups	1989.986	1	1989.986	64	.0000
Within groups	6307.927	205	30.770		
Total	8297.913	206			

Table E.2 Relationship Between Motherhood Ideology and
 Employment Status Among Mothers With Young Children

Employment Status	Motherhood Ideology			
	Low (11-19)	Moderate (20-24)	High (25-36)	Total
Employed	93.3% (70)	81.3% (52)	51.5% (35)	75.8% (157)
Not employed	6.7% (5)	18.8% (12)	48.5% (33)	24.2% (50)
Total (100%)	75	64	68	207

The measure of motherhood ideology used in this analysis is taken from the scores on the motherhood ideology scale, discussed in Appendix D. Scores ranging from 11 to 19 are coded as low or not traditional; those from 20 to 24 are coded as moderate; and those from 25 to 36 are coded as high or traditional. These three ranges of scores were picked so as to divide the respondents into groups of equivalent size; each category contains one third of the respondents.

$\chi^2 = 35.59$; $p < 0000$.

Table E.3 OLS Regression Testing Predictors of Labor Force Participation
 of Mothers With Young Children

The dependent variable is continuous, ranging from 0 to 60 hours of employment reported per week.

Variable	Model 1		Model 2		Model 3		Model 4	
	ß	SE	ß	SE	ß	SE	ß	SE
Afford Childcare	.056	1.17	0.58	1.16	.107	1.126	.097	1.03
Better Available Childcare	.183*	1.20	.179*	1.19	.152*	1.155	.182**	1.06
Mother's Education	.176*	.802	.193**	.802	.127	.776	.102	.724
Number of Kids	-.064	1.38	-.083	1.38	-.013	1.339	-.030	1.24
Mother's Occupation	-.195**	1.33	-.193**	1.32	-.127	1.300	-.122	1.19
Spouse's Income	-.160**	.811	-.159**	.805	-.130	.783	-.145**	.717
Child Care Preferences			.128*	.369			.196**	.330
Motherhood Ideology (single item)					-.307**	.930		
Motherhood Ideology							-.462**	.193
Constant	10.761	7.67	2.053	8.86	17.266**	7.466	27.902**	8.59
Adjusted r^2 for each model	.156		.168		.234		.351	

$^*p < .05$; $^{**}p < .01$; $^{***}p < .001$.

References

Aldrich, C. A., & Aldrich, M. M. (1938). *Babies are human beings*. New York: Macmillan.

Amott, T., & Matthaei, J. (1996). *Race, gender, and work: A multi-cultural economic history of women in the United States*. Boston: South End.

Bachu, A. (1993). *Fertility of American women: June 1992* (U.S. Bureau of the Census, Current Population Reports, P20-470). Washington, DC: Government Printing Office.

Barnett, R. C., & Rivers, C. (1996). *She works, he works: How two-income families are happy, healthy, and thriving*. Cambridge, MA: Harvard University Press.

Becker, G. S. (1981). *A treatise on the family*. Cambridge, MA: Harvard University Press.

Berk, R. A. (1979). *The new home economics: An agenda for sociological research*. Beverly Hills, CA: Sage.

Brannen, J., & Moss, P. (1987). "Fathers in dual-earner households—through mothers' eyes" in C. Lewis and M. O'Brien (Eds.), *Reassessing fatherhood: New observations on fathers and the modern family*, pp. 126-143. London: Sage.

Brayfield, A. (1995). A bargain at any price? Child care costs and women's employment. *Social Science Research, 24*, 188-214.

Brazelton, T. B. (1992). *Touchpoints: The essential reference*. Reading, MA: Perseus.

Cattan, P. (1991). Childcare problems: An obstacle to work. *Monthly Labor Review, 114*, 3-9.

Chaiken, S. (1986). Physical appearance and social influence. In C. P. Herman, M. P. Zanna, & E. T. Higgins (Eds.), *Physical appearance, stigma, and social behavior* (The Ontario Symposium, Vol. 3, pp. 143-177). Hillsdale, NJ: Lawrence Erlbaum.

Chebat, J. -C., Filiatrault, P., & Perrien, J. (1990). Limits of credibility: The case of political persuasion. *Journal of Social Psychology, 130*, 157-167.

Collins, R. (1992). Love and property. In *Sociological insight: An introduction to non-obvious sociology* (2nd ed., pp. 119-139). London: Oxford University Press.

Coontz, S. (1992). *The way we never were: American families and the nostalgia trap.* New York: Basic Books.

Coontz, S. (1997). *The way we really are: Coming to terms with America's changing families.* New York: Basic Books.

Dreikurs, R. (1958). *The challenge of parenthood.* New York: Penguin.

Eagly, A. H., & Chaiken, S. (1975). An attribution analysis of the effects of communicator characteristics on opinion change: The case of communicator attractiveness. *Journal of Personality and Social Psychology, 32,* 136-144.

Eagly, A. H., Wood, W., & Chaiken, S. (1978). Casual inferences about communicators and their effect on attitude change. *Journal of Personality and Social Psychology, 36,* 424-435.

Edin, K., & Lein, L. (1997). *Making ends meet: How single mothers survive welfare and low-wage work.* New York: Russell Sage Foundation.

Eggebeen, D. J., & Hawkins, A. J. (1990). Economic need and wives' employment. *Journal of Family Issues, 11,* 48-66.

Engels, F. (1884). *The origin of the family, private property, and the state.* Chicago: C. H. Kerr.

England, P., & Farkas, G. (1986). *Households, employment, and gender: A social, economic, and demographic view.* Hawthorne, NY: Aldine.

Estes, S. B., & Glass, J. L. (1996). Job changes following childbirth: Are women trading compensation for family-responsive work conditions? *Work and Occupations, 23,* 405-436.

Etaugh, C., & Study, G. G. (1989). Perceptions of mothers and effects of employment status, marital status, and age of child. *Sex Roles, 20,* 59-70.

Ferree, M. M. (1990). Beyond separate spheres: Feminism and family research. *Journal of Marriage and the Family, 52,* 866-884.

Folk, K. F., & Yi, Y. (1994). Piecing together child care with multiple arrangements: Crazy quilt or preferred pattern for employed parents of preschool children? *Journal of Marriage and the Family, 56,* 669-680.

Galinsky, E. (1999). *Ask the children: What America's children really think about working parents.* New York: William Morrow.

Garey, A. I. (1995). Constructing motherhood on the night shift: "Working mothers" as "stay-at-home moms." *Qualitative Sociology, 18,* 415-437.

Garey, A. I. (1999). *Weaving work and motherhood.* Philadelphia: Temple University Press.

Gerson, K. (1985). *Hard choices: How women decide about work, career, and motherhood.* Berkeley: University of California Press.

Gerson, K. (1993). *No man's land: Men's changing commitments to family and work.* New York: Basic Books.

Glaser, B. G., & Strauss, A. L. (1967). *The discovery of grounded theory.* New York: de Gruyter.

Glass, J., & Camarigg, V. (1992). Gender, parenthood, and job-family compatibility. *American Journal of Sociology, 98*(1), 131-151.

Glass, J. L., & Riley, L. (1998). Family responsive policies and employee retention following childbirth. *Social Forces, 76*(4), 1401-1435.

Glenn, E. N. (1994). Social constructions of mothering: A thematic overview. In E. N. Glenn, E. Nakano, G. Chang, & L. R. Forcey (Eds.), *Mothering: Ideology, experience, and agency* (pp. 1-29). New York: Routledge.

Gnezda, M. T., Hock, E., & McBride, S. L. (1984). Mothers of infants: Attitudes toward employment and motherhood following birth of the first child. *Journal of Marriage and the Family, 46*(2), 425-431.

Goldscheider, F. K., & Waite, L. J. (1991). *New families, no families? The transformation of the American home.* Berkeley: University of California.

Gordon, L. (1988). *Heroes of their own lives: The politics and history of family violence.* New York: Penguin.

Haas, R. G. (1981). Effects of source characteristics on cognitive responses and persuasion. In R. E. Petty, T. M. Ostrom, & T. C. Brock (Eds.), *Cognitive responses in persuasion.* Hillsdale, NJ: Lawrence Erlbaum.

Harding, S. (1986). The instability of the analytical categories of feminist theory. *Signs, 11*(4), 645-664.

Hayes, C., Palmer, J. L., & Zaslow, M. J. (Eds.). (1990). *Who cares for America's children? Child care policy for the 1990s.* Washington, DC: National Academy Press.

Hays, S. (1996). *The cultural contradictions of motherhood.* New Haven, CT: Yale University Press.

Hertz, R., & Ferguson, F. L. T. (1996). Childcare choice and constraints in the United States: Social class, race, and the influence of family views. *Journal of Comparative Family Studies, 27,* 249-280.

Hill-Collins, P. (1994). Shifting the center: Race, class, and feminist theorizing about motherhood. In E. N. Glenn, E. Nakano, G. Chang, & L. R. Forcey (Eds.), *Mothering: Ideology, experience, and agency.* New York: Routledge.

Hochschild, A. R. (1989). *The second shift* (A. Machung, Writer). New York: Avon.

Hochschild, A. R. (1997). *The time bind: When work becomes home and home becomes work.* New York: Metropolitan Books.

Horai, J., Naccari, N., & Fatoullah, E. (1974). The effects of expertise and physical attractiveness upon opinion agreement and liking. *Sociometry, 37,* 601-606.

Howard, J. (1998, October 19). A legal full-court press: Can a single mom—the Sparks' Pam McGee—raise a child and play in the WNBA? *Sports Illustrated,* p. 23.

Jaggar, A. M. (1988). *Feminist politics and human nature.* Totowa, NJ: Rowman & Littlefield.

Kessler-Harris, A. (1990). *A woman's wage: Historical meanings and social consequences.* Lexington: University Press of Kentucky.

Klein, E. (1984). *Gender politics.* Cambridge, MA: Harvard University Press.

Knapp, G. (1997, August 17). What does Reggie know? *The Indianapolis Star.*

La Leche League International. (1991). *The womanly art of breastfeeding* (5th ed.). New York: Penguin.

LaRossa, R., & LaRossa, M. M. (1989). Baby care: Fathers vs. mothers. In B. J. Risman & P. Schwartz (Eds.), *Gender and intimate relationships: A microstructural approach.* Belmont, CA: Wadsworth.

Leach, P. (1994). *Children first.* New York: Knopf.

Leibowitz, A., Waite, L. J., & Witsberger, C. (1988). Child care for preschoolers: Differences by child's age. *Demography, 25,* 205-220.

Lenski, G., Nolan, P., & Lenski, J. (1995). *Human societies.* New York: McGraw-Hill.

Leslie, L. A., Anderson, E. A., & Branson, M. P. (1991). Responsibility for children: The role of gender and employment. *Journal of Family Issues, 12,* 197-210.

Leuck, M., Orr, A., & O'Connell, M. (1982). *Trends in child care arrangements of working mothers* (U.S. Bureau of the Census, Current Population Reports, Series P-23, No. 117). Washington, DC: Government Printing Office.

Luker, K. (1984). *Abortion and the politics of motherhood.* Berkeley: University of California Press.

Maddux, J. e., & Rogers, R. W. (1980). Effects of source expertness, physical attractiveness, and supporting arguments on persuasion: A case of brains over beauty. *Journal of Personality and Social Psychology, 39,* 235-244.

Mason, K. O., & Kuhlthau, K. (1989). Determinants of child care ideals among mothers of preschool-aged children. *Journal of Marriage and the Family, 51,* 593-603.

McHale, S. M., & Crouter, A. C. (1992). You can't always get what you want: Incongruence between sex-role attitudes and family work roles and its implications for marriage. *Journal of Marriage and the Family, 54,* 537-547.

McLanahan, S., & Glass, J. L. (1985). A note on the trend in sex differences in psychological distress. *Journal of Health and Social Behavior, 26*(4), 328-336.

McLanahan, S., & Sandefur, G. (1994). *Growing up with a single parent: What hurts, what helps.* Cambridge, MA: Harvard University Press.

McMahon, M. (1995). *Engendering motherhood: Identity and self-transformation in women's lives.* New York: Guilford.

Merton, R. K. (1975). *Social theory and social structure.* Glencoe, IL: Free Press.

Moore, K. A., & Hofferth, S. L. (1979). Women and their children. In R. E. Smith (Ed.), *The subtle revolution: Women at work* (pp. 125-158). Washington, DC: Urban Institute.

The need to treat yourself [Time for you, sex & marriage: Dr. Evelyn Bassoff answers readers' intimate questions]. (1999, May). *Parents,* p. 85.

Newsweek. (1996, October 6, pp. 23-28).

O'Connell, M., & Rogers, C. C. (1983). *Child care arrangements of working mothers: June 1982.* (U.S. Bureau of the Census, Current Population Reports, Series P-23, No. 129). Washington, DC: Government Printing Office.

O'Kelly, C. G., & Carney, L. S. (1986). *Women and men in society: Cross-cultural perspectives on gender stratification.* Belmont, CA: Wadsworth.

Parsons, T., & Bales, R. (1955). *Family, socialization, and the interaction process.* Glencoe, IL: Free Press.

Perry-Jenkins, M., & Crouter, A. C. (1990). Implications of men's provider role: Attitudes for household work and marital satisfaction. *Journal of Family Issues, 11,* 136-156.

Peterson, R. R., & Gerson, K. (1992). Determinants of responsibility for child care arrangements among dual-earner couples. *Journal of Marriage and the Family, 54,* 527-536.

Pleck, J. H. (1979). Men's family work: Three perspectives and some new data. *Family Coordinator, 28,* 481-488.

Polachek, S. (1981). Occupational self-selection: A human capital approach to sex differences in occupational structure. *Review of Economics and Statistics, 63,* 60-69.

Presser, H. B. (1986). Shift work among American women and child care. *Journal of Marriage and the Family, 48* 551-563.

Presser, H. B. (1988). Shift work and child care among young dual-earner American parents. *Journal of Marriage and the Family, 50,* 133-148.

Presser, H. B. (1989). Can we make time for children? The economy, work schedules, and child care. *Demography, 26,* 523-543.

Presser, H. B. (1994). Employment schedules among dual-earner spouses and the division of household labor by gender. *American Sociological Review, 59,* 348-364.

Reskin, B., & Padavic, I. (1994). *Women and men at work.* Thousand Oaks, CA: Pine Forge Press.

Rollins, J. (1985). *Between women: Domestics and their employers.* Philadelphia: Temple University Press.

Romero, M. (1992). *Maid in the U.S.A.* New York: Routledge.

Rosenfeld, R., & Spenner, K. (1992). Occupational sex segregation and women's early career job shifts. *Work and Occupations, 19,* 424-449.

Ross, C. E., Mirowsky, J., & Huber, J. J. (1983). Dividing the work, sharing the work, and in-between: Marriage patterns and depression. *American Sociological Review, 48,* 809-823.

Rubenstein, C. (1998). *The sacrificial mother.* New York: Hyperion.

Saltzman, A. (1997, February 10). A family transfer. *U.S. News & World Report*, pp. 60-62.

Scarr, S., Phillips, D., & McCartney, K. (1989). Working mothers and their families. *American Psychologist, 44*(11), 1402-1409.

Segura, D. A. (1994). Working at motherhood: Chicana and Mexican immigrant mothers and employment. In E. N. Glenn, E. Nakano, G. Chang, & L. R. Forcey (Eds.), *Mothering: Ideology, experience, and agency*. New York: Routledge.

Shorter, E. (1975). *The making of the modern family*. New York: Basic Books.

Shostak, M. (1981). *Nisa: The life and words of a !Kung woman*. New York: Random House.

Spock, B., & Parker, S. J. (1998). *Dr. Spock's baby and child care* (7th ed.). New York: Pocket Books.

Stafford, R., Beckman, F., & Dibona, P. (1977). The division of labor among cohabiting and married couples. *Journal of Marriage and the Family, 39,* 43-56.

Strauss, A., & Corbin, J. (1990). *Basics of qualitative research: Grounded theory procedures and techniques*. Newbury Park, CA: Sage.

Strober, M. H. (1990). Human capital theory: Implications for HR managers. In D. I. B. Mitchell & M. A. Zaidi (Eds.), *The economics of human resource management*. Oxford, UK: Basil Blackwell.

Strober, M. H., & Chan, A. M. K. (1999). *The road winds uphill all the way: Gender, work, and family in the United States and Japan*. Cambridge: MIT Press.

Tanner, N., & Zihlman, A. (1976). Women in evolution, Part I: Innovation and selection in human origins. *Signs, 1*(3), 585-608.

Therborn, G. (1980). *The ideology of power and the power of ideology*. London: Verso.

Thompson, L., & Walker, A. J. (1989). Gender in families: Women and men in marriage, work, and parenthood. *Journal of Marriage and the Family, 51,* 845-871.

U.S. Department of Labor. (1997). USDL 97-195. Washington, DC: Government Printing Office.

Uttal, L. (1996). Custodial care, surrogate care, and coordinated care: Employed mothers and the meaning of child care. *Gender & Society, 10,* 291-311.

Walster (Hatfield), E., Aronson, E., & Abrahams, D. (1996). On increasing the persuasiveness of a low prestige communicator. *Journal of Experimental Social Psychology, 2,* 325-342.

Walzer, S. (1998). *Thinking about the baby: Gender and transitions into parenthood*. Philadelphia: Temple University Press.

Weissman, M. (1998, September). Count on me: How to create and nurture a supportive network of friends, neighbors, and other moms. *Working Mother*, pp. 38-42.

West, C., & Zimmerman, D. H. (1987). Doing gender. *Gender and Society, 1,* 125-151.

White, L., & Keith, B. (1990). The effect of shift work on the quality and stability of marital relations. *Journal of Marriage and the Family, 52,* 453-462.

Wolf, N. (1991). *The beauty myth*. New York: Doubleday.

Zigler, E. F., & Lang, M. E. (1991). *Child care choices: Balancing the needs of children, families, and society*. New York: Free Press.

Index

for innovators, 116-117, 138-139
for pragmatists, 57, 59, 109-110,
 114-115
in author's model, 90, 98, 126
quantitative analysis, 124
structural models, 72
widespread accepted, 78, 141
Edin, K., 34, 38, 128
Education:
 homeschooling, 101, 150
 of women, 17, 27, 97
 See also Schools
Egalitarian cultures, 11
Egalitarian gender role strategies, 88,
 177
Eggebeen, D. J., 16, 77, 78-79,
 128-129, 131, 132, 144
Employers:
 family friendly, 31, 58, 73-74, 182
 on-site child care, 73-74
Employment. See Labor force
 participation
Engels, F., 12, 81-82
Epistemology, 43, 44
Erikson, Erik, 23
Estes, S. B., 75, 78
Etaugh, C., 78, 127
Experts, child rearing, 24, 28-32
Expressive role, 13, 69-70

False consciousness, 168, 183-184
Families:
 African American, 28
 child care provided by members,
 151, 155
 child-centered, 23
 ideologies communicated in, 27-28,
 53-54
 patriarchy in, 82-83
 politicians on, 33
 roles in children's social problems,
 33-35
 sizes, 74-75
 See also Traditional family model;
 Work-family balancing and
 weaving

Family friendly employers, 31, 58,
 73-74, 182
Family leave, 96, 97, 105
Family Medical Leave Act, 105
Family Values rhetoric, 33, 34-35
Family Wage Act, 15
Family-home day care, 62-63, 155
Fatherhood ideology, 178
Fathers:
 breadwinner role, 77, 82, 97, 100,
 101, 127, 136-137, 178
 child rearing attitudes, 178
 employment schedules, 75-76
 expectations of, 178, 180
 factors in employment decisions, 72
 family leaves, 96, 97, 105
 incomes, 124, 129, 134, 135
 instrumental role, 13, 69-70
 lack of information in study, 174
 nonoverlapping shift work, 60-62,
 119-121, 151-153, 160
 penalized for putting work before
 family, 37-38, 81, 105
 reactions to wives' employment
 decisions, 175-176, 177
 seen as inadequate substitutes for
 mothers, 70, 149
 shared responsibility for child care,
 111, 119-120, 151-152, 158,
 160, 175, 177-178
 single parents, 81
 solo caregivers, 111, 151
 work-family balancing and weaving
 issues, 37-38, 81, 96-97, 105,
 120, 174-178
 See also Men; Parenting
Fatoullah, E., 33
Feminist theories, 6, 79-83
 conflict theories, 81-83
 critiques of gender relations, 79-80,
 90-91
 critiques of scientific method,
 43-45
 explanations of maternal labor force
 participation, 90-91, 167-168
 liberal, 80
 radical, 80

gender roles, 13, 100, 101, 105-106,
 178
low stress levels, 102
mother's child care responsibility,
 13, 101-103
negative outcomes, 34
proportion of American families, 97
See also Intensive motherhood
 ideology

United States economy, 12, 15-16, 77,
 130
U.S. Department of Agriculture, 127
U.S. Department of Labor, 17, 72, 97
Uttal, L., 107, 108, 147, 149, 155, 158

Wages:
 decline in men's, 16, 130
 gender gap, 15, 129, 130, 166
 of women, 129
 See also Incomes
Waite, L. J., 147, 160
Walster, E., 33
Walzer, S., 29, 42, 85, 91, 180-181
Weber, Max, 50
Weissman, M., 32
Welfare, 127-128
West, C., 180
White, L., 61
Williams, David, 37
Witsberger, C., 147
WNBA. *See* Women's National
 Basketball Association
Wolf, N., 106
Women:
 child care abilities, 71
 childless, 2, 17, 86, 182
 economic dependence, 83
 economic production, 12-13, 68
 educational attainment, 17, 27, 97
 employment discrimination, 71
 expressive role, 13, 69-70
 incomes, 72
 proportion of labor force, 96

seen as husband's property, 82
unpaid household work, 12, 13
wages, 129
See also Gender roles; Labor force
 participation; Mothers
Women's National Basketball
 Association (WNBA), 35-37
Wood, W., 33
Woodward, Louise, 2, 3, 35
Work-family balancing and weaving:
 biases in research on, 44
 by innovators, 120
 expert advice, 29-30, 31, 32
 future research needs, 174, 186
 in agricultural era, 12
 in subsistence cultures, 11
 integration, 3, 148
 issues for families, 1-2
 issues for men, 37-38, 81, 96-97,
 105, 120, 174-178
 public debate about, 2, 35-36
 social influences, 182-183
 strategies, 3-4, 65, 97, 171
 with school-age children, 186
 working hours issues, 58, 104-105
Working Mother magazine, 31-32, 73
Working mothers:
 conflicts with stay-at-home mothers,
 42, 102, 141, 180-183
 court cases involving, 2-3, 35-36, 38
 criticism of, 2-3, 102, 141
 health, 114
 hours worked, 104-105
 involvement in school activities,
 178-181
 magazines for, 31-32
 motives for working, 55, 103-104
 noneconomic benefits of working,
 55, 56, 103-104, 106, 107,
 110-111, 118
 occupations, 124
 part-time employment, 57, 110,
 112-113, 155
 rejection of intensive motherhood
 ideology, 123, 159
 time spent on appearance, 105, 106

About the Author

Angela J. Hattery is Assistant Professor of Sociology at Wake Forest University. She joined the department in 1998 after 2 years as Assistant Professor of Sociology at Ball State University. She earned her PhD in sociology in 1996 at the University of Wisconsin—Madison and her bachelor's degree in sociology and anthropology at Carleton College in 1988. Her current research focuses on the ways in which mothers with young children balance and weave work and family. She has utilized both surveys and interviews in order to examine this phenomenon. In addition to the qualitative data reported in this book, she is working on several articles that focus on the quantitative findings. She has done research on work and family and on sexual violence. Her areas of specialization include gender, family, and social psychology. She has a son and a daughter.